DIALOGUES FROM DELPHI

DIALOGUES
FROM
DELPHI

By Jacob Loewenberg

Essay Index Reprint Series

BOOKS FOR LIBRARIES PRESS
FREEPORT, NEW YORK

INTERNATIONAL STANDARD BOOK NUMBER:

0-8369-1886-X

LIBRARY OF CONGRESS CATALOG CARD NUMBER:

77-121485

PRINTED IN THE UNITED STATES OF AMERICA

Preface

THE PRESENT VOLUME, composed of a series of dialogues, is designed to bring into clear focus some of the crucial issues in aesthetics and criticism. But these issues are here viewed in broad perspective; in choice of topics and in the treatment of them the work is addressed to laymen rather than to specialists.

I have attempted to exploit fully the resources of the dialogue, which is a form singularly appropriate for dealing with controversial themes. There is something artificial about a dialogue if used as a medium to convey the author's own point of view. A dialogue so constructed is virtually a monologue with frequent interruptions. Only one of the personages is made to represent the author, the role of the others being merely to serve as foil or spur. The author's spokesman is in a dominating or privileged position, and those other speakers who are induced to voice opposition to his contentions are forced in the end to yield assent to them. The author is thus a sort of *deus ex machina* who, through a chosen character, contrives to marshal the arguments in defense of a particular thesis and to remove objections that may be raised against it by the supposititious antagonists. Although it takes skill to manage a dialogue of this kind, it is a literary game of playing, so to speak, with loaded dice. This procedure I have scrupulously avoided. I have employed the dialogue to reproduce that kind of spontaneous conversation in which two speakers are evenly matched. The point of view of each, gradually developed and deepened by contrast with the other, remains distinct and retains its cogency. Neither

speaker speaks for me. A dialogue is essentially a debate and
should, to be exciting and dramatic, reflect the play and inter-
play of conflicting ideas. If it is to possess a literary value
and vitality of its own, a dialogue must consist of an elabo-
rate pattern of point and counterpoint.

This literary device lends itself especially to an explora-
tion of basic disagreements over problems of art. Many
questions in aesthetics and criticism are still moot, and it is
with these that the following dialogues are mainly concerned.
The questions considered and brought to light are those that
may be said to provide pabulum for various theories, none
as yet so definitely established that all the others could be
definitely ruled out of court. I have taken to heart what David
Hume said in his *Dialogues Concerning Natural Religion*,
namely, that "reasonable men may be allowed to differ,
where no one can reasonably be positive." The subject of
art, like the subject of religion, is one in which there is room
for honest differences of opinion. It is in Hume's spirit that
I have conceived my two characters: I have permitted them
to disagree in their approach and attitudes to certain prob-
lems of art which neither of them (nor I as their author)
can solve with dogmatic assurance. It is enough if the prob-
lems themselves can be so pointed out or pointed up that rival
interpretations of them may be entertained as hypotheses of
equal relevance and equal significance.

The conversations between the two persons in the dia-
logues are those of thoughful laymen who, through sharing
a common interest in the arts, are unlike in taste and judg-
ment. The aesthetic experience of laymen cannot be ignored
unless we suppose that artists intend their creations to be

enjoyed solely by other artists or by expert critics. It will hardly be denied that any theory of aesthetic experience aspiring to be comprehensive must include within its scope the tastes and judgments of the general public. No theory of art can lay claim to validity if it lacks reference to varying degrees of response to objects of beauty. How far technical knowledge of the arts is requisite for aesthetic appreciation is a debatable matter, and is debated at length in some of the dialogues. We are certainly all laymen in our response to the beauty of nature: technical knowledge of its mode of production is here precluded: we cannot, for example, understand a natural sunset as we may understand a painted sunset—as the execution of a definite plan, the result of a special method, the expression of a particular style. Should it be said that aesthetic appreciation of nature is radically different from aesthetic appreciation of art? This too is a subject of prolonged discussion between the two speakers. At any rate, whatever be the contrast between the professional and the lay attitude to beauty, it is the latter which is of primary importance in the following dialogues.

The two characters speak accordingly as laymen, and the style in which they speak is altogether free from the special locutions that have their place in the learned treatises on aesthetics and criticism. Technical expressions have been eschewed here almost entirely. The debate carried on is couched in a language which is neither academic nor colloquial. The reader will note marked differences in the diction of the two speakers, as befits their different characters: if the prose of one is more impassioned, that of the other is more ironic. But, as often happens in spontaneous conversa-

tion, each adopts on occasion, consciously or not, the other's mode of speech.

I have named my two speakers "Hardith" and "Meredy." For the choice of the names, which may seem like a *tour de force*, there is some justification in the first dialogue, which culminates in antithetical conceptions of life as embodied in the novels of George Meredith and Thomas Hardy. The speakers are divided in their philosophical sympathies and literary valuations; one has a preference for the works of Hardy, the other for those of Meredith. If I have taken the liberty of playing upon the names of these novelists, this poetic license, as it were, should not lead the reader to assume that my speakers have been created in their images. There is, of course, no resemblance between my fictitious characters and the two writers of fiction. I have retained the same names throughout, though I might have invented others, partly because I liked them but chiefly because I associated the names with quasi-real persons, each being present to my imagination, in the course of writing the dialogues, as indefeasibly individual and generally consistent.

The consistency of the two speakers should not, however, be viewed in too mechanical a fashion. The psychological integrity of character is not the same as the logical integrity of discourse. Occasional lapses from strict cogency in the utterances of both speakers seemed to me to be required for the sake of verisimilitude to spontaneous conversation. Friends engaged in a sustained discussion are often found to steal each other's thunder, one saying what the other should have said, and borrowing, whether seriously or playfully, the language or argument of his opponent. It is characteristic

of a spirited debate—and this is its irony, which the dialogue must preserve and not suppress—that the participants not only contradict each other but not infrequently contradict themselves. But I have not deliberately sought to introduce contradictory elements in the ideas or expressions of the two speakers: they appear in their proper contexts as natural and apposite. I could not help impersonating each character in turn as a distinct mind in complete detachment from myself. It was as if each dictated his ways of thinking and phrasing in accents peculiarly his own.

In the title of the work the word "Dialogues" has been employed to exhibit fairly the manner of presentation of the subject, which is achieved not by disquisition but by dialogue, not by an *ipse dixit* but by the interchange of conversation. And to give the conversations a local habitation and a name a visit has been made to Delphi, the oracular seat of Apollo, who in the very beginnings of Europe's intellectual life smiled with divine approval upon men's works and men's thoughts in the domain of art. In another sense, too, it seemed appropriate to evoke his image, discreetly not naming him but merely referring to his temple site on the flank of Parnassus: the oracles of Apollo, for all their supposed finality, were often found dauntingly capable of more than one meaning, even as the participants in a dialogue will view a concept from different angles of the mind. For the title altogether, "Dialogues from Delphi," with its felicitous references, I am indebted to my friend Mr. W. H. Alexander, of Berkeley.

The dialogues, in the order of their composition, were first read before the Arts Club of the University of California, to the members of which I owe a debt of gratitude for having

provided me with the incentive to write them. They also served as the text for a course, entitled "Philosophy of Art," which I gave at Harvard University as a visiting lecturer during the academic year 1947–1948. To the students of that course I wish to express my thanks for their attentive perusal of the issues raised in this book. It was their task to find in the erudite works of aesthetics and criticism authoritative support for the lay opinions voiced by Hardith and Meredy.

Berkeley, California J. L.
April, 1949

Contents

I

The Comic as Tragic

HARDITH: Now that Allison has left us, I must tell you frankly that you have suffered your love of paradox to carry you too far. A little *jeu d'esprit*, a little intellectual irresponsibility, is a good thing: it enlivens conversation and stimulates reflection. But too much of it is dangerous. If you continue to play with ideas in your extravagant manner, people will put you down as a sophist. They will refuse to take you seriously. They will find you interesting and entertaining, but not quite sane or sound. I am sure you want people to laugh with you, not at you. As your friend, I must warn you against the tendency to yield to your acrobatic wit with such reckless abandon.

MEREDY: Thank you for this friendly warning. Of course I don't want to be called a sophist. Although I enjoy dialectic for its own sake, there is often much earnestness beneath my play with ideas. But tell me, Hardith, why do you take me to task? What have I said that you object to?

HARDITH: You said that comedy is more tragic than tragedy. You lectured Allison, a professor of Greek, on the profundity of Greek comedy. You pushed paradox to the limit by maintaining that Aristophanes reveals the pathos of life more poignantly than Euripides; *The Clouds*, you

insisted, deals with a graver situation than *The Trojan Women.* How could you say such a thing? What led you to make a statement so fantastic? What, do you think, is Allison's judgment of your competence as a literary critic?

MEREDY: I am sorry I shocked our friend Allison. I have no doubt that he dismissed my remark as an expression of ignorance or perversity. But I did not speak without sincerity. I really meant what I said.

HARDITH: What! Are you really serious in your view that comedy is more tragic than tragedy? Can anything be more topsy-turvy? My dear fellow, there is something in your manner of speech that reminds me of Oscar Wilde.

MEREDY: How do I remind you of Wilde?

HARDITH: I am thinking of his dialogue, *The Critic as Artist.* Your view of the comic as tragic betrays the same affectation of novelty and eccentricity.

MEREDY: You flatter me, Hardith. I admire Wilde for the excellence of his prose.

HARDITH: I grant the beauty of his prose. I dislike the insincerity of his pose. What a pity that such literary perfection should be lavished on clever sophisms! How specious the reasoning, clothed in a style so flawless, that the critic is an artist, and that criticism is more creative than creation! Are you imitating this virtuoso in paradoxes? I cannot help thinking of your epigram, "Comedy is more tragic than tragedy," as inspired by Wilde's "Criticism is more creative than creation." The resemblance between them, in sound and purport, is too striking to be accidental.

MEREDY: You are quite wrong. My theory of the comic has nothing to do with Wilde's theory of criticism. I am

concerned with a different theme, and if I have expressed
this theme in an epigram resembling in form one of
Wilde's, I am only too pleased to have recalled to your
mind a master of luminous diction. I do not deny my
appreciation of Wilde's essay. His contention that the
critic is an artist seems to me sound. There is wisdom in
his eulogy of the critical spirit. And there is much to be
said for his method in conveying this wisdom through
deliberate paradoxes. The paradoxes—and there are far
too many of them in Wilde—arrest our attention; they
may be irritating, but they are also challenging. Some
forms of dogmatism can be broken down in no other way.
How undermine the inveterate dogma that criticism and
creation are antithetical? By dazzling us with glittering
paradoxes Wilde effectively attacks that dogma, showing
that criticism and creation are complementary functions
of the mind; that the higher the creation, the more self-
conscious or critical it is; and that the higher the criti-
cism, the more independent or creative it becomes. It is
only of the highest kind of criticism that he says it is
"more creative than creation," meaning its capacity to
"create the intellectual atmosphere of the age," to develop
in the mind a "more subtle quality of apprehension and
discernment," and to break the path for fresh aesthetic
forms, for new attitudes and points of view. The paradox,
which lies more in the manner than in the matter of Wilde's
assertions, becomes attenuated when we recognize that the
antithesis between criticism and creation is entirely con-
ventional. For those who draw an absolute distinction
between them, the paradox remains unalleviated; but

those of us who are relativists, who do not divide the mind into special compartments or separate faculties, will see no anomaly in the statement that the artist may be a critic and the critic an artist. You see, Hardith, I perceive more than nimbleness of wit in Wilde's theory. What I find tenable in it is the emphasis on the necessity of understanding criticism and creation as conjoined and not as disjunctive. We have long been familiar with Matthew Arnold's definition of literature as a criticism of life, a definition which we may extend to cover all art. Wilde supplements Arnold's definition by a process which logicians call "conversion." If all art is criticism, some criticism is art. And some criticism, as he shows, is a high form of art, perhaps the highest. What Wilde says, often with impudence but always with brilliance, has a serious and profound meaning, namely, that ideas are not absolute and mutually exclusive. They have no fixed contours or boundaries. In his use of criticism and creation as ideas that occupy and annex each other's territory, and territory which only convention has assigned to them, Wilde illustrates the natural pliancy of living ideas. Vital ideas are fluid and mobile. I am thus quite serious in maintaining that the ideas of the tragic and the comic are essentially variable and elastic. No, my *view* of the comic as tragic is in no sense dependent upon Wilde's defense of the critic as artist. Its sources and influences lie elsewhere. It is possible, however, that my *description* of the comic as more tragic than tragedy was unconsciously suggested by Wilde's language. "Criticism is more creative than creation" is an epigram that one does not soon forget. It is

the sort of thing that keeps ringing in one's ear. For all I know, I may be beholden to Wilde for what I am frank enough to consider a felicitous phrase.

HARDITH: To tell you the truth, Meredy, I am a little suspicious of the felicity of your phrases. To me the happiest expressions are the simplest. An honest man, if he has anything important to say, will not deliberately speak in riddles. To defend the critical spirit, it is not necessary to resort to a confusion of concepts. To mix concepts is as objectionable as to mix metaphors. According to usage, criticism and creation are antonyms rather than synonyms; to say that criticism is even more creative than creation is to fly in the face of rational discourse. One might as well say that a square is more circular than a circle. Language is indeed flexible, but even poetic license must not be construed as freedom to talk nonsense. Your dictum that comedy is more tragic than tragedy proclaims a flagrant contradiction. You assert in the same breath a difference and an identity; comedy, to be more tragic than tragedy, must still be understood as comedy. *The Clouds* of Aristophanes, for example, remains a comedy, in accordance with the usual meaning of the term, yet that meaning we must immediately abandon if we are to regard it as more tragic than *The Trojan Women* by Euripides. What is to be gained by such an assault upon good sense?

MEREDY: What you call an assault upon good sense is in fact a defense of better sense. Let us ignore Wilde's theory of creative criticism, and let us confine the discussion to my view of tragic comedy. You speak of tragedy and comedy as if they were opposites in every respect. Your allusion to

squares and circles betrays your precisianism. You want all terms of discourse to be as naked of ambiguity as the concepts of mathematics. Of course, a square is a square, and a circle is a circle. By no stretch of the imagination can the properties of the one be assumed by the other. This is good sense in the field of geometry. But is it good sense to demand such exactitude, that is, such freedom from equivocation, in discourse concerning all human interests and values? Tragedy and comedy are complex terms; they cannot be employed without qualification. Considered as literary *genres*, they are indeed distinct, as distinct as the epic and the sonnet, in the material they use, in the method by which they work, in the structure which they embody, and the aesthetic appeal at which they aim. It would be absurd to confuse these two species of literature; each owes its nature to different conditions of construction, and each has its appropriate form and design. If I take them primarily as works of art, I do not challenge the traditional distinction between *The Trojan Women* and *The Clouds*. One is indefeasibly a tragedy, and the other a comedy. But what I do challenge is the exclusive use of tragedy and comedy in this formal or literary sense. These terms have a wider meaning and a deeper significance. Many human situations and circumstances may be regarded as tragic or comic in accordance with a philosophic rather than a dramatic use of these terms. Is life itself to be viewed as a tragedy, or as a comedy? This question is not meaningless. Apart, then, from their application to two general kinds of dramatic art, to two different ways of treating human characters and situations, tragedy and

comedy may apply to the material or theme of literary
art, whatever be the form in which the artist casts it. What
one calls tragic or comic may thus refer either to *subjects*
treated or to the special *treatment* of them. And I contend
that I am not talking nonsense when I say, in too elliptical
a fashion perhaps, that comedy is more tragic than trag-
edy. What I mean is that a comic treatment of a subject
may reveal its intrinsic tragedy more clearly than a tragic
treatment.

HARDITH: I see what you are driving at. You seem to con-
ceive of subjects as inherently tragic and comic, and of
tragic and comic ways of treating them, and hence that a
tragic subject may be treated comically and a comic sub-
ject tragically. But even if I grant this, I don't see how a
tragic theme treated in a comic manner can ever become
more tragic than if treated in a tragic manner. I should
think that it would forfeit whatever tragic significance it
had in itself, if made to assume a comic form. Where is the
tragedy if the subject is so presented as to induce laughter?

MEREDY: Is laughter so ignoble that you deem it incompati-
ble with tragedy? There is, of course, laughter and laugh-
ter. Different men laugh at different things, in different
ways, and in different keys. The sad smile, which is an
inward laughter in the minor key, might well be the most
appropriate response to tragedy when it appears in comic
garb. But the subject of laughter is a complicated one,
and its relation to comedy is far from obvious. It is rash
to suppose that what prompts our laughter is necessarily
comic. As we may weep for joy, so may we also laugh from
fear and grief. Since laughter may express varied emo-

tions, it is unwise, I think, to make it the basis for defining
the essense of comedy.

HARDITH: I am not so sure. If I consult my own experience, I
find that the emotional responses invariably produced by
tragedy and comedy are distinct and unmixed. A real
tragedy moves me to tears; a comedy causes me to laugh.
But let that pass. For the moment I am more interested in
your strange view of comedy as being more tragic than
tragedy. What are your reasons for this view? What is
your evidence? What actual comedy seems to you to
embody a tragic content?

MEREDY: Every good comedy reveals to a sensitive and dis-
cerning mind a tragic situation. Let me give you an ex-
ample. The example happens to be one that first opened
my eyes to the true import of comedy. A little while ago,
because of a certain turn of expression, you wrongly
traced my view to the influence of Oscar Wilde. No, it
was not Wilde who inspired my view of the comic as
tragic. The man who first directed my attention to it was
the philosopher Hegel. Years ago I was struck by an inci-
dental observation of his concerning the relation of Greek
comedy to Greek tragedy. The observation occurs in an
obscure but profound book entitled *The Phenomenology
of Mind*, a book which has remained closed to all but a
few intrepid scholars. Well, in one part of that remark-
able work, Hegel depicts the glory that was Greece. He
finds the epitome of that glory in Greek tragedy; for in
Greek tragedy he discerns the ideals and values by which
Greek life was dominated. Indeed, through the medium
of tragedy the Greeks voiced their deepest faiths and their

noblest aspirations: the tragic poets made vivid the belief in the superiority of the universal over the particular, in the necessary rule of reason, in a divine plan of the world; and they made articulate the desire for temperance and justice, for harmony in thought and action, for a stable and well-ordered State. These faiths and these aspirations constitute the background for the fatal issues depicted in Greek tragedy, because, in the last analysis, these fatal issues supervene upon violation of the universal laws of sanity and the permanent foundations of the good life. Such in brief is the philosophic meaning of Greek tragedy; it is at once a summary and a vindication of pervasive ideals and values to be cherished and reverenced. What is genuinely tragic in Greek tragedy is thus a situation in which those who are guilty of subverting the principles requisite for a disciplined character and a just society become the instruments for bringing misery and destruction to themselves and to others. Now, if Greek tragedy may be said to express an impassioned justification of truths conceived as immutable, Greek comedy voices a critical assault upon them. It is perhaps an exaggeration to assert that Greek comedy represents the most tragic turning point in ancient civilization; but consider what a revolution in ideas it manifests. In comedy, the ideals and values acknowledged and honored in tragedy are mercilessly abandoned to scorn and ridicule. The ancient faiths are shown to be delusions, and the ancestral hopes fictions. The standards of thought and conduct, no longer assumed to have their source in the nature of things, sink to the level of transitory conventions. Ideas formerly exalted as

eternal and universal now become local and ephemeral.
In a word, the tragic theme of Greek comedy is the dissolu-
tion of the bonds that bound the cities in early Hellas;
sacred rites, venerable traditions, unquestioned loyalties,
inveterate convictions, all these now appear as insubstan-
tial as clouds. Greek comedy proclaims to the world—so
Hegel says—the death of the immemorial gods and the
absolute power of man. And this power is that of the comic
poet, for it is he who shows that the gods are but fabled
creatures, and that their decrees are only fancies. And
though comedy's material is material for mirth, dealing
as it does with the follies and foibles of mankind, its tragic
import lies in the fact that the things we laugh at are things
once sacred, and that what we deride as absurd belongs
to some of the fairest visions of the human spirit. That
which in tragedy is treated with grandeur and dignity, be-
cause it touches the deepest and most universal aspects of
life, comedy turns into satire and caricature. Can anything
be more tragic? If Hegel is right in his opinion that what
is implied in Greek comedy is the disintegration of Hel-
lenic civilization, then its tragic significance is indeed
greater than that of tragedy.

HARDITH: There is much wisdom in what you have garnered
from Hegel, and I admire the eloquence in which you have
conveyed it. I suspect, however, that the eloquence is yours
and not the philosopher's, for though my knowledge of
Hegel is slight, I have always regarded his style as the
acme of obfuscation. But if you have not altered his
thought by rendering it intelligible, what am I to make of
so broad a generalization? Does Greek comedy become

tragedy just because to one philosopher it represents an
effete phase of Hellenic culture? Might not another philos-
opher see in it precisely the opposite, namely, the flower-
ing and ascendancy of the critical spirit? Of that spirit,
as we know, the Greeks were the incomparble votaries,
and comedy was simply the consummation of it. And
though comedy be taken as exemplifying ruthless criti-
cism of the theoretical beliefs and the moral aspirations
voiced by tragedy, such criticism may be nothing more
than a challenge to reëxamine traditional ideas and to
defend on a new basis values that are growing obsolescent.
Aristophanes, for example, made fun of Socrates and
exposed him to ridicule, yet this great comic poet might
well be looked upon as a Socratic at heart who used his
genius to compel his fellow men to know themselves and
their destiny.

MEREDY: What you say strikes me as sound. And your opin-
ion about the importance of Aristophanes is particularly
pertinent. In the cultivation of self-knowledge an Aris-
tophanes may succeed where a Socrates failed. So serious
indeed is the function of comedy. And in assigning to
Aristophanes a Socratic mission you have unwittingly
paid a high tribute to the comic spirit. With this I certainly
have no wish to quarrel. But your praise of Aristophanes
hardly refutes Hegel's thesis. In Greek comedy, whether
Aristophanic or other, Hegel saw not merely criticism but
iconoclasm, an iconoclasm sweeping in extent and dis-
astrous in results. The tragic significance of Greek comedy
lies in the implication that the apotheosis of universality
and wholeness, inherent in Greek tragedy, was a worship

of idols. It is only in relation to Greek tragedy that Greek comedy assumed for Hegel a tragic aspect. Iconoclasm is always calamitous: it attacks what men cherish, it destroys the high and enduring things for which they live. And when, through satire and caricature, the attack is made upon the things treated in tragedy as inviolable—the spiritual realities of Religion and the moral ends of the State,—such iconoclasm, seen in historical perspective, spells desolation. It is perhaps one of the gravest episodes in one of the greatest of human tragedies—the decline and fall of Greek civilization. Those who set a supreme value on that civilization must take a tragic view of everything that contributed to its dissolution. And can you deny that the iconoclasm of comedy had a corrosive and subversive influence on Hellenic culture?

HARDITH: Your question, of course, is a rhetorical one. You know very well that I lack learning enough to venture an opinion on so difficult a subject. And if you don't mind my saying so, Meredy, your own erudition is hardly adequate for the task of interpreting with accuracy the effect of comedy on the course of Greek civilization. I am aware, however, that in taking a tragic view of Greek comedy you are only reproducing a speculative observation of Hegel's. I will not deny the force of that observation; singularly perspicacious, it throws light on an aspect of Greek comedy that is seldom perceived. But how does this support your more general theory that comedy is more tragic than tragedy? Is one philosopher's ingenious conception of the few literary products of Greek genius a sound basis for so paradoxical a theory?

MEREDY: I have other grounds for maintaining a theory which you persist in calling paradoxical. I have mentioned Greek comedy, invoking Hegel's interpretation of it, in order to exhibit a classic example. The example, though not decisive, is instructive, showing that dramatic poetry having the comic form may reveal to some minds a situation more tragic than that which appears in the form of tragedy.

HARDITH: But this "tragic situation," which "dramatic poetry having the comic form" is said to reveal, to whom may it be revealed? Surely not to the ordinary person for whom a comedy, concerning itself as it does with incongruous circumstances and ludicrous characters, is something which provokes him to hearty laughter. Only for those who bring to the contemplation of comedy a reflective judgment of life can it be more than an occasion for mirth. It requires a mature and cultivated mind to see the serious in the comic. And to perceive the tragic in the comic, if it can be perceived there, calls for consummate mastery in discernment. In other words, the comic is nothing but comic, and if it has anything else to reveal, it will reveal it only to minds subtle in perception and profound in judgment.

MEREDY: Here we are in complete agreement. None but sensitive minds, fully aware of implications hidden from the callous or the incurious, can perceive the tragic in the comic. Neither pure tragedy nor pure comedy exists for the multitude. Viewed as different species of dramatic art, tragedy and comedy presuppose for their aesthetic appreciation minds gifted with generous feelings and

sympathetic imaginations. Regarded as representing by different methods human characters in relation to one another and to their environment, tragedy and comedy demand the intellectual acumen requisite for a just estimation of the inner motives and the outer conditions that control human behavior. If a mature intelligence is needed for recognizing the tragic as tragic, a much more seasoned intelligence is required for the recognition of the tragic in the guise of the comic. Yes, Hardith, comedy is one thing as seen by plain men, but quite another when perceived by reflective minds.

HARDITH: Far be it from me to dispute a truism. Men of different grades of sensitivity and intelligence will naturally vary in their enjoyment and understanding of any work of art. I take it for granted that some men, because of their native or acquired powers, might see in a comedy implications of which other men less acute will remain unaware. Why not leave the matter thus? Why turn a truism into a paradox? Why strain the idea of the comic to the point of blurring its fixed distinction from the tragic?

MEREDY: It is not I, Hardith, who can be accused of blurring distinctions. Have you forgotten my contention that between the tragic and the comic there are many differences? You, who think of their difference as chiefly aesthetic, are more prone to confusion than I am. It would be foolish not to recognize as legitimate the venerable distinction between the two species of dramatic art. Where and how to draw the line that divides tragedy and comedy,—this is indeed a difficult question, and I am willing to leave it to Aristotle or to any other authority on "poetics." But the

field of dramaturgy has no monopoly of the epithets
"tragic" and "comic"; they have, I must repeat, a wider
range of application. Look abroad, Hardith, and contem-
plate the grave state of the world; in many parts of it fools
and knaves are in exalted places, exacting and receiving
homage from a large number of mankind; the state of
affairs in many societies is at the mercy of fraud and
superstition, fanaticism and idolatry. Tell me whether it
is not appropriate to speak of the condition of many na-
tions as tragic, and of their tyrannical rulers as comic.
What now transpires in some countries threatens to deal
destruction to the fairest fruits of civilization, and it trans-
pires there at the bidding of persons clearly grotesque or
demented. Here, outside the domain of art, you find trag-
edy in terms of life, and tragedy, I hasten to add, wrought
by comic figures.

HARDITH: I admit that we may use words with a certain lati-
tude, and I am no pedant who would deny you the right
to speak of the tragic fate of nations or the comic demeanor
of their rulers. You may quote Shakespeare, if you like,
who said that "the world's a stage." There is much truth
in the comparison. The world *is* the theater of men's real
calamities and follies, and the theater *does* picture life in
all its portentous or ludicrous aspects. This is simply a
compendious way of stating the close connection between
actual experience and dramatic art. And though I grant
the propriety of describing actual characters and cir-
cumstances as tragic or comic, I must insist that the words
tragedy and comedy, when taken strictly, have exclusive
reference to products of art. Mention these words, and

what I immediately think of is a Greek or a Shakespearean
play. But quite apart from strict usage, a question to
which I attach more importance than you seem to do, there
is the question of the essential nature of tragedy or com-
edy. Art alone, I hold, discloses the unmixed essence of
either. The world may be likened to a stage, but the trag-
edies and comedies enacted there are never pure. Your
own illustration, though impressive, shows that in the
real world the tragic and the comic are inextricably
intertwined. And when you speak of comedy as being more
tragic than tragedy, you obviously do not have in mind the
ludicrous features of everyday reality; what you think
of, if I understand you aright, is a more universal scope
and a profounder sense of the ludicrous, which only art
can make manifest.

MEREDY: You have conceded more to my point of view than
you perhaps intended. You speak of pure tragedy or pure
comedy. So do I. You find the purity of either exemplified
in the products of art. I also discover in art, and in art
alone, the tragic and the comic in their undistorted or un-
adulterated forms. It is the function of great art, unless
we assume it to have no relevance to experience, to throw
into relief some fundamental aspect of life, and to raise
it above the trivial and the accidental. Even the trivial or
the accidental, when a true artist makes it the object of
his preoccupation, acquires an unwonted meaning or un-
suspected significance. The genuine artist sees more, and
sees more attentively, than we do. His is not another world
than ours; it is our common world more deeply conceived
and more adequately interpreted. When tragedy or com-

edy as portrayed by a sincere artist is said to be pure, the purity must be understood as purity of vision or discernment; the artist sees life in its essential manifestations, he apprehends human vicissitudes as typical. A profound truth was voiced by Aristotle when he said that art imitates nature. What it imitates, however, is not nature perceived at random, but nature revealing itself to an acute intuition and a disciplined imagination.Thus, whether the artist constructs a tragedy or a comedy, the construction will be accepted by us as an authentic image of the real world if the characters and circumstances chosen for representation are unmistakably representative, in the sense of answering to what is pervasive and recurrent in human experience. Pure tragedy or comedy, therefore, differs from the impure kind in its catholicity, in being more truly expressive of the nature of our actual world as observed by a clear and synoptic mind. And such pure tragedy or comedy need not always assume the form of a play. There are other modes of art for representing representative characters and circumstances. The novel, for example, is an excellent medium for the exhibition of the tragic or comic aspects of life.

HARDITH: Our agreement, I think, is more verbal than real. My conception of dramatic art is quite orthodox. You speak of tragedy and comedy as if they were forms of art of equal rank and importance. I cannot attribute to them a comparable function or value. Tragedy is a revelation of the darker things in existence, comedy of the lighter. Tragedy is elevating, comedy entertaining. Tragedy concerns itself with men's fate or destiny, comedy with their

flaws and infirmities. Tragedy is a dignified portrait of life, comedy a transparent caricature. One draws us away from folly, the other attracts us to it. One addresses itself to our common humanity, representing character as true to type; the other attends to the excrescences of human nature, depicting some individual defect or deformity. Consider Shakespeare. Can you seriously maintain that his tragedies and comedies have the same universal verisimilitude and import? If we knew Shakespeare by his comedies only, would we recognize in them a poet who had touched human life at its deepest level? I cannot but feel that in writing his comedies Shakespeare sought relaxation, as it were, from his profounder labors, so incredible are the imbroglios and so rollicking the fun. His comedies are intended to amuse, and not to probe, as his tragedies do, the mysteries of our existence and the secrets of our souls. No, Meredy, you cannot deny that comedy is inferior to tragedy as a picture of life or as a form of art. What you say of tragedy, which I find eminently just, can be applied to comedy only by a sort of dialectical *tour de force.*

MEREDY: Your attitude toward comedy is certainly conventional. You share the common prejudice that solemnity is superior to humor. Are you a puritan at heart? Do you regard mirth as ignominious? Is laughter morally offensive to you? The comic spirit is not frivolous because it does not wear a long face. Your fastidious preference for the obvious blinds you to the serious intent of comedy. "Our sincerest laughter with some pain is fraught." How true this is of Shakespeare! Your interpretation of his

comedies is uncritical. There is of course much fun in
them, exuberant fun. Many of the circumstances are un-
believable, and some of the characters are clowns. Yes,
there is a superabundance of buffoonery in all his lighter
plays. Yet their poetic lightness does not prove the poet's
lightness of heart. The idea that Shakespeare wrote his
comic plays in a holiday mood, so to speak, seems pre-
posterous. These plays are not products of a genius turn-
ing his back upon the graver issues of life; there is here
no lapse of creative power or dignity of purpose. The
comic plays have a gravity of their own: they show us that
the folly of fools is the ineradicable folly of mankind.
Falstaff, Malvolio, Dogberry, and the rest are drawn to
a universal scale. They exemplify men's permanent capac-
ity for coxcombery. Shakespeare's comic creations even
in their most fantastic and sportive forms paint humanity
as it indefeasibly is. Human beings display but rarely the
heroic virtues, the monstrous vices, the consuming pas-
sions with which the persons in a tragedy are endowed;
they are not often protagonists or antagonists of great
principles or moral forces; they seldom resemble, in feel-
ing or action, an Othello or a Lear, a Hamlet or a Macbeth.
In their actual and ordinary comportment, men and
women have a greater likeness to the characters presented
in comedy; they are affected, pretentious, hidebound,
shortsighted, arrogant, intolerant, vain, conceited, covet-
ous, churlish. Most of their miseries result from their
foibles. *The real world is a world of fools.* This is a sober
judgment, Hardith, and one that subtly pervades the com-
edies of Shakespeare. If you look beneath their persiflage,

you will find a sane mind exposing to our view the ubiqui-
tous incongruities and contradictions of human life.

HARDITH: In Shakespeare are many mansions, containing
different treasures of wisdom. To me, his deepest wisdom
is conveyed through the tragedies. By their high themes,
their moral aspirations, their imaginative power, their
universal truth, their lyrical beauty, their dramatic com-
pleteness I recognize the perfect genius of Shakespeare.
The comedies may be great works of art, but they are not
his greatest. A minor Shakespeare, as it were, his afflatus
less fervid, speaks through them. The tragedies deal with
the sublime, the comedies with the ridiculous. And to be
more moved by a noble than by a ludicrous subject is not
the idiosyncrasy of a puritan. But I will not quarrel with
you if in your estimation the comedies and tragedies have
a like dignity and importance. Your approach to Shake-
speare is simply not mine.

MEREDY: I don't think it is altogether a matter of approach.
The works of Shakespeare, reflecting life in all its multi-
farious aspects, will mean different things to different
men. The question which of the works reveal his authentic
genius does not greatly agitate me. What I am chiefly
concerned with is to defend the serious function of com-
edy. And this I can most persuasively defend by indicating
its tragic content. You are wrong in supposing that I con-
sider Shakespeare's tragedies and comedies to be works
of art equal in greatness. I may not be conventional, but I
am not eccentric. I share your *aesthetic* preference for the
tragedies. They pull at our heartstrings with elemental
force by fixing our attention upon issues and crises the

gravity of which is palpable; so manifest indeed is the
spectacle of human frustration and defeat that it touches
and kindles by instant appeal our deepest emotions, ex-
citing to the highest degree our passions of pity and awe.
But although we are profoundly stirred by the portentous
actions and calamitous events portrayed in tragedy, we
do not clearly discern their causes or reasons. Our im-
passioned contemplation inhibits our reflective judgment.
We are so affected by the fateful things that men do and
suffer that we perceive their pathos without distinctly per-
ceiving their necessity. We stand aghast before life's dis-
asters, not understanding that their root lies in straining
to excess or in stretching beyond limit some human faculty
or interest. Tragedy depends not on external circumstances
alone; it hinges on circumstances precipitated by human
action under the governance of an overweening passion or
idea. Now this overweeningness of passion or idea, which
is the mainspring of tragedy, is also the source of comedy.
Genuine comedy, addressing intellect rather than feeling,
strips human nature to the skin, and holds a mirror before
its naked illusions. It reflects our pretensions and absurdi-
ties in their true colors. It exposes the truth, honestly and
unflinchingly, that men suffer because of the interplay of
follies either in themselves or in society. It turns our vision
upon the original source of tragic issues, revealing as
it does what is wrong with the world, what ails it, what
inordinate desires and blind purposes underlie human
behavior. In comedy we are thus face to face with men's
protean and pregnant delusions, our perception is focused
more upon them than upon the events and issues they pro-

duce. The tragic significance of comedy, being too subtle
and too deeply hidden to be seized directly, has its root
in thought, and thought must unearth it. Hence its aesthetic
inferiority to tragedy; the latter, invoking our emotional
reactions to suffering and misfortune, achieves its effect
immediately. But comic art, though it keeps our feelings
at a lower ebb, quickens the pace of our reason. Emanating
from the intellect, it speaks to the intellect; it forces upon
our minds the reflection that the world is at the mercy of
folly, and of folly continually sliding into new forms.
What a melancholy reflection! How pathetic a comic view
of life! Comedy thus understood has a tragic content, and
a content more tragic than that of tragedy, since it drives
home the truth—a truth too stark and too candid to appeal
to our sentiments—that the real world is a world of fools.

HARDITH: And you find this truth, as you call it, embodied
in Shakespeare's comedies? Well, if you say you find it
there, I am not disposed to contradict you. But I must use
my own eyes, and mine can see nothing of the sort. Shake-
speare's world is vast, not to say cosmic, and the comedies
represent but a small segment of it. They depict a sphere
of a low order, and that inferior region, so glaringly over-
drawn in studied sportiveness, suggests to me the spirit
of a carnival rather than a philosophy of life.

MEREDY: Under the veneer of comic gayety there is a deep
seriousness. You see the gayety, I the seriousness. In Shake-
speare, it is true, laughter is not always pure; it frequently
supervenes upon mere joke or jest. If he exposes human
nature to ridicule, the exposure is not sufficiently com-
plete. He but seldom strips us to the skin; more often he

only removes a few garments in a playful or teasing way. But Shakespeare's are not my favorite comedies; they contain too many madcaps and harlequins. Nevertheless, they paint humanity with deadly accuracy.

HARDITH: What are your favorite comedies?

MEREDY: The comedies I prefer are those of Molière. In his plays the comic spirit comes to its fullest fruition. They are works of indefectible art. The style is unaffected and unlabored. Both in matter and manner the plays exemplify the utmost economy and simplicity. They are equitable in judgment and equable in temper. There is no venom in their sting, no spitefulness in their thrusts. They do not preach or scold. Without chiding us for being deluded, Molière uncovers with consummate justness our hidden human nature, the propensity to cherish our congenial foibles being not the least of our inevitable follies. The characters he presents to our view are truly representative. What a gallery of rogues and impostors, hypocrites and snobs, pedants and bigots, simpletons and worldlings, egoists and idolaters, cynics and sentimentalists, fanatics and philistines! Molière's comedies exhibit to us the major forms of human folly in natural array, redolent of actuality, strikingly authentic. Hardly a variety of human experience is here overlooked; types of temperament in perpetual conflict with themselves and the world are probed for their very essence. Take, for example, *Le Tartuffe*, *Le Misanthrope*, and *Les Femmes savantes*. Those plays are not caricatures, partly revealing and partly hiding the real traits of human personality; they are true pictures of varied character, drawn from life, and

drawn with exquisite taste and subtle delicacy. These comedies provide a mirror wherein we may see, if we but use our eyes, the calm reflection of living men and women. The violent opposition of ideas, the irrational antagonism of wills, and the wanton rivalry of passions, of which any state of civilization is an epitome, are venerable themes; the variations of them, discernible in the life of society that surrounds us, have but the appearance of novelty. Hence the greatness of Molière's comedies; they emanate from a clear conception that human follies are patterns of behavior that recur as rhythmically as the seasons. Molière knows what ails the world, that Folly renders life chaotic and precarious; and he knows also the specific for the world's ailments, namely, to assail Folly and put her to flight. But this, too, he knows, that Folly is omnipresent; that she is many-headed; that she has a prolific nature; and that her meretricious charms are seductive. If you recognize that protean Folly is the real *dramatis persona* of pure comedy, and if you admit that in one form or another Folly is the source of whatever is insensate or ignoble in our human world, you will look upon Molière as a tragic poet in disguise. Yes, Hardith, Molière's comedies must be taken seriously, not only because they are superlative works of art, but also because they embody a trenchant criticism of life, a criticism universal in scope.

HARDITH: Your estimation of Molière is admirable. His comedies are indeed great exemplars of art and insight. But you give a one-sided interpretation of them. Not all the characters portrayed by the poet are rogues or dupes. He paints other characters, in opposition to them, that are

sane and wise. They are representatives of good sense, speaking in the name of reason and justice, and vindicating these ideals as guides of civilized conduct. These humane characters are also human; they, too, are drawn from life. The real world is not all on madness bent: it is a strange blend of good and evil. Molière has his feet on solid ground, and he observes human nature through clear eyes. He sees homely virtues and noble ideals as well as shams and delusions. If he depicts men dominated by Folly, he represents them also as intelligent and sagacious. Molière's genius is the genius of common sense; his shafts are aimed at those whose performances violate its shrewd maxims and prudent canons. His standard of valuation is not the standard of a visionary: it is the standard of one who has a sober regard for our common humanity. By exposing to ridicule all sophistry and illusion, Molière is intent upon extolling the good life as actually lived by men of sound judgment and disillusioned reason.

MEREDY: True, Hardith, profoundly true. What you say puts my view of Molière in a clearer light. I agree that Molière is a champion of common sense, and that his comedies express reverence for its ideals and values. But the common sense he cherishes is of a high quality and is possessed only by persons of rare honesty and integrity. Reason and justice, for example, are generally prized for their excellence, but how many comport themselves in conformity with the principles of reason and justice? The common sense which Molière vindicates is, alas, not a common mainspring of human action. The offenses against good sense are epidemic, and the prevalence of these offenses

furnishes the poet with inexhaustible material. Yes, Molière
has a deep love for humanity, and it is this love which
inspires his comic art. He has a vision of what we might
be, if we could live and act in accordance with our latent
goodness, and for this reason he castigates the degradation
of our own better humanity. The few characters that per-
sonify his conception of a better humanity are indeed
drawn from life, showing that his standard of valuation
is not, as you rightly insist, that of a visionary. The actual
world provides him with models of sanity against which
to measure the profuse follies of mankind. A tender hu-
manism governs his pensive attitude toward these follies.
He laughs at them, but his laughter is not gross or coarse.
The matter is too serious for brutal hilarity. His laughter
is scrupulous, imbued with kindness, humility, and re-
straint. But on the subject of Molière's laughter I must
refer you to George Meredith. He discerned its true nature
with singular acumen. Do you know his essay on the Comic
Spirit?

HARDITH: I have of course read his novels, but I am not
acquainted with the essay you speak of. Does it deal with
Molière?

MEREDY: Not entirely. It is a remarkable defense of the
humane importance of pure comedy. But the more you
read it, the more obvious it becomes that Meredith was a
close student, if not a conscious disciple, of Molière. His
admiration for the poet's genius is unstinted. The few
allusions he makes to his comedies are worth more than
volumes of criticism. And his analysis of comic laughter
is particularly impressive. The laughter of comedy, the

purest expression of which he finds in Molière, is "honorable" laughter. Meredith speaks of it as the "laughter of the mind"; or as a laughter which is spiritual, thoughtful, delicate, subtle, of unrivaled politeness, impersonal, addressed to the intellect, nearer a smile, often no more than a smile. His happiest description of it, however, is "silvery," suggesting the metallic quality proper to it. And, indeed, Molière's laughter is never brazen or wooden, shrill or sharp, harsh or hollow. Its sound is "finely tempered," showing "mental richness rather than noisy enormity." In various ways Meredith distinguishes "silvery" laughter from the baser kinds. People are ready, he says, to "surrender themselves to witty thumps on the back, breast, and sides; all except the head." The laughter directed by the intellect and addressed to the intellect is too sane and too sad to appeal to the average mind; it presupposes as its fundamental condition a study of the actual world which the average mind has neither the strength nor the will to endure. *C'est une étrange entreprise que celle de faire rire les honnêtes gens.* This utterance, quoted by Meredith, shows that Molière was conscious of the difficulty of his undertaking. His plays will always remain "caviare to the general," proceeding as they do from clear reason and good taste; their inward aspect is too fine for those who regard comedy as a cheap form of entertainment.

HARDITH: I do not deny that Molière's plays are works of elegance and refinement, and that his laughter is what Meredith by his hyperboles describes it as being, but I fail to see that their meaning is particularly subtle. They

show no more than what you find revealed by comedies of lesser breed, namely, that people make fools of themselves, that they are the dupes of their obtuseness and obstinacy, and that their worst enemies are their own blind and deluded natures.

MEREDY: But the tragedy of it, Hardith, the tragedy of it! You have distilled its essence in a few words of faultless precision. Yes, man is his own worst enemy; he is the victim of his own illusions, the prey of his own impostures. Steeped in folly, he is the source and vehicle of conflict and instability. The miseries of the world are caused by its fools, and its fools are numberless. This is the tragic situation made manifest by the comedies of Molière. Look there for a faithful image of life. And look there for a mind saddened in the presence of men's betrayal of their genuine humanity, a mind that never stoops to scorn or hatred.

HARDITH: You go too far, Meredy. You are attributing to Molière's *bonhomie* a strange subtlety.

MEREDY: The subtlety is not strange: it is a quality intrinsic to the comic spirit. The comic spirit is a messenger of charity that spares not the rod. It is, in Meredith's phrase, "humanely malign." Meditate on this striking juxtaposition of words; it reveals in a flash the subtle function of comic art. What a crushing scourge Molière wields upon Folly! Yet how gentle and compassionate the spirit that directs it! But Molière is not unique in being "humanely malign." Meredith, in coining this expression, must have had in mind the uses of his own artistic products. It is not necessary, as I have said, that comedy should appear in

the form of a play. Consider works such as *Tristram Shandy* and *Don Quixote*. Fiction is an admirable medium for the display of the comic spirit. The great novels of Meredith are clear radiations of that spirit. And though Meredith speaks of Molière's polished smile as unrivaled, the civilized laughter that resounds in his own novels is of similar quality, prompted as it is by a critical intelligence, a warm heart, and a sober vision of the actual.

HARDITH: You have given me a new approach to Meredith. I must study his essay on the Comic Spirit, and reread his novels in the light of it. I confess that I have so far missed their significance. I shall shock you perhaps if I say that Meredith bores me. His style is so diffuse, his plots so thin, his characters so odd. If I compare his novels with those of Thomas Hardy, for example, I find them deficient in dramatic structure and emotional appeal. Hardy moves me, Meredith tires me.

MEREDY: You obviously have not the key to Meredith, or you would not dismiss him in so cavalier a fashion. I grant that his style is often obscure, enigmatic, elliptical, and overwrought. One wishes Meredith could have written simply rather than ingeniously. But his style apart, which is original and fastidious, abounding in memorable epigrams and aphorisms, the idea of the comic as tragic governs the life of most of his novels. One of his stories bears the title *The Tragic Comedians*. Describe by the same name all of his creations, and you have a clue to their depth and wisdom. What a tragic comedian is Sir Willoughby Patterne in *The Egoist*! The hero of this novel inspires our pity and moves our sympathy. He is a com-

manding figure, he is a "gentleman of family and prop-
erty," he is an "idol of a decorous island." This "colossus
of Egoism," a lonely and pathetic character—not a real
human being, perhaps, but a typical symbol of humanity,—
is here exhibited, in a manner worthy of Molière, as an
absurd personage to be laughed at, as a mule and as a
dupe. In the fatuous selfishness of the man, seen in comic
perspective, lies his tragic destiny. Any novel by Meredith
is a sort of compendium of society; it is conceived to
throw reflection upon imposing persons whose farcical be-
havior is disastrous to themselves and their world. You
must judge Meredith as a writer the burden of whose song
is that human tragedy springs from human perversity.
His novels are designed to kindle a thoughtful vision of
human fate: they show how the civilized values of life are
constantly imperiled and thwarted by the prevalent follies
of incorrigible fools.

HARDITH: You seem to argue as if external circumstances
had no relation to human tragedy. The philosophy of life
which you attribute to Meredith seems to me quite inade-
quate. Man's fate lies outside him; his destiny is contrived
by powers over which he has no control. He is subject to
unknown influences; he is at the mercy of unforeseen acci-
dents. Life is tragic because men are continually swept
into the tide of irrational events. Their noblest aims and
their highest aspirations are exposed to the cruel ravages
of chance. In the antics of the cosmos, so to speak, is the
locus of human tragedy. This is what Thomas Hardy so
clearly perceived. He looked at the cosmic setting of
human life with irony and resignation, and he expressed

his elegiac vision of things in works of great power and beauty. The "satires of circumstance"—the chief theme of Hardy's masterpieces—certainly do play havoc with men's schemes and hopes. The untoward occurrences that determine our lives and govern our actions often appear to us as if they were pranks of nature. Hardy had a sharp eye for the "bludgeonings of chance": he seized upon them as the typical causes of human misfortune. In *Jude the Obscure, Tess of the d'Urbervilles,* and *The Return of the Native*—to speak only of these three great novels—the fatal turn of events is decided by incidents altogether fortuitous and unpredictable. Here everything hinges upon some unexpected fact or circumstance that poisons human character and engenders dire consequences. In Meredith the criticism is of humanity as if it were responsible for its destiny; Hardy's is rather a criticism of the universe, man's fate being blindly shaped by inscrutable forces. In representing man as the prey of these forces, as the victim of the "satires of circumstance," Hardy gives to tragedy a profundity not broached by Meredith. Human tragedy, being a part of the tragedy of existence, is inevitable; and it is inevitable because nature is inimical to human desire and human reason.

MEREDY: I am not unmoved by the gloomy picture of existence painted by Hardy with such deep feeling. Nor am I insensible of the artistic perfection of his great novels. And I admit that Hardy's cast of mind was more speculative than Meredith's. But what Hardy expresses is not tragedy, but pessimism. He solicits pity for man because he envisages man as a helpless creature of irrational circum-

stances. He condemns the universe because it was not con-
trived to satisfy human needs. But what is man that the
universe should be mindful of him? Pessimism (and op-
timism as well) is too anthropocentric. It considers the
world as if is were framed on a human scale. The pessimist
conceives the world as malignant, the optimist as benefi-
cent, but both commit the same pathetic fallacy, the fal-
lacy of measuring cosmic forces in terms of human values.
Hardy's philosophy, decrying these cosmic forces, de-
mands that the ways and operations of nature be judged
as good or evil in accordance with a human standard, good
being what fosters human interests, and evil what frus-
trates them. Hardy, who sees everywhere human failure
and defeat, absolves men from responsibility; he ascribes
all failure and defeat to the ambushed trammels of cir-
cumstance. He laments the tragedy of existence because
existence is alien to the good life as valued by man. But if
existence is tragic, it is presumably not tragic to itself.
There is no tragedy of existence if we have the courage to
face the truth that the universe is nonhuman. Expressions
such as "satires of circumstance" or "irony of fate" are
similes and figments of human fancy: the universe, not
endowed with a human mind, is incapable of being either
satirical or ironical. If tragedy is not to be confused with
pessimism, in the form in which Hardy voices it, human
beings must be held responsible for their own fate. Human
tragedy has its source in the free exercise of human action.
There can be no tragedy, in the pregnant sense of the term,
if men are entirely precluded from determining their own
way of life. Meredith, though less speculative than Hardy,

is more critical. He leaves the universe to itself, as being
beyond good and evil, and he confines himself to the nar-
rower sphere of human volition and conduct where alone
moral distinctions have meaning and relevance. The causal
origins of men's character and behavior, as a naturalist
might interpret them, do not concern him; he addresses
his genius to inner personality and outer comportment in
the present, subjecting them to the earnest judgments of
a laughing humanist. The laughter of his Comic Spirit
brings into clear relief the *human* basis of tragedy, the
tragedy wrought by men's ignorance of their own good, by
their blindness to their own ideals, by their callous defec-
tion from their professed principles, by their insensate
pursuit of antagonistic interests, by their fatuous pride
and their perverse zealotry. It is folly, Hardith, which is
the fountainhead of tragedy; and comedy, being criticism
of folly, is indeed the "ultimate civilizer," as Meredith
calls it.

HARDITH: I confess that I am bewildered. You have thrown a
new light on comedy. If your idea of the comic is to be
accepted, the ordinary notion of it will have to undergo a
radical transformation. How different is the popular use
of it! For you will not deny that the name comedy is gen-
erally attached to low and inane forms of entertainment.
But then, all good things are open to perversion. It is prob-
ably true that at the highest level of art no sharp line
divides comedy from tragedy. I remember the saying of
Socrates at the close of the *Symposium* that the genius of
tragedy and of comedy is the same. And there is of course
Dante, who, lending to comedy a divine dimension, sur-

veyed under its name the torments and the agonies of the human race. Yet, how astonishing that comedy should be a name applicable alike to the sublime and the ridiculous! I must evidently meditate on this subject further—but not today. In a few minutes Allison will be here. He proposed that we dine together at a new restaurant he has discovered, and go to the concert afterward. The program is unusually good tonight, consisting entirely of selections from Wagner's operas. You will join us, won't you?

MEREDY: No, thanks, not tonight. I am not in a convivial frame of mind. And as you know, I have no ear for Wagner. I do not enjoy his music. It often strikes me as artificial and pretentious, and especially so when I am in a serious mood. Our conversation has made me pensive. I shall spend the evening at home reading Molière.

II

Wagner's Music and Aesthetic Criticism

HARDITH: You should have gone with us last night. The concert was superb. As I listened to the various selections from Wagner's operas, I could not help wondering at your perversity. What makes you so deaf to the beauty of Wagner's music; so unresponsive to its elemental force and universal sweep? I know that you are not insensitive to music; you are quite open to its seductive influence, and you always yield to its subtle appeal. Tell me frankly, Meredy, is your dislike of Wagner genuine or is it just an affectation?

MEREDY: No, Hardith, my distaste for Wagner is not insincere, though I often express it with too much vehemence. My vehemence, I admit, is injudicious, and should be taken with a grain of salt. I am intemperate in speech whenever my feelings are aroused. That they should be so strongly stirred by Wagner's music is a tribute to it; for if it were less powerful, in conception or form, my reaction to it would be less impetuous. It is impossible to be cold or indifferent about Wagner; his compositions, I know, fill you with delight, but upon me they have quite the opposite effect.

HARDITH: I have heard you say this many times, and with
more gusto. I can understand why Wagner should fail to
affect you aesthetically in the same manner as he affects
me. What I cannot understand is the intensity of your dis-
like of him. There must be more to our different reactions
to Wagner than a mere difference of taste. Other com-
posers elicit from us dissimilar responses, but concerning
them you express yourself with greater moderation. Take,
for example, Tschaikowsky. You don't enjoy his music,
and I do. Although you condemn his music as obvious and
superficial, you do not suffer it to make you irascible. Why
does your criticism of Wagner assume such an extreme
form? Have you what the psychoanalysts call a "complex"
about him? Is your dislike of him purely irrational, defy-
ing explanation, or can you give some reasons for it?

MEREDY: Your question is a difficult one to answer. Can any-
one give adequate reasons for his likes and dislikes? Re-
member that I am a mere tyro in aesthetics, and that with
regard to music I am a plain ignoramus. The technical
side of music is a sealed book to me. Unable to rise above
the sensuous or the emotional level, I am naïve enough to
assume that music is primarily intended for the ear and
the heart, and I judge it with reference to these two organs.
I want music to affect me pleasantly and to move me
deeply. This is the ultimate reason why I like Beethoven
and Brahms: the sensuous quality of their music gives me
the highest kind of pleasure, and as I am listening to it my
profoundest feelings are stirred in sympathy with those
that I imaginatively attribute to its composers. When I
hear Beethoven and Brahms my spirit expands, vicari-

ously partaking of the impassioned experience and afflatus of artists who used their art to enrich and exalt the humane aspirations of mankind. If I were called upon to explain why I don't enjoy Tschaikowsky and Wagner, I can only say that their music is not pleasing to my ear and that it does not touch the deeper springs of my heart. Their compositions irritate me; they irritate me by their everlasting pyrotechnics and climaxes, and by their melodramatic devices to appeal to the sentimental side of my nature. I can take no pleasure in being vexed, and vexation of spirit is precisely what I experience when I hear Tschaikowsky or Wagner, especially Wagner. And after all, the most cogent reasons a layman can give for his musical preferences must always be in terms of his sensuous and emotional satisfactions.

HARDITH: I am not disposed to quarrel with you so long as you choose to represent the layman's point of view. But is the layman's criticism of music, or of any other art, canonical and ultimate? Is it criticism at all in the proper sense of the term? Your defense of the layman's judgment is something new in your intellectual armory. It is strange that you, of all people, should flaunt the mantle of the unsophisticated! But if you elect to play the role of wolf in sheep's clothing, muffling your subtle mind when you approach the subject of music, I cannot argue with you. It is true that the layman's judgments of music are merely the expressions of his immediate perceptions and wayward feelings. His standard boils down to the fatuous truism that he likes what he likes. And such a truism, the dogma of the simpleton, silences effectively all debate: *de gusti-*

bus non est disputandum. But how can a critical mind fall
back on a maxim so trite? Is taste essentially capricious?
Has knowledge no influence on its formation? You will
not deny that technical understanding of an art enhances
greatly our appreciation of it. If your erudition of music
were comparable to your erudition of poetry, you would,
I am certain, place less reliance on your willful likes and
dislikes, and judge Wagner, as you judge Shakespeare,
with your head, and not merely, to use your own locution,
with your ear and heart. If you studied his compositions
in relation to their creative forms and original designs,
their dramatic development and brilliant orchestration,
you would recognize in Wagner a great master of his art,
if not one of the greatest. If you were a trained critic of
music, you would be less cavalier in disparagement of an
artist so exemplary. You would discover perhaps that your
censure of him has little to do with his music, being rather
the result of a deep-seated prejudice that you bring to it.
Imagine yourself hearing *Parsifal* without knowing the
name of its composer; would you, I wonder, fail to enjoy
it? This glorious expression of the spirit of holiness would
not leave untouched your religious sentiments and aes-
thetic feelings. No, Meredy, you don't approach Wagner's
music with the ingenuous perceptions of the layman; for
the layman, as a rule, likes and appreciates it. Somehow
the name of Wagner releases in you a fundamental bias,
and it is this bias which distorts your judgment. Any com-
position that has Wagner's name attached to it seems to
you unsavory, not because the music is unenjoyable, but
because the music happens to be Wagner's. What is the

cause of your bias? Why is it directed against Wagner with such singular force? Although I have heard you speak with disesteem of other composers—of Tschaikowsky, for example,—you never allow your bias to carry you so far.

MEREDY: You must believe me when I say that my attitude toward music is that of an unfeigned layman. Any other attitude is precluded by my lack of technical knowledge. If I had that knowledge, it would indeed open to me a new source of appreciation; but the formal aspect of music, which technical learning would bring within my ken, is ancillary to sensuous and emotional appreciation, and not the condition of it. If it were a necessary condition of it, musicians would write only for musicians, since they alone can fully understand the technical devices employed by a composer to achieve certain sensuous and emotional effects, and not for a general audience that is sensible of the effects without being sensible of the methods used to achieve them. To make technical knowledge requisite for appreciation would render music, as it would render every other art, essentially esoteric. Do you suppose that a musician addresses himself primarily to a coterie of professional experts? No, Hardith, the appeal of his art is universal, speaking directly to the perceptions and passions of all of us. The analogy with poetry, which you yourself invoke, is instructive here. You credit me with some technical understanding of poetry, and this understanding, though far from adequate, enables me indeed to appreciate the craftsmanship by means of which a particular poet in a given work of art expresses his intent, his intent being to communicate some vision or experience,

some mood or feeling; appreciation of that craftsmanship, however, I do not find necessary for sharing in fancy what the poet seeks to convey, not to other poets, but to every sensitive mind in sympathy with the things that move and excite him. Technical knowledge of poetry is not a prerequisite to an aesthetic appreciation of it; that kind of appreciation has its roots in the perceptive and affective ingredients of our nature, and a person who suffers from sensuous and emotional anemia will not enjoy poetry, although he may be the unrivaled connoisseur of its laws and forms. And this is true also of music. Theoretical knowledge of its technical resources is one thing; imaginative participation in its inward resources, resources cognate with those of poetry, is quite another. The musician, like the poet, embodies in his art a "spiritual" content. This content is a compound of experience and passion, communicated not through words but through sounds, which may be seized directly without a knowledge of the musician's technique. So even if I were a connoisseur of the forms and designs employed by Wagner to express what he was intent upon, my judgment of the content of his music would, I believe, remain unaltered, since it is a judgment concerned exclusively with sensuous and emotional values. Whatever be the technical devices ingeniously used by Wagner to produce his particular patterns of sounds, they are patterns which neither give me sensuous pleasure nor induce in me sympathy with what they are designed to celebrate or glorify. And this is what I mean when I say I don't like Wagner. Is there any moral or aesthetic obligation on my part to like what I happen

not to like? The asseveration that "I like what I like" is
neither truistic nor trite. It is an ultimate judgment. It is
not merely the dogma of the simpleton. It is the only uni-
versal dogma which is unexceptionable. The most critical
of men asserts it when, in the presence of any work of art,
he consults his unadulterated experience and honestly reg-
isters what he perceives and feels. The dogmas of the intel-
lect, being frozen beliefs, are corrigible by suasion; our
aesthetic preferences are dogmatic in a more radical sense,
in the sense of being altogether beyond rational proof. Our
aesthetic preferences are unashamed confessions that we
incline toward anything that gives us delight and satisfac-
tion. And any man is free to avow, without being gainsaid,
what natural object or what work or art does or does not
produce in him sensuous delight and emotional satisfaction.
HARDITH: Far be it from me to curb men's freedom to confess
either what they prefer to enjoy or what they prefer to be-
lieve. And that men are dogmatic in their preferences, in-
tellectual as well as aesthetic, I should be foolish to deny.
But the dogmas of the intellect, you admit, are open to
correction. Why should aesthetic dogmas be viewed as
privileged? All dogmas are intolerable to me, and confes-
sion of their inevitability seems to me a confession of
failure on the part of the critical spirit to perform its task
of challenging them. Of course, any man is entitled to as-
sert his private dogmas, and by saying, "I believe what I
believe," he is secure in the citadel of his prejudice. Yet
that citadel may be assailed by the weapons of argument
and persuasion. What a man believes, he can also be made
to disbelieve if his critical faculty is sufficiently developed

and sharpened. By study and reflection he may transcend his bias and substitute for his former unreasoned beliefs beliefs more rationally grounded. Why should not a man's aesthetic dogmas be amenable to the same analysis and criticism? Taste is no less perfectible than knowledge. What a man likes at one stage of his aesthetic cultivation, he may come to dislike at another, and *vice versa*. It is a matter of education and refinement of sensitivity and discrimination. But to return to Wagner. In relation to his music you seem unable or unwilling to shed your prejudice, and being too critical to take refuge in the puerile tautology that you dislike what you dislike, you "rationalize" your prepossession by propounding the theory that all aesthetic preference is a confession of the incorrigible dogmatism inherent in feeling. Granting the dogmatic nature of feeling, in the sense that it is impervious to criticism, your strong dislike of Wagner does not seem entirely aesthetic. I suspect that you disesteem Wagner on other grounds, and this disesteem prevents you from enjoying his music. I still think that you would enjoy it if you heard it as music and not as Wagner's. If the music were anonymous, your mind would be open to its magic strains and its poetic themes.

MEREDY: Your point regarding anonymous music raises important issues, but before commenting upon it I wish to clarify my meaning of aesthetic dogmatism. I grant, of course, that taste is subject to change and development. And I do not underestimate the function of criticism in the formation of our aesthetic judgments. But what specifically are aesthetic judgments? Do they refer to the merit

of a work of art, or to the nature of our experience in the presence of it? If it is the intent of our judgments to pronounce upon the degree of excellence pertaining to a work of art, standards are obviously brought into play, and standards, however derived, are always open to polemic. Dogmatism about standards, though prevalent, is indeed fatuous. Here criticism finds a vulnerable target. It is always possible to argue with a man concerning his criteria for judging the value of a work of art and to persuade him that they are arbitrary or one-sided. By study and reflection he may succeed in exchanging one set of criteria for another. But if our judgments merely express what we experience in relation to a work of art, whether we respond to it with sympathy or antipathy, criticism is impertinent. How can we be argued out of our likes or dislikes? We either experience them or we do not, and though our likes and dislikes may shift and waver in accordance with the change and development of taste, the experience of them is the final court of appeal, there being no standard other than this experience itself. Aesthetic judgments in this sense, and in this sense only, are ineradicably dogmatic, confessing as they do with complete assurance, without possibility of contradiction, what as a matter of fact we experience. Here is the chief difference, which you seem to overlook, between intellectual dogmatism and aesthetic dogmatism: the former concerns belief involving some external standard in support of its validity, and in impugning the standard we undermine the validity of the belief; the latter has to do with experience, with perception and feeling, and experience carries with it its own certifi-

cate of validity, which is another way of saying that ex-
perience is its own standard, the only question at issue
being, not what the experience should be as measured by
a criterion beyond it, but what the experience indefeasibly
is when undergone in the immediate presence of a work
of art. Aesthetic dogmatism of this kind is absolute and
infallible, and there is nothing criticism can do to shake
it. In other words, of the beliefs we entertain we may de-
mand that they be reasoned and reasonable; of our aes-
thetic likes and dislikes we cannot make this demand. Like
other affective states, they supervene inevitably with vary-
ing degrees of intensity upon sensuous apprehension of a
particular object. Let me give you an illustration of the
difference between dogmatism of belief and dogmatism of
experience. Consider a man in love with a woman. Here is
your dogmatist *par excellence*. He is sure beyond doubt
of his lady's unexcelled perfection and of his undying
passion for her. You may either admire or deplore his
taste, but your attitude toward the lady, since you are not
in love with her, is, as the lawyers say, incompetent, irrele-
vant, and immaterial. Suppose, now, you induce him to
express his lyrical dogmatism in terms of judgment. You
will find that his judgment will take the double form I
have mentioned: the judgment of the lady's excellence
meriting his love, and the judgment embodying his feel-
ings for her. The first is a dogmatic belief, the second a
dogmatic experience. How could you criticize either judg-
ment? As for the judgment of his belief, it is presumably
founded on evidence which, if adduced by the lover, is
indeed open to question. Has the lady the qualities he

attributes to her? Is he perhaps blind to her blemishes?
Is his standard of beauty or wit or goodness high enough?
If the lover condescends to argue with you at all, you may
perhaps succeed in making a dent in his dogmatism. But
as for his judgment of experience, you are reduced to
silence. You cannot argue about his state of mind. The
dogmatism of his feelings is impregnable. He loves the
woman, and that, from his point of view, is ultimate, not
susceptible of criticism. And a man governed by hate is
similarly dogmatic. Hate, like love, is a compound of
belief and experience, the belief that a person is hateful,
because of his character or actions, and the experience of
hatred produced by him. The belief is always debatable,
since one requirement for its acceptance is sufficiency of
evidence, and another is an adequate standard for apprais-
ing the validity of that evidence. Now, the evidence may
be incomplete and the standard inadequate, but the actual
feeling of hatred is a stubborn fact; the experience of it
cannot be reasoned away as if it were a hypothesis leaning
on insufficient proof. It is a categorical or dogmatic state
of mind either present or absent. When hatred is present,
its presence is its sole evidence, and if absent, it will not
be caused automatically by the proof that a person is hate-
ful. Now, I submit that the dogmatism of aesthetic judg-
ments is like that of love and hate. Such judgments are
fusions of beliefs and experiences. Criticism may shake
our dogmatic beliefs in the merits or demerits of particu-
lar works of art by showing that the standards by which
we are guided are essentially relative and variable; but
no criticism can touch the categorical or ultimate likes or

dislikes that result from perceiving these works of art, since they are what they are, neither their presence nor their absence being under the control of reason. And although our aesthetic likes or dislikes seldom reach the depths of love or hate, they share with these passions the same irrational dogmatism which makes them impervious to criticism. Tell me, Hardith, if I have conveyed to you clearly my ideas on aesthetic dogmatism, for they have an important bearing on the subject of anonymous music.

HARDITH: You have expressed your ideas clearly enough, and, as usual, you have pushed them to extreme lengths. I agree that our likes and dislikes are impervious to reason. I agree also that this imperviousness endows them with an illusory finality. But the finality *is* illusory if the term connotes immunity from change. The dogmatism of our feelings is no less mutable than the dogmatism of our beliefs. You have admitted that all aesthetic dogmatism is a blend of experience and belief. And if belief, which is not impervious to criticism, exercises some influence on experience, our like or dislike of a work of art may gradually change as a result of our altered belief concerning its merits. Take your own example of love. A man in love is certainly dogmatic, and dogmatic in the double sense you discern. But love is notoriously fickle. It is a sensitive plant drawing sustenance from belief and withering in the absence of it. Love is sustained by belief that the object of it is intrinsically meritorious; discovery of evidence incompatible with this belief may alienate the strongest affection. The proverb that love is blind is an expression of cynicism. The profounder the emotion, the more lumi-

nous the vision of its object. Our mature affections are rooted in the firm conviction that the objects upon which they are lavished are worthy of them, and when this conviction is shaken, our affections are apt to languish. Aesthetic likes and dislikes may similarly fluctuate with the fluctuation of our beliefs, which admittedly are open to criticism, about the intrinsic value of works of art in the presence of which these feelings are so seemingly final. So, while I concede that your dislike of Wagner is something unalterable by criticism, your preconceived notions about his music are not immutable. If you could change the dogmatism of your beliefs about Wagner, the dogmatism of your feelings in relation to his music would undergo a corresponding change. And I repeat that if you heard Wagner's music without knowing it was his, your aesthetic judgment, in its twofold capacity of belief and experience, might be radically different.

MEREDY: I am glad to have your assent to my contention that there is a dogmatism of feeling which, unlike the dogmatism of belief, does not come within the range of criticism. This contention does not require me to equate finality with changelessness. You are wrong in convicting me of so preposterous an equation. Our feelings are not exempt from mutability; though subject to change, each feeling as it occurs is a law unto itself. No feeling can be contradicted by another. If one feeling is replaced by a different feeling, toward the same person or the same thing, the different feeling is absolute or authoritative in its own right, and this is all I mean by its finality; for, unlike beliefs, feelings do not refer beyond themselves to antecedent evidence

supporting them and to standards for appraising that evidence. There is no evidence and no standard for feelings except the feelings themselves. It is thus absurd to ask me to give evidence for my dislike of Wagner. In the experience of the dislike lies its only evidence, and as long as I have the experience, no previous or subsequent feeling can serve as a standard for vindicating or impugning it. It is true, however, that my experience is not unmixed with belief. I do not deny the influence which experience and belief may exert upon each other in my attitude toward Wagner. I grant that my attitude is an amalgam of both. But in this amalgam I find it difficult to discern with assurance which of the two is primary, and which is induced by the other. This difficulty is not peculiar to me; it is inherent in the aesthetic attitude. In the analogous attitude of love, you insisted, and you insisted rightly, that change in feeling may result from change in conviction. But the reverse seems equally true: our convictions of a person's merits may wax or wane in accordance with the ebb and flow of our feelings. Can we ever settle the question whether love is the cause or whether it is the effect of belief in the intrinsic worth of its object? I am free to acknowledge, therefore, that my present dislike of Wagner may have been engendered by an antecedent belief, perhaps altogether extraneous to my perception of his music, or that my present belief about him may be a consequence of emotional experiences anterior to this belief. The indubitable fact remains that I do not like Wagner's music, and that I do think it, perhaps mistakenly, to be cheap and tawdry. What I would feel and believe if I

heard the music without knowing it was Wagner's, I cannot tell. It might be an experiment worth trying with such compositions of his as are unfamiliar to me.

HARDITH: I wish you could try the experiment, and try it honestly. It might alter your present aesthetic judgment about Wagner.

MEREDY: It might, and it might not. I have certain opinions about anonymous art, and especially about anonymous music. There is a good deal of humbug about art criticism, resulting from its unavoidable mixture of experience and belief. The critic, no less than the layman, is moved by his will to believe in the merit of a work of art if he knows it to be the work of an artist with an established reputation. An anonymous painting may remain unnoticed for a long time, but if some experts identify it as a Rembrandt, critics as well as laymen find a new and enhanced pleasure in its contemplation. And the disproof of its authenticity, by other and more competent critics, will invariably produce abatement of the aesthetic experience. A rose by any other name would smell as sweet, but a work of art to which a great name is affixed emits a peculiar odor of sanctity. The art of music is singularly subject to such bias, for the ear is a more conservative organ than the eye. An unknown composer struggles perpetually and often in vain against this innate conservatism. Yes, Hardith, there is a magic influence in names. You will recall the hoax which Fritz Kreisler played some time ago upon critics and laymen alike. He attributed certain delightful pieces of his to a classical composer, and everyone was taken in by the ruse, its purpose being

to predispose the mind to believe in their excellence and thus to intensify the aesthetic enjoyment of them. It would be a good thing if all music came to us unnamed. I wonder whether we should then be more ingenuous and more candid in our aesthetic judgments. We might attend perhaps with greater discrimination to the immediate values of music, to its sensuous and emotional qualities, without the intrusive notions now imposed upon us by the critics. At present we are too timorous to avow our honest preferences, and we feign to like what we do not enjoy. But if all music were anonymous we could hear it simply as music, and our belief regarding its merits would not be prejudged by awareness of the composer's high or low repute. Think of listening to a symphony without knowing whether it was by Beethoven or Berlioz! What a boon to yield to its direct appeal, free from conventional idolatry or disdain! Partiality for music such as Beethoven's would thus be spontaneous, and preference for that of Berlioz would not be ignominious. And who can tell of what judgments our professional critics would deliver themselves if called upon to divulge the inward meaning of a symphony or an opera in ignorance of its composer's identity? I should not be surprised at the ensuing reversal of many present pontifical utterances. Shorn of their function to canonize one composer and to stigmatize another, our critics would be confined to the task of analyzing the music itself without preconception to guide their analysis. Concerning its formal aspect—such as rules of harmony, arrangements of themes, modes of orchestration, and the like—critics might continue to enlighten us, if they pos-

sessed special learning of what I have called "technical workmanship"; but with regard to its spiritual aspect, the poetic content to be sensuously enjoyed and sympathetically felt, there is no reason for supposing that the dogmatism of the critics would represent more than the limits of their sensitivity and imagination. If music were anonymous, the critics as well as laymen could do nothing else than register their personal reactions to it, and the divergencies of these reactions would be as great among the critics as among the laymen. So when you ask me how I would react to Wagner's music if the identity of the composer were unknown to me, to this speculative question I can give you no definite answer. It is conceivable that my response to it would differ from my present one; but then, so might yours. I can turn the tables on you, Hardith, and ask with equal propriety what your reactions to Wagner's music would be like if you did not know it was his. How certain are you that your enjoyment of it is uninfluenced by the prestige of the composer? You might find an anonymous *Tristan* insufferably boring. And would it not be ironical, since in the domain of speculation everything is possible, if a Wagnerian opera not known as Wagnerian elicited an unfavorable reaction from you and a favorable one from me?

HARDITH: Your love of paradox has caused you to give a peculiar twist to my suggestion regarding anonymous music. I made the suggestion merely to impugn the dogmatism of your beliefs. You have certain beliefs about Wagner, antecedently formed, which prevent you from enjoying his music. Are these beliefs derived from the

music itself? Would you have them if you heard the same music under another name? The question is a fair one. How can you throw it in my teeth? My beliefs about Wagner are not dogmatic. They are supported by evidence amenable to criticism. They rest not alone on the prestige of the composer but on the achievements that justify his prestige. Yes, Meredy, these achievements by any other name would be deemed great. You speak as if the prestige of an artist were accidental, the result, as it were, of a conspiracy of critics. Do you really expect me to believe in the sincerity of your animadversion upon criticism? You, usually an eloquent protagonist of the critical spirit, must know that critics of music, like those of any other art, are far from gullible. Their praise and dispraise are not willfully bestowed. If they succeed in determining or influencing the taste of laymen, it is because they are governed in their criticism by standards which the laymen come to recognize as valid. Critics may, of course, go astray. New and unknown artists often remain unduly neglected until their genius makes itself felt through works of genuine excellence. But this only proves that criticism is cautious and responsible, never dispensing its meed of tribute without complete assurance that it is well deserved. Not with sudden glow does the fame of an artist burst upon the world; his acclaim, if it comes at all, comes slowly and gradually. It owes its inception to but a few discerning critics the diffusion of whose judgments is at first endemic. And when the reputation of an artist is once established, and established by a consensus of critical tastes, it remains well-nigh unimpeachable. This, you

must admit, is true of every artist who by general consent has at last won the epithet "great." Time was when Wagner was an unknown and struggling composer at the mercy of conservative and unsparing criticism. But his works, by their sheer power and beauty, overcame opposition, gaining favor by degrees, and now they are justly prized and praised as the consummate fruits of a universal genius. Laymen are thus not imposed upon by a great name when the name is that of an artist who has run the gantlet of rigorous criticism. Wagner is great because his music is great, and its greatness, though but grudgingly acknowledged in the beginning, has now for its basis the most scrupulous standards of valuation. What are your standards for questioning the merit of Wagner's art? And how do you justify your standards in opposition to those laid down by eminent and judicious critics?

MEREDY: My objection to critics is not that they are critical, but that they are not critical enough. These high priests of art, like the high priests of religion, proclaim their fallible opinions as if they were revealed truths. I do not share your faith in the unerring judgments of critics. In the field of art criticism, principles are not always distinguishable from prepossessions. I cannot overlook the fact, which you do not deny, that original and profound artists had to fight their way to recognition in the face of fatuous criticism. Think of Beethoven and Walt Whitman! Think, to take a contemporary example, of Epstein! Yes, Hardith, critics ignore, if they do not fulminate against, the first appearance of a strange genius, and a single voice crying in the wilderness in his behalf may later swell

into a flattering chorus. In this tendency you see a sign of laudable reserve, I a token of lamentable obtuseness. The present encomiasts of an artist denounced by former critics are not free from the "idols of the mind"; they have merely exchanged one kind of bias for another. Critics of every age, uncritical of their prejudices, are blind to the merits of a new art; it takes time for these prejudices to become attenuated, and for new ones to be formed, before a new art gains desultory attention and eventual favor. I am not simple-minded enough to attribute to critics preternatural clairvoyance or exceptional acumen, and I cannot help exercising my own critical faculty to criticize the critics. They speak with too much assurance where assurance is not possible. Their dictatorial powers to fix standards of valuation are self-assumed. Whence their mandate to formulate certain standards and to rule others out of court? If critics are said to govern our aesthetic judgments, they can do so only with the consent of the governed. Here if anywhere the democratic principle is beyond challenge. The authority of critics can have no other sanction than our own experience. And if my own experience runs counter to a standard declared to be authoritative, that standard, as far as I am concerned, forfeits its alleged validity. And if this is true of standards of valuation as applied to any art, it is singularly apposite in connection with music. Music is one of the most elusive of the arts. More than any other, it stirs our secret feelings and passions. It transcends the boundaries of verbal discourse. How lame and impotent are words in revealing the essence of music! The phrases of the most

articulate of critics cannot convey its inward spirit. The
nature of music is ultimately ineffable. You will not dis-
pute the fact that language and music are incommensura-
ble, and that the medium of the one cannot be substituted
for that of the other. Yet it is speech, an alien vehicle,
upon which critics depend for expressing the unutterable
quality of music and the standards for its valuation! No
wonder many of them talk nonsense—nonsense, that is,
when their words are grafted upon the direct experience
of music, an experience of which we may truly say that
it beggars description. I am thus not impressed by the
critics who are so vociferous in their pronouncements upon
the meaning and value of music. As I listen to their words
I find that they are often a "counterfeit presentment" of
the sounds heard. These words may indeed express what
the critics experience, but if my perceptions and feelings
are at variance with them, my own experience is what I
must implicitly trust and fall back upon. So if all the
critics of Wagner's music were to declare it supremely
enjoyable, their declaration would be authoritative for
those only who find in the music what the critics say they
find in it. It obviously cannot be authoritative for me if
the music does not give me the sensuous and emotional
satisfaction which the critics assert it must afford. How
can the verbal judgments about music claim greater
validity than the experience they purport to appraise?
I owe no deference to the opinion of experts if my own ex-
perience negatives it; and I cannot exchange my own
experience for that of anyone else. Fortunately, the critics
of Wagner are not unanimous. There are those who share

my dislike of him. I have read somewhere that Sibelius, who is surely a competent judge, has a decided antipathy to Wagner.

HARDITH: I am amazed at the excess to which you carry your dialectic. You don't seem to realize that in berating the critics you open the floodgates of subjectivism. Everyone master in the domain of aesthetic judgments! This, my dear fellow, is plain anarchy. The critics alone can save us from the Babel of voices in questions of art. Your mystic view of music—in saying that it is ineffable you speak as a mystic—applies to all art, in the sense that experience, and not the description of experience, is what ultimately matters. But where does this lead you? If aesthetic experience defies description, why say anything at all; and if we do speak of it, are not some descriptive terms more adequate or more appropriate than others? You are too intellectual to be satisfied with either horn of a dilemma your mysticism entails—complete silence or complete confusion. There is no mystery about aesthetic experience; like any other kind of experience, it is subject to analysis and interpretation. I see no reason for making an enigma of it; and I am unwilling either to withdraw it from discourse altogether or to surrender it to the verbiage of the illiterate. What a strange consequence of sophistication if it exalts into a principle mute feeling or flatulent speech! No, Meredy, I can't believe that you mean to jettison objective standards in relation to aesthetic judgments. And who but the critics of art are competent to formulate with precision objective standards in the light of their experience and their sustained reflections on it?

MEREDY: I do not deny the necessity of standards or the possibility of their formulation. And I recognize the capacity and expertness of critics to fix some standards which, for want of learning, I am not disposed to question. But what are standards? In speaking of them, we must bear in mind three sets of values that pertain to works of art. I call them *immediate* or *intuited* values, *formal* or *technical* values, and *spiritual* or *cultural* values. The names do not matter; you are free to replace them by others. All I ask is that you allow me to keep these values distinct. I submit that in the direct experience of works of art lies their primary value. Flowers may bloom unseen and birds sing unheard, but works of art are created to be perceived and enjoyed. What we speak of as aesthetic experience is the experience of pleasure or delight that follows on sensuous occasions and at their promptings, and this experience may indeed be induced by natural facts; but the facts made by man—we had better call them "artifacts"—aim at this experience by conscious design. Artists labor in vain if what they produce fails to engage the emotions they intend to excite. In a work of art, mind thus speaks to mind, and the mind addressed, the mind of spectator or auditor, is the judge of its immediate value. How can a work of art be said to possess immediate value for a mind that feels no enjoyment in perceiving it? With respect to this kind of value everyone is of necessity his own critic, his indefeasible experience being his ultimate standard of valuation. If this be subjectivism, make the most of it. No man can cede his experience to another; it remains inalienable so long

as he asserts nothing more than its presence, of which he is the only authoritative witness. And if immediate values are subjective, in the sense that individual experience constitutes their sole measure, this measure is at the same time also the most objective. Ah, I hear you exclaim, a paradox, a most ingenious paradox! Yes, a paradox, but one that is inescapable. For in perceiving a work of art, what more objective fact can a man reveal, if he but consult his experience, than the fact that he is affected by it in certain ways? It is beside the point to insist that, if he were more sensitive or more imaginative, a specific artifact would affect him differently; the objective fact is how it does affect him, not how it should. If we confine our attention to immediate values, and to no other, their subjective status is impregnable, individual experience being the only objective standard to which they are amenable. Put me down, then, as an aesthetic subjectivist. And put me down also as an aesthetic mystic. Any work of art, unless words are its chosen vehicles, speaks to us through a medium for which discourse cannot be substituted without falsifying its particular message. Language may intimate or suggest, but can never truly reveal, the immediately felt values of a work of art composed of pigments or sounds.

HARDITH: You have made out a strong case for your view, but its strength is specious, like that of all subjectivism and mysticism; it is beyond challenge because it is beyond argument. If you choose to take your stand on your individual and ineffable experience in the presence of a painting or a symphony, there is nothing I can say to dislodge you from your position. Retreat into immediacy is escape

from suasion. This renders futile all dispute about aesthetic values. Why not leave the matter thus? Why discuss at all what on your hypothesis transcends the ambages of locution? But you are quite loquacious about aesthetic values, and you confront me with what purports to be an argument that the only objective standards for them are subjective. Here I must demur. To my simple mind the terms "subjective" and "objective" are poles apart. What is to be gained by identifying words held by common consent to be mutually exclusive? But evidently a paradox is something you cherish. Let us agree for the sake of argument that what you call immediate values are subjective. How regard them as objective if, according to you, they are at the mercy of the variable and ineffable intuitions of different individuals? I reserve the word "objective" for aesthetic values that are subject to a consensus of critical judgments.

MEREDY: I am glad that we don't have to debate further the status of immediate values. Let me, however, explain more clearly the one point to which you object so emphatically. In speaking of immediate values as being at once subjective and objective, I did not mean to indulge my taste for dialectic. What is at stake here is a theoretical matter, namely, the difference between ordinary perception and aesthetic perception. In ordinary perception, what we see or hear is a public thing, and because it is public we deem it objective. The antidote to subjectivism lies in the same public object upon which our individual perceptions must converge. But aesthetic perception is affective perception: what makes it aesthetic consists in its "hedonic" quality,

the quality of pleasure or delight we take in the object. Although the object, be it a painting or a symphony, is public, the hedonic quality it induces in our perceptions is strictly private. We may legitimately speak of seeing the same colors or hearing the same sounds, their sameness being either a theoretical inference or a social postulate, but there is no such inference or postulate for the belief that we perceive them with identical feelings, equal in kind and intensity. On the contrary, the belief in the incommensurable difference of feelings is attested by all the evidence which psychology can muster. Since nothing but feelings, the concomitants of our perceptions of a work of art, and not the perceptions themselves, are the criteria for its immediate values, these criteria will be as subjective as the feelings that form their basis. And if I call them also objective, I do so not in the sense that they are public, but in a sense much more fundamental. Criteria for immediate values, though having their locus in the private feelings of each individual, depend upon facts than which none can be more indubitable—the feelings themselves. In short, the hedonic feeling, intimately experienced by each individual in the presence of a work of art, constitutes the bedrock of aesthetic value. Destroy the feeling, and you destroy the value, for they are one and indivisible. Of the validity of subjectivism and mysticism outside the field of aesthetics I am indeed severely critical; but these strange doctrines lose their strangeness for me when I apply them to the nature of aesthetic value. As long as aesthetic value, in its primary sense, is a matter of feeling, I, for one, in a theoretical discussion of it, am willing to avail myself

of the arguments of such philosophies as vindicate the
supremacy of individual experience. Though sterile else-
where, in aesthetics subjectivism and mysticism are tri-
umphant and irrefutable.

HARDITH: As you well know, I have no head for the subtleties
of philosophy. Your defense of speculative subjectivism
and mysticism, limited solely to aesthetic values, leaves
me unconvinced. I see no justification for making an ex-
ception of aesthetic values. If individual experience is the
measure of them, why not extend this measure to other
values as well? Should every man be taken as the authori-
tative spokesman for what is true in science or what is
good for society? The standards for values other than
aesthetic are justly held to be exempt from individual
caprice. To me all values are on the same plane: the
reasons that impel me to view truth and goodness as
objective, I consider to be pertinent to aesthetic values
also. But then, I do not identify these values with feelings.
An aesthetic theory based upon feelings builds not on
bedrock but on a quicksand. Besides, even if we make
individual feelings the standard of aesthetic values, how
do we know that they are incommensurable? On your
hypothesis, no man is acquainted with feelings other than
his own. He is not sure that feelings differ, unless he rejects
the theory that they are ineffable, and accepts verbal de-
scriptions or expressions as a clue to their nature or qual-
ity. Between silent feelings we can obviously institute no
comparison. The only feelings that we may compare are
those which people *say* they have. Are all utterances about
aesthetic feelings equally trustworthy? Here, I think, is

the fundamental issue between us. Your subjectivism is
catholic, mine is selective. You accord to everyone the
privilege of making pronouncements about aesthetic feel-
ings; I, to those only who are blessed with discernment
and taste. There are right aesthetic feelings and wrong
aesthetic feelings, just as there are right beliefs and wrong
beliefs regarding truth and goodness. And critics are more
reliable than laymen in their judgment of value, aesthetic
as well as nonaesthetic, because they are learned and dis-
criminating, their standard being derived from shared
rather than monadic experience. Feelings are no less pub-
lic than the objects that engender them, if we consult their
embodiments in discourse, and the language of critics
concerning the feelings experienced in the presence of cer-
tain works of art is marked by an astonishing degree of
agreement. But feelings, however collective and unani-
mous, are not decisive. I trust the critics, not on account
of their emotional reactions to works of art, but on account
of their painstaking analysis of the works themselves, for
in these works, in their forms and structures, lie the chief
aesthetic values. The objective nature of a work of art
determines its aesthetic worth, regardless of what you call
the "hedonic" quality of its perception. Away, then, with
the anarchy of subjectivism and the secrecy of mysticism!
I humbly turn to the critics, those that are preoccupied
with the formal and technical aspects of art, for an under-
standing of aesthetic values and aesthetic standards. I can
glean little about them from my own amorphous intuitions.

MEREDY: You have certainly succeeded in sharpening the
main issue that divides us. Our disagreement is indeed

fundamental; it is focal in most of the learned treatises
on aesthetics. For the view that aesthetic value is primarily
a matter of hedonic experience you will find among com-
petent writers protagonists as well as antagonists, so we
are both in good company. But, as I have said, I am only
a layman in the field of aesthetics. Not negligible, how-
ever, are the layman's reactions to art, for these reactions
must be taken into account by any aesthetic theory. Artists,
I repeat, do not create their artifacts for other artists or
for professional critics. The effects they aim at are in-
tended to impinge directly upon every sensitive mind.
The appeal of art is not esoteric, but universal, and if it is
universal, every layman must be the judge of any artifact
regarding the affective response it produces in him. The
point of departure for our discussion was Wagner's music.
You like it, and I don't like it. Our different affective re-
sponses may be due to the nature of the music; they may
be due also to the nature of our sensitivity or to the nature
of our bias. But the immediate aesthetic value of the music
for each of us is nothing else than the hedonic quality of
our perception, a quality no critic can prescribe or pro-
scribe, the quality simply being what it is whenever ex-
perienced. But this only touches the immediate aesthetic
values,—not the only ones, as you rightly insist, though
for me they are primary. Aside from the question of their
primacy, regarding which theories have always differed,
we agree that immediate values are subjective, that indi-
vidual experience is their locus and basis. With respect to
the other values I have mentioned, our views coincide.
The nonimmediate values of a work of art, formal or tech-

nical and cultural or spiritual, involve standards derived
not from individual feeling but from objective judgment.
And by objective judgment I mean judgment the content
of which is the work of art itself, something "public" de-
manding analysis and interpretation. As for nonimme-
diate values, I share your respect for the experts; for an
artifact, apart from being an object of hedonic experience,
is also an object of special knowledge, pertaining to its
material and form, conception and execution, meaning
and significance. Such knowledge is manifestly the result
of consummate discipline and erudition, and the layman,
lacking the knowledge, is cut off from a source of appre-
ciation open to the scholar. And if the critic is a scholar,
I must perforce bow to his informed judgment. The aes-
thetic values he is concerned with, those that have to do
with an artifact's medium, design, and purport, are in-
accessible to the untutored mind. But scholarship is one
thing, enjoyment another, and it is a moot question how
much the former enhances the latter. The highest kind of
appreciation, it is true, is both "hedonic" and "cognitive,"
consisting in enjoyment and understanding, but it is pos-
sible to have one without the other. I, for example, like a
Bach fugue, despite my ignorance of the mode and plan of
its construction; another man, though he be a learned con-
noisseur of the same composition, may not find it enjoy-
able at all. The point is that a work of art may be enjoyed
without being understood, and understood without being
enjoyed. And if aesthetic values are not only hedonic but
also cognitive, the latter values, whatever their connection
with the former, are such as only a judicious student of

art can bring to light and appraise, a student possessing the requisite training and aptitude. Concerning the non-immediate or cognitive values, those revealed by technical analysis and reflective interpretation, the judgments of critics are decisive, and though not definitive, because they do not always agree, these judgments cannot be challenged by laymen whose approach to art is sensuous and emotional. To return to Wagner: my right to pronounce judgment about the immediate values of his music I cannot renounce, based as it is upon my indefeasible hedonic experience, but about its nonimmediate values I must either remain silent or echo the opinion of critical scholars. If critical scholars tell me that Wagner's music is great, because of its formal excellence or technical perfection, how can I, a mere layman, either verify or contradict this opinion?

HARDITH: What you say about nonimmediate values strikes me as sound. And I am glad that you have at last acknowledged that certain aesthetic values depend upon cognitive judgment and not merely upon hedonic experience. I like your word "cognitive," strange though it is in the vocabulary of aesthetics. It is a felicitous synonym for the term "critical," focusing attention more clearly upon those values of art the appreciation of which is founded on learning. Fully to appreciate a work of art is to know it, and we know a work of art when we understand how and why the artist has created it. I do not deny the importance of the hedonic aspect of appreciation, but, unlike you, I seek to subordinate it to the cognitive or critical side. After all, there are fundamental questions about a work of art

that only a profound student of it can attempt to answer. Has the artist made the most effective use of his material? Are his methods of construction old or new? Are his chosen forms adequate vehicles for his purpose? Does the work completely realize his creative intent? Our feelings unaided by understanding are no guides to such values as do not lie on the surface but are deeply imbedded in the work itself, in its matter and form, style and technique, conception and aim. The determination of those values, which you happily describe as cognitive, you have the wisdom to leave to the critics or scholars of art. How in the light of this wisdom can you still persist in your attitude toward Wagner? Why not admit that your feelings are untrustworthy, and that Wagner's music has the excellence which the experts attribute to it?

MEREDY: Far be it from me to quarrel with the experts, so long as their expertness is kept within proper bounds. I recognize their authority only with respect to those values which I have called formal or technical. Here, there is scope for knowledge and understanding; for art is also a craft, and artistry is often but another name for craftsmanship. For this reason I should prefer to reserve the adjective "aesthetic," in conformity with its etymology, for those values which are sensuous and affective. The values intrinsic to an artifact, owing to its excellent workmanship, I should be inclined to describe as "artistic." In my use of these adjectives, often confused, what is aesthetic is not always artistic, and what is artistic may not be aesthetic. A natural sunset, for example, is one thing, a painted sunset quite another. A natural sunset is certainly

an aesthetic object, since the contemplation of it evokes in sensitive minds a congeries of hedonic feelings and moods, but unless we succumb to animism, we should hardly speak of it as artistic, the forms and designs discernible in it not ensuing from an *intentional* act of creation. A painted sunset is precisely what a natural sunset is not, an object created by man, owing its order and configuration to the spirit of choice and the instinct of selection, and being an expression of perceptive acumen and technical skill. And though an artistic object, a painted sunset possesses aesthetic value only if it gives rise to experiences felt to be pleasurable or delightful; but such an object, while exemplifying admirable craftsmanship, may have as a concomitant of its perception affective indifference or actual dislike. In the last analysis, artistic values, as distinguished from aesthetic, belong to an artifact if its form is adequate to its material, its style appropriate to its subject, its design harmonious with its aim. Any artifact, be it a statue or an opera, has to be judged on its merits as an example of good or of bad artistry; and the question whether it is one or the other is obviously a matter of expert opinion. Many critics affirm that Wagner's music is the work of a master of his craft, that it exhibits perfection of form and structure, that it represents the quintessence of imaginative power and technical proficiency. These critics presumably know what they are talking about. And if they concur in using the epithet "great" as applying to the artistic values of Wagner's music, their judgment is one I am willing to acquiesce in, if it is a judgment for which they can marshal the requisite evi-

dence. But when they extend the epithet to include the
aesthetic values, such as are based upon hedonic experi-
ence, I demur unhesitatingly. Here, as I have said, I must
be my own critic and my own judge.

HARDITH: But critics do not pronounce Wagner's music great
merely on account of its artistic values. There is more to
it than excellence of craftsmanship. Form and technique
are in Wagner subsidiary to content or subject matter.
His music is great because it is expressive of human life
in all its manifestations. Apart from the richness of the
material and the effective organization of it, Wagner's
music tells a "story," enacts a "program," illuminates a
"philosophy." In expressing extramusical ideas through
the medium of sound, Wagner's compositions are truly
matchless. Their "themes" are melodic as well as dra-
matic. Wagner's music unfolds the drama of existence,
the agony of the spirit, the depth of passion, the glory of
life. It is music that not only sings but speaks, and speaks
eloquently, in sure accents, of love and hate, fear and
cruelty, joy and sorrow, lust and renunciation. Wagner
shows that it is possible to think in music, and the
"thoughts" his music conveys are virile and dynamic. His
world is tragic, the scene of struggle and pain, but it is a
world in which he takes pride and delight. His composi-
tions celebrate fortitude and pity, fortitude in adversity
and pity for suffering. Wagner's music is a deliberate
expression of a philosophy of heroism and compassion.
You spoke earlier of the spiritual or cultural values of
art. If I interpret your third set of values aright, this
music exemplifies them to a superlative degree.

MEREDY: You are the perfect Wagnerite. Your favorite com-
poser seems to satisfy you on all three grounds—aesthetic,
artistic, and spiritual. I am sorry to take issue with you
again. I admit that Wagner's music is expressive, and
expressive of a philosophy of life. It is indeed "program"
music, in the sense that, like representative painting, it
depicts definite subjects and situations. The content of
Wagner's music is one borrowed from that of language.
We must not forget his librettos that served as texts for
his compositions. Program music, it is said, is not pure
music. But let the critics wrangle over the question of
"purity." Whether pure or not, Wagner's music purports
to be a translation into the medium of sound of ideas origi-
nally expressed in linguistic form. The content of his
music is thus not a matter of conjecture, as it is with other
great composers. What is the extramusical content of a
symphony by Beethoven or Brahms? In the absence of a
definite text or program supplied by the composer, our
imagination is free to read into it whatever content we
choose. But not so with Wagner. There are his librettos.
These literary compositions are what the music is "about,"
and of their spiritual or cultural values, reflected in the
music, I have an opinion at variance with yours. Suffering,
endurance, pity, these and other stock experiences ex-
pressed in most operas, are indeed voiced with supreme
artistry in Wagner's works. But what appears to you as
a dramatic view of life strikes me as a melodramatic one.
Where you see pathos I find bombast. When Wagner is
not flamboyant he is sentimental. His energy, which is
prodigious, generates heat rather than light. I shall shock

you perhaps if I characterize his philosophy as the apotheosis of violence or the glorification of barbarism. His chief characters are grandiose, not great, spirited, not spiritual. Not long ago I witnessed a performance of *Tristan*. The singing was magnificent, the orchestra brilliant, the spectacle dazzling. What artistry, I thought, but what ferocity! Even to tenderness Wagner must impart a kind of fury! That unending *Liebestod* I found morally revolting—no restraint, no dignity, no resignation. The last gasp of the dying hero breathes wild desire and raging defiance. Yes, you may look upon *Tristan* as a paean of love, but love without grace or nobility or sweetness. Yes, such love is elemental. To me, however, the word "elemental" is but a euphemism for what is savage and primitive. The most precious things in life are not naked passions and unsubdued ambitions, and, as I read his librettos, it is these which Wagner celebrates in his major compositions. In the final reckoning, the ideal he worships in the *Ring* is force—force militant, predatory, ruthless. The will to power, of which Wagner is the apostle, is not mitigated by the "religious" music of his later years, for the religion which he expresses seems to me lacking in profundity of vision or feeling. Compare it, for example, with Beethoven's *Missa Solemnis*. Beethoven could sound religious depths to which Wagner was a stranger. I should except the *Meistersinger*. This work I enjoy. For here Wagner was touched by the comic spirit which alone, in George Meredith's phrase, is the "ultimate civilizer."

HARDITH: I am afraid it is useless to prolong the discussion. Our judgments of Wagner are too diametrically opposed

to be reconciled. Your last attack on him, on moralistic grounds, seems to me particularly unjust. Are you a disciple of Plato in laying down the law to artists concerning what subjects they should be permitted to treat, and how they should treat them?

MEREDY: And are you disposed to retreat into an ivory tower from which to proclaim the doctrine of "art for art's sake"? No, I am not a disciple of Plato. I should not dream of interfering with artists in their choice or treatment of themes. But remember, we have been discussing those values pertaining to art that are spiritual or cultural. These values are extra-aesthetic and extra-artistic, and thus are amenable not to moralistic but to ethical or social criticism. I do not demand that art be didactic. I am not a puritan. But neither am I a purist: I do not accept the view that art should inhabit a moral vacuum beyond good and evil. Of art aspiring to greatness, in the spiritual sense of the term, I require that it be a mirror of humane ideals, an epitome of the life of reason, a vindication of the generous faiths and dreams of mankind. I insist that our great artists be also great men, the apostles not of untamed pride and force but of chastened humility and love. Wagner's music, however exemplary its aesthetic and artistic values, falls short of spiritual and cultural grandeur, because what it expresses, the philosophy it adumbrates, is a sublimation of tribal arrogance, martial prowess, sentimental yearning. Of the things deeply cherished by a humanist and a humanitarian Wagner is not the preserver but the destroyer. And this is my ultimate reason for disliking him.

HARDITH: If you are sincere in what you say, you are certainly perverse. I do not recognize my Wagner in your one-sided picture of him. Wagner's genius, singular and complex, cannot be disposed of by a layman in so cavalier a fashion. I wonder how a learned student of Wagner's music would react to your sweeping generalizations. He would, I am sure, laugh at you.

MEREDY: I should not mind his laughter; and I should compliment him on his sense of humor. In all likelihood, however, he would take me seriously, and talk to me about Wagner's amazing achievements from the point of view of the professional critic and scholar. I should listen in all humility to his defense of Wagner as the creator and master of new forms and new expressions, and I should be persuaded that Wagner had raised the art of grand opera to the highest level of perfection. But granting the artistic values of Wagner's compositions, I should still maintain the layman's right to pronounce judgment on their aesthetic and spiritual values, for these have to do with my own experience and my own interpretation.—But come, let us forget Wagner. We have discoursed long enough about him, and with too much solemnity. Our friend Allison, as you know, has a goodly collection of recorded music. I propose that we go to his rooms to hear some Gilbert and Sullivan. Here is music inspired by the comic spirit. We may honestly enjoy its melodious strains without debating whether it be great or not. To be sure, this music is the result of admirable artistry, and it has a spiritual content of its own. It is usually called light, but its lightness is deceptive. Its essence lies in its comedy,

and comedy, as you have heard me remark on another occasion, has for its cultural mission criticism of life's follies and vindication of a sane world. Yes, Hardith, the comic operas of Gilbert and Sullivan afford a more penetrating insight into human nature and a wiser estimate of human comportment than the grand operas of which they purport to be caricatures.

III

Aesthetic Freedom

HARDITH: Our recent discussion about Wagner's music has raised a good many questions in my mind. I have no desire to revive that particular controversy. Our views of Wagner are too irreconcilable; and to dwell on them further would serve no useful purpose. Let us agree to differ in our attitude toward Wagner, since we cannot alter the fact that his compositions induce in us opposite feelings and divergent judgments. But our discussion was not confined to Wagner; it ranged over the entire field of aesthetics. I have been reflecting on your opinions about aesthetic experience and aesthetic criticism, and concerning many issues they involve I should like to hear you state your position more clearly. Are you inclined to continue today our previous and informal conversation about art?

MEREDY: I am always willing to talk about art, and an informal exchange of ideas by laymen may clarify certain aspects of it ignored or obscured in learned books. Art is not the exclusive property of specialists. Laymen have a vital stake in it, and their aesthetic preferences cannot be treated as negligible. For scholarships in every field, including the field of aesthetics, I have indeed the greatest respect, and I should be foolhardy to oppose the impres-

sions of a layman to the judgments of men trained in aesthetic criticism and valuation. But I should be foolish to carry modesty to the length of silence just because I lack proficiency in analysis of artistic technique and form. The effects which the arts aim at are universal, and concerning these effects on my own mind I feel free, indeed I have the right, to express an opinion. This is simply the freedom and the right of every auditor or spectator to reveal how any work of art affects him. What I claim for myself I should accord to others. Every man is competent to discourse on art; he is competent to speak of the interest he takes in it and of the value it has for him. This being my conviction, let us by all means exercise the prerogative of laymen and converse about art without fear and trembling. Never mind if what we say should strike the experts as impertinent or fatuous. What questions do you wish to put to me?

HARDITH: There is one question I intended to raise to which you have already given a partial answer. It concerns what we may call "aesthetic freedom." You say that every individual is free, though he has no training or discipline in any of the arts, to express an opinion about aesthetic values. This seems to me to set a premium on ignorance. You pretend to speak in behalf of all laymen, but are you a true representative of that class? You have a tutored mind, and your approach to art is not so simple or so ingenuous as you would have me believe. After all, the perception you bring to a symphony or a painting, however limited your knowledge of its form or style, is the perception of a sensitive and seasoned intelligence. You are

intimately acquainted with poetry, too, and appreciation of the technique of this art enables you to divine something of the technique of another. No, Meredy, you are not a perfect specimen of the breed we are talking about. How about a layman altogether without learning and without acumen? Would you extend to him the right to pronounce judgment on the value of a work of art? Would you, in other words, make aesthetic freedom universal?

MEREDY: You flatter me. I do not consider myself an exceptional layman. But I do not wish to defend aesthetic freedom on personal grounds. The restriction you would impose on the exercise of this freedom seems to be based on two mistaken views. You place art on too high a pedestal, and you underestimate the common man's appreciation of it. Art, you appear to hold, is "caviare to the general." This aristocratic theory, which asserts the right of aesthetic freedom to be the privilege of the few, denies art's universal appeal, and betrays a snobbish attitude toward the masses. It is only around art that is occult that we find many a strange and exclusive cult gathered. But is esoteric art good art? Good art, unlike an exotic delicacy, is a wholesome pabulum for all men. The witticism that *Hamlet* is full of quotations epitomizes the general contagion of a great poet's wisdom and diction. All the arts, if their themes are significant and their forms intelligible, communicate something of their inner spirit to the rank and file, complete anesthesia to them being seldom encountered even among those whom you would look down upon as artless and unlettered. Yes, Hardith, art is more honored by my democratic than by your aristocratic

theory. According to your theory, art is a luxury, cater-
ing to a sophisticated caste; according to mine, art is a
necessity, intent upon elevating or deepening our com-
mon visions and our common feelings. Moribund are all
works of art if what is enshrined in them is insulated from
the emotions and aspirations of the many. Consider the
classics: they live not in the formal treatises of the learned,
but in the hearts and minds of the vulgar. The vulgar (in
the original and not in the derogatory sense of the word)
are those who throng our museums, our concert halls, our
theaters. Few of them are trained connoisseurs of what
they see or hear. Yet most people, though deficient in
professional knowledge or academic erudition, have the
capacity for liking and enjoying a painting by Botticelli,
a symphony by Mozart, a play by Shakespeare, a novel
by Dickens. Without ordinary capacity for aesthetic
experience, widely diffused and infectious, the classics
would long since have been forgotten or would have
merely survived in curiosity shops as odd manifestations
of the human spirit. Our curiosity shops are actually full
of a number of things, discarded fruits of individual fancy
and skill, of great interest to the collector or antiquarian
but now condemned to oblivion because men failed to take
pleasure in them, or have ceased to do so. Indeed, large
sections of our museums and libraries are nothing else
than just such curiosity shops. The old masters, once
young and unknown, are beholden for their immortality
to the multitude; if they are not a joy forever to the great-
est number of people, they perish and deserve to perish.
Aesthetic freedom, the freedom of everybody to pro-

nounce judgment on a work of art, is a condition of its survival, for no work of art attains the status of a classic until the judgment of its value has become epidemic.

HARDITH: What you say contains a mixture of sense and paradox. I am far from denying the necessity of an educated public for the survival of artistic achievements. Without such a public the greatest of these achievements might die for want of interest or attention. But only an educated public is the repository of aesthetic values. I am unable to concede that "everybody," whether educated or not, is free to pose as a critic of art. I cannot enjoin upon the masses the virtue of silence in the presence of what they do not understand. Their democratic right of free speech is, of course, inalienable. What I impugn is not the expression but the validity of their aesthetic judgments. These judgments sound to me like the chatter of parrots. Oh, the inanities heard on all sides at concerts and in picture galleries! How many of those who "patronize" the arts do so on aesthetic grounds? Think of the number of people who are driven to sundry performances and exhibitions, not by thirst for aesthetic experience, but by gregariousness and fashion! It is a sign of "culture" in most societies to be on speaking terms with the arts, to be conversant with them for purposes of conversation. How ostentatiously men and women of leisure—and particularly our women—feign to be votaries of the Muses! Of the lower classes I will say nothing. The fine arts seldom come within their ken. The cheapest entertainments are seemingly good enough to satisfy their aesthetic needs. How much of great art would survive if its life depended

on "democratic" appreciation, that is, on the concurrent
judgments of a "majority" in any given society? Those
who pay attention to high artistic accomplishments consti-
tute everywhere but a small minority, and of that minority
only a few possess sufficient cultivation for full and genu-
ine enjoyment. You have mentioned the classics. The
prestige of the old masters is indeed undeniable and well
merited. It is the prestige of excellence; but excellence
is determined by expert judgment and not by popular
opinion. You seem to make the excellence of the classics
hinge upon their universal appeal. The word "universal"
must here be taken with a large dose of salt. Not everyone
enjoys and appreciates the masterpieces of art. These
masterpieces, it is true, afford aesthetic satisfaction to
many people, but the reasons for their doing so are numer-
ous and complex, the chief reason being the pervasive
diffusion of critical estimates regarding their eminence.
Artists do not become classical until they are very old—
their "hoary head is a crown of glory." It is only in the
course of time, after decades or centuries of criticism, that
the old masters achieve general, though not universal,
recognition, their greatness growing more manifest with
the lapse of years. Their greatness, at first discovered and
later established by criticism, finally comes to be taken
for granted. Yes, Meredy, the classics are enjoyed because
they are great, not great because they are enjoyed. They
owe their immortality not to the ignorant multitude, but
to judicious critics, and to an educated public influenced
by these critics. If this view be aristocratic, make the most
of it. Aristocracy means "the rule of the best," and the

aristocracy I defend is that of superior minds, minds that are most cultivated and most informed. Such minds alone are fit to govern opinion in matters of aesthetic taste.

MEREDY: Irony, my dear Hardith, does not become you. I was evidently unwise in my choice of epithets. Your argument is plausible if you use the word "democratic" in its worst and the word "aristocratic" in its best connotation. No, I do not propose to submit works of art to a majority vote. The question of artistic excellence is obviously one which only experts are competent to settle. It would be absurd to deny that most people are ignorant of the formal or technical values of art. If the intrinsic merit of artistic achievements consisted in these values, and in these alone, none but the most learned would be entitled to pronounce aesthetic judgments. I share your disdain for cavalier or fatuous criticism. I also deplore idle chatter about the arts. If "art for art's sake" is a sophism, "art for palaver's sake" is a scandal. But you are too hard on the amateurs; you put them all in the same class. I gladly join you in holding up to scorn those who are pretentious, disingenuous, affected, and priggish. Coxcombs and charlatans are ubiquitous; their supercilious prattle is audible in every concert hall and every picture gallery. But there are amateurs who are sincere lovers of art. They are usually humble and silent. And if they speak at all, their words, though hackneyed, are honest expressions of genuine feeling. It is easy to laugh at those who often say that they don't know much about art but that they know what they like. This popular aphorism, cited by the sophisticated as the epitome of philistinism, is not so ludicrous as it

sounds. Although jejune in form, it expresses substantial wisdom. It implies the fundamental distinction between the technical or formal values of art and its immediate or intuited values. These two sets of values are often confused, even by professional critics. In the interest of clarity we should have separate labels for them. Let us call the first set of values "artistic," and the second "aesthetic." The former has to do with the degrees of excellence in craftsmanship as discerned by the connoisseur, the latter with the quality of hedonic experience as enjoyed by the amateur. It is one thing to judge a work of art in relation to the nature of its material, the method of its construction, the design of its structure, the execution of its aim, the style of its expression; it is quite another thing to judge a work of art solely with reference to the hedonic effects caused by it. Knowledge of the medium or the means through which an artist seeks to achieve certain effects is not the same as the experience of these effects which his work is designed to engender. And any man, since he alone must be acknowledged as the authoritative spokesman for his experience, is an authentic vehicle of valid aesthetic judgments, provided only that such judgments merely reveal the effective states of mind a work of art induces in him. Now when a man declares that he does not know much about art he is candidly confessing ignorance of its *mode of production;* but this ignorance does not preclude knowledge of its *mode of operation* upon his senses and feelings. Everyone knows how a work of art affects himself; everyone knows, and knows immediately and infallibly, if he experiences pleasure or delight in its

contemplation. Don't sneer then at those amateurs who,
through an aphorism unjustly ridiculed, disavow knowl-
edge of artistic values while at the same time professing
knowledge of aesthetic values. Laymen, modestly dis-
claiming the one kind of knowledge and rightfully pro-
claiming the other, constitute the general public without
whose spontaneous approbation an art languishes, and
the more widespread the approbation the more viable the
art. My democratic theory remains unshaken by your
exaggerated notion of the role of the critics. Whatever
influence they have on the formation of public taste, they
are not the dictators of it. Government of taste, like demo-
cratic government of a national state, requires the consent
of the governed, and this consent any man is free to yield
or to withhold in accordance with his own experience and
judgment. I do not advocate, as you wrongly suppose,
submitting to a plebiscite the determination of the *artistic*
merit of a painting or a symphony; I only contend that
everyone has the right to pass judgment on its *aesthetic*
worth in terms of the sensuous and emotional satisfactions
which he himself experiences in its perception.

HARDITH: You will forgive me if I smile at your attempt to
impart a profound meaning to an egregious platitude.
Those who constantly parrot this platitude would be
greatly surprised to hear your subtle interpretation of
it. The vulgar speak truly when they say they "don't know
much about art," though they say this not with humility,
but as if ignorance were a virtue; the added assertion that
"they know what they like" is prejudice masquerading as
taste. It is plain sophistry to speak of "knowledge" in

connection with plebeian response to art. By taking up the cudgels in behalf of the aesthetic rights and liberties of the masses, you carry your love of democracy to absurd lengths. Don't misunderstand me: my devotion to political democracy is no less ardent than yours; but principles valid in the sphere of government are not equally valid in the domain of art. Your defense of these principles in relation to art is fallacious: it hinges on an arbitrary use of the term "aesthetic." You limit the word solely to the immediate values of art, and since these values are subjective, the only standard for them being hedonic experience, it follows that everyone is an authoritative critic or judge of them. Aesthetic values, as you adroitly phrase it, have nothing to do with an artist's mode of production, but only with his product's mode of operation upon our senses and feelings. Now I do not deny the subjectivity and relativity of hedonic experience: individuals differ in their sensitivity and emotional reactions, and hence in their judgments of value. But if all aesthetic values are transferred from a work of art to the effects produced by it, and effects felt differently by different individuals, the feeling of each being a law unto itself, democracy of aesthetic judgments is tantamount to anarchy. Political democracy rests on a consensus of opinion; controversial questions are decided by suasion and vote, the majority imposing its will on the minority. There is no analogue for this in aesthetic controversy. If feelings are said to determine the immediate values of a work of art, how arrive at a consensus of them? Between feelings as feelings we can institute no comparison; and even if we could, the result

would not lead to a compromise among them, since no man can cede his feelings to another, his feelings being what they are, impervious to criticism and argument. This, I repeat, is not democracy, but anarchy, and anarchy of a kind that is only too prevalent in popular discourse about aesthetic values. "I don't know anything about art, but I know what I like"—this banality you raise to the dignity of an aphorism, and in its tiresome reiteration you hear wisdom instead of bigotry. Yes, Meredy, you are led to an extreme view of art by a scruple of theory. But for your theory that all aesthetic values are immediate values—values incorrigibly subjective and relative—you would not be guilty of a paradox so flagrant, the paradox of *laissez faire* in aesthetic judgments, everyone, forsooth, being free to criticize a work of art on the basis of his undisciplined perceptions and wayward emotions. To be sure, you recognize other values, discerned not by amateurs but by connoisseurs, and in affixing different labels to them you regard them as if they were nonaesthetic or extra-aesthetic. Thus, you draw a sharp line between aesthetic and artistic values. Excellence of craftsmanship, which is the source of artistic values, concerns the mode of production of artifacts and not their mode of operation upon our senses and feelings; artistic values belong therefore to a different dimension of judgment, knowledge of them not being requisite for aesthetic enjoyment. By a similar separation you would mark off a third dimension of judgment relevant to the spiritual content and cultural significance of art; but knowledge of the expressive values of artistic creations is likewise extraneous to aesthetic ex-

perience. What you contend for is a three-dimensional conception of art. In accordance with this conception, the word "aesthetic" is preëmpted for the immediate values, and the artistic and the cultural values consequently fall outside the compass of aesthetic judgment. According to my view, which differs radically from yours, the three kinds of value constitute a unitary complex, and the title "aesthetic" pertains to the entire complex and not merely to one of its elements. Hedonic experience, though necessary, is not a sufficient condition of aesthetic judgment. In its pregnant meaning, aesthetic judgment of a work of art includes knowledge of its mode of construction as well as understanding of its relevance to human life. All three dimensions of value, distinguishable but inseparable, are thus intrinsic to the total content of aesthetic experience. Unlike your theory, therefore, mine is based upon an inclusive definition of aesthetic experience, covering "hedonic" as well as "cognitive" ingredients, the latter involving comprehension of the technical and spiritual aspects of artistic production. Since the amateur, whose freedom of judgment you so eloquently champion, is admittedly lacking in this comprehension, his aesthetic experience is essentially rudimentary or truncated. Genuine and complete aesthetic experience presupposes perceptive acumen, profound emotion, refined taste, sympathetic imagination, mature intelligence, critical judgment, consummate learning. And you will agree that few men and women are blessed with these gifts and powers.

MEREDY: I certainly agree that rare indeed are the gifts and powers you mention. But aesthetic experience is a matter

of degree, its fullest fruition occurring when a man possessed of the uncommon qualities you enumerate is in the presence of a superlative work of art. The aesthetic experience you are intent upon is singular, the resultant of two exceptional factors, presupposing an exceptional work of art and an exceptional mind contemplating it. You look for the locus of aesthetic experience in the conjunction of these two extraordinary phenomena. But the extraordinary or the exceptional is not the typical. Just as the stars are not of equal magnitude, and those who behold them cannot all be learned astronomers, so the objects that prompt the aesthetic experience need not be on the same plane of perfection, and the minds undergoing this experience should not be required to approach them with the same interest and attitude. Works of art differ in excellence, and the enjoyment of them differs in intensity. You take so exalted a view of aesthetic experience that you seem reluctant to admit its authenticity unless that authenticity is engendered by artistic achievements of the highest merit and induced in minds belonging to the *élite*. You misconceive art by making a fetish of it. Your aristocratic theory culminates in sheer idolatry; you turn art into a cult, and you accentuate the distance between its votaries and the laity. No, Hardith, art is not preternatural; the enjoyment it affords is epidemic as well as endemic. All men are capable of deriving from all art, in varying degrees of intensity, sensuous pleasure and emotional satisfaction.

HARDITH: I plead guilty to the charge of perfectionism. The demand for perfection, in every field of human interest,

is not idolatry; and if you choose to identify this demand with image worship, the image worshiped is the image of an ideal. How can we speak of values, whether aesthetic or nonaesthetic, as having "degrees," without at the same time implying some standard or scale in relation to which they may be graded? My ultimate measure for aesthetic values is approximation to the ideal of perfection. I do not deny that aesthetic experience is "epidemic," in the sense that all mankind may derive from art some pleasure or satisfaction, in varying degrees of intensity. But if you admit that aesthetic enjoyment is amenable to gradation, the issue between us is clear and definite. You base your theory on the lowest degree of enjoyment; I base mine on the highest. Appropriating the term "aesthetic" for the one dimension of hedonic values, you regard the technical and cultural values of art as extrahedonic and therefore as extra-aesthetic. Now I do not concede that the terms "hedonic" and "aesthetic" are equivalent. Aesthetic perception is not only affective; it is also cognitive, involving critical discernment of the formal and spiritual aspects of art. But granting for the sake of argument that aesthetic enjoyment is synonymous with hedonic experience, the hedonic experience of those who have some knowledge of art, knowledge of its workmanship and significance, is higher or deeper than the hedonic experience of the ignorant. Yes, Meredy, the more adequate the knowledge of a work of art, the more nearly perfect is the aesthetic enjoyment of it. So I come back to the contrast between your three-dimensional and my unitary theory of art. The values you arbitrarily separate I merely distinguish. You

see in a work of art a *juxtaposition* of values; I see in it a *context* of values. You limit the name "aesthetic" to the immediate values, as if they could be segregated from the artistic and the cultural; I give the name to the work of art as a whole, all its values being, as it were, concentric. Consequently, you identify aesthetic enjoyment with feeling, I with feeling that is instinct with knowledge. Not admitting knowledge as part of aesthetic enjoyment, you surrender the only objective standard for measuring its degrees, since feelings are ultimately incommensurable; for me, knowledge of art is essential, and, knowledge being subject to gradation, the greater one's knowledge the higher the degree of aesthetic experience. Our irreconcilable views have their root in our different uses of the word "aesthetic." If the sense I give to the word seems to you honorific, the meaning you impart to it strikes me as degrading.

MEREDY: "Degrading," my dear Hardith, is a strong expression. I do not dishonor the word "aesthetic" by making it descriptive of a universal experience. It is you who debase an exoteric adjective: you employ it to characterize special interest in art by a coterie of connoisseurs. The sense with which you endow this adjective is not honorific; it is precious. But let that pass. Speaking of words, let me say that I accept gratefully your felicitous description of my theory as "three-dimensional." The separation of distinct levels of value is indeed fundamental to the democratic conception of aesthetic experience. That experience is nothing less than pleasurable or enjoyable experience; the immediate value of a work of art and the feeling of

delight in its presence I consider to be one and the same thing. Artistic and cultural judgments of value, supervening upon aesthetic experience, form no essential part of this experience, although they may often enhance it. I have an additional reason for maintaining this view. We have been discussing aesthetic experience as if the only objects inducing it were works of art. But there is nature, with its fields and woods and rivers, its clouds and mountains and seas, its crystals and flowers and birds, its rocks and deserts and stars. Think of the plethora of natural facts, the glorious patterns of colors and sounds, open to aesthetic enjoyment, and open to everyone with eyes to see and ears to hear. Yet natural facts are not artifacts: no laboring psyche has contrived their forms and designs, their rhythms and harmonies. Is nature an artist? Do we know by what technical means and for what spiritual ends nature produces such a profusion of aesthetic objects? Are not these objects aesthetic whenever our perception of them is not mere perception, but hedonic perception? And can it be denied that hedonic perception of natural phenomena is universal? Here abysmal ignorance of method and aim of construction is no bar to complete sensuous delight and rich emotional satisfaction. No, we cannot ascribe to nature artistic and cultural values, for these values have their origin and being in *human* skill and *human* purpose. The only aesthetic values pertaining to nature's creations are immediate values, coinciding with the congeries of hedonic feelings and moods diversely evoked by them in all sensitive minds. The aesthetic values of nature, all being immediate, thus constitute but a single

dimension; artistic and cultural values, which critics and
scholars discern in artifacts, have here no meaning or
relevance. Your conception of aesthetic experience seems
to have no application whatever to nature. And I confront
you with the following dilemma. Of two things one (as the
French say)—either aesthetic enjoyment of nature is pre-
cluded, because nature's technique and intent are beyond
our ken; or else aesthetic experience is simply the experi-
ence of pleasure or delight, following upon sensuous con-
templation alike of nature and of art, understanding of the
manner and purport of creative activity not being a neces-
sary condition or integral part of that experience.

HARDITH: A hit, Meredy, a "very palpable hit"! But I do
not find the dilemma you thrust at me embarrassing, for
I look upon aesthetic experience of nature in a different
light. I grant, of course, that simple minds may derive
enjoyment from natural phenomena without reference to
the mode and intent of their production. What is the justi-
fication, however, for describing as "aesthetic" the sundry
feelings and moods which everyone experiences in the
presence of nature? In its primary meaning the word
"aesthetic" applies to the perception of artifacts, princi-
pally those which are said to represent the "fine arts,"
and this perception, the complexity of which I have suffi-
ciently emphasized, involves sensuous enjoyment as well
as appreciation of artistic and cultural values. It is only
in a derived sense—derived, that is, from the perception
of art—that we may legitimately speak of perception of
nature as aesthetic. Between nature and art, between facts
and artifacts, there is no deep and yawning chasm; we

may bridge the gulf that seems to divide them by envisaging nature as analogous to art. We enjoy and appreciate works of nature as if they were works of art, imputing to them by a poetic license intended meanings and designs. And this poetic imputation is the basis of our aesthetic experience of nature. Without it, indeed, little *can* we see in nature that is ours. Only a great imagination could draw nature to the human scale, picturing, for example, the sea as "baring her bosom to the moon," and the howling winds as "up-gather'd now like sleeping flowers." To the prosaic mind such images seem gratuitous and impertinent: the sea has no bosom, flowers do not sleep, and winds and flowers are heterogeneous. What a man, without a tincture of poetry or speculation, beholds in nature's splendors is, therefore, something strange and wondrous, having no affinity with his own passions and aspirations. Nature moves him not; for everything in nature he is out of tune! The poet laments our general failure to humanize nature and to perceive it as cognate with our feelings and desires. To be intimate with nature, to find it congenial, we must look upon nature as if it imitated art, as if its forms and designs were significant and expressive. I say "as if" advisedly, for we are dealing here with a fiction. For this aesthetic fiction, if I may so name it, the fiction of interpreting nature in terms of art, we are beholden to the poets. Only by sharing this fiction, by seeing nature as the poets see it, can our enjoyment of nature's phenomena be spoken of as truly aesthetic. The dilemma you put forward I thus replace by another. Either the enjoyment of nature is incommensurable with that of art, in which case

the word "aesthetic" has one meaning as applied to nature and a quite different meaning as applied to art; or else, if the word "aesthetic" is to have the same sense in relation to both, it can have that sense only by the grace of an imaginative but pregnant license, the license of perceiving nature as unconscious art.

MEREDY: You astonish me! You have often accused me of indulging in paradoxes! Yet what could be more paradoxical than your present attempt to bolster an untenable argument? To save your aristocratic theory of aesthetic experience you take refuge in the myth that nature is unconscious art. This fabled anthropomorphism is undeniably a venerable poetic license. But is a particular license of poetry a general principal of aesthetics? You argue that to the poet alone, who would rather be a "pagan suckled in a creed outworn," is vouchsafed an aesthetic experience of nature comparable to that of art: he alone can

> Have sight of Proteus rising from the sea;
> Or hear old Triton blow his wreathèd horn.

Great Zeus! Must we be possessed of the genius of a Wordsworth if we are to enjoy nature? Are the glories of earth and sky hidden or veiled from men unable to rise to the highest poetic level? Aesthetic experience of nature becomes thus one of the rarest things in the world. There is certainly method in your fastidiousness. If consistency is a jewel, you flaunt it with the pride of a lady wearing a precious ruby. Yes, Hardith, you are consistent, but at what a price! Consider the implications of your theory. The universal pleasure or delight taken in nature is not

aesthetic at all. To appreciate nature is to humanize it,
and to humanize nature is to perceive its forms and de-
signs as if they were created in unconscious imitation of
art. No aesthetic experience of nature, therefore, without
prior and expert knowledge of art. For only those who
understand how and why human artists consciously
produce their artifacts could discern in nature similar
achievements by unconscious craftsmanship. It follows
that all but a few art connoisseurs and art critics are pre-
cluded from genuine love of nature. Can anything be
more anomalous? The root of the trouble lies in your
aristocratic conception of aesthetic experience. I am will-
ing *à la rigueur* to accord to this conception a semblance
of cogency when it is applied solely to human creations.
But its application to nature's creations seems to me fan-
tastic. I cannot take seriously the figment of the imagina-
tion that nature is a species of art. How preposterous to
set up art as a model for nature! Aristotle thought other-
wise. You recall his famous dictum that "art imitates
nature." In the order of genesis, nature precedes art; our
aesthetic experience of nature is thus prior to that of art.
In the history of the individual as well as in the history
of the race, what comes first is hedonic experience of
natural phenomena, and this experience is noncognitive,
in the sense that it does not rest on antecedent understand-
ing of the mode and intent of their production. The enjoy-
ment of nature is originally innocent and spontaneous;
the sophisticated analogy between nature and art forms
no part of its essence. And later enjoyment of art is
equally innocent and spontaneous. Most men approach

artifacts as if they were natural facts, products of an
unknown creative force, the hedonic and not the cognitive
values preëmpting the aesthetic qualities ascribed to them.
There is no dilemma here. All objects, whether natural or
artificial, are on the same aesthetic plane; the distinction
between them is not aesthetic but extra-aesthetic, artifical
objects possessing what natural objects lack, namely, ar-
tistic and cultural values. The gist of my contention is that
the term "aesthetic" extends equally to facts and artifacts;
the aesthetic experience of both is synonymous with pleas-
urable perception, and everyone may experience pleasure
in the presence of any object without knowing to what
method or purpose it owes its construction. And for this
contention I may enlist the support of Aristotle, whom I
have quoted already. Art, he said, imitates nature. Strictly
speaking, no artists can imitate nature's technique or in-
tention, for he has no knowledge of either. In what, then,
does the imitation consist? The imitation, to put it suc-
cinctly, is not artistic or spiritual, but only aesthetic. In
creating his objects, the artist aims to produce upon our
sensibility and our feelings effects that are cognate with
the effects produced by the objects of nature; he seeks
through his artifacts to induce in us hedonic states of mind
resembling in quality and intensity those caused by nat-
ural phenomena. Yes, there is continuity between art and
nature, as the word "imitation" aptly suggests; but the
continuity lies in the hedonic experience similarly engen-
dered by both, and not in the theory that one is a species
of the other. But this view of imitation demands that we
separate sharply the aesthetic values, such as are imme-

diately felt, from the nonimmediate values, the artistic and the spiritual, which are revealed by analysis and criticism. Frankly, I do not like the word "imitation"; its connotation is misleading, implying the relation of copy to original. Art is not a replica of nature, nor nature a replica of art. But Aristotle's use of imitation as an aesthetic category is altogether different from your use of it, for he accorded priority to nature. Such priority involves no paradox if we interpret it as priority of hedonic experience: we actually begin with the enjoyment of nature, and subsequent enjoyment of art is simply a continuation of it, the same immediate delight taken in nonhuman creations being extended also to human creations.

HARDITH: I wish you had not introduced Aristotle into our conversation. Your knowledge of Aristotle is more adequate than mine; I am therefore precluded from entering upon a learned discussion of his theory of imitation. As I understand Aristotle—and I am only a dabbler in philosophy,—imitation has two meanings, one related to the *creation of art*, and the other to the *appreciation of nature*. Nature is the standard for the production of art, and art the measure for the appraisal of nature. So close is their connection that art may be spoken of as nature in miniature, and nature as art writ large. You misinterpret Aristotle in imputing to him the paradox that, because nature is a manifestation of art and art a reflection of nature, each is a species of the other. What Aristotle demonstrates is not the *similarity* between nature and art, as if one were the original and the other the copy, but rather their *unity*, comparable to the unity of the two sides of a shield, the

same mode of explanation being applicable to both. But it is the philosopher, and not the ordinary man, who can conceive of art and nature as one in principle. For what essentially is nature? If we consult our random sense impressions, nature appears as a congeries of things, things particular and accidental, kaleidoscopic and evanescent; but if we interrogate reason, nature is seen as the habitat of permanent and universal types, which are subject to law and order. The philosophic appreciation of nature requires that we employ for its explanation concepts or categories borrowed from art, the products of which are the result of purposive activity and constructive design, embodying what Aristotle speaks of as "final causes." Nature is not intelligible save to the synoptic eye of reason, which discerns everywhere significant forms and adaptation of means to ends. In other words, appreciation of the creativity of nature as not different from the creativity of art has its source in men's higher faculties; it issues from thinking and understanding and not from mere perception and feeling. And what essentially is art? Here too the answer must be in terms of reason rather than in those of sense impressions. If art is interpreted as imitating nature, the nature it imitates is nature as comprehended by thought. Aristotle demands of the artist that he approach nature as a philosopher, seeing the universal in the particular and the necessary in the contingent. Classical literature, one of the arts which Aristotle had principally in mind as he was elaborating his theory of imitation, illustrates superbly the affinity between poetry and philosophy. The Greek poets depicted natural char-

acters and situations not as casually observed, but as
deeply understood. They imitated nature in representing
the individual as the incarnation of the type, the type as
the image of law, and law as the manifestation of uni-
versal reason. Consider, for example, the delineation of
the heroines of Homer and of the tragedians. Penelope,
Nausicaa, Andromache, Antigone, Iphigenia, and all the
rest, are women whose beauty and truth lie in their typical
humanity. What these women lose in subtlety and finesse
they gain in clearness and power. Not that the delicate
gradation of their character is at all blurred; what is
obliterated is merely their idiosyncrasy. The conception
that individuality is uniqueness was seemingly foreign to
the Greek poets. The exclusive feelings or desires that
render human beings incommensurable they indeed rec-
ognized, but only as unessential. In discarding them they
sought to bring into relief the more stable and lasting
traits of human personality. The delineation of the typical,
for which Greek literature is noted, was inspired by the
belief in the superiority of the universal over the par-
ticular. Through the medium of metrical language and
sensuous imagery, Greek poetry gave expression to the
same fundamental conviction that is found embedded in
Greek philosophy. Classical poetry is a eulogy of reason.
The ultimate kinship between reason and reality is its
postulate. In any of the Greek tragedies, we have an ar-
tistic epitome of a rational view of the nature of things:
it deals with situations and characters conceived as typi-
cal, both the situations and the characters bound together
by laws of inward necessity, and the whole subject to unity

of action and design. Yes, Meredy, among the Greeks the continuity of art and nature was a canon at once literary and philosophical. I venture the opinion, and I know I am rash in doing so, that Aristotle's theory of imitation was a justification of the poets' practice. What they expressed through their art, Aristotle justified in his philosophy. But the continuity of art and nature, which his theory of imitation vindicates, must be understood as a continuity of creative force. Art does not imitate nature in reproducing or copying her particular creations. The imitation of art consists in *emulation*. Art emulates deliberately nature's unconscious power to adapt means to ends, and to embody in sensuous material permanent and intelligible forms. Although I hesitate to air my views of Aristotle in your presence, the little knowledge I have gained from a study of his philosophy leads me to deny that imitation signifies the continuity of hedonic experience which is engendered by natural and artistic productions. Imitation, as I understand it, is a principle that applies chiefly to the construction rather than to the enjoyment of art.

MEREDY: You are too modest in underestimating your knowledge of Aristotle; what you say is quite orthodox, and can be supported by many passages from his works. But Aristotle's theory of imitation, as you interpret it, is vitiated by a barefaced paradox. Imitation, you contend, is a principle implying that in nature and in art the method and aim of creation are the same, art achieving laboriously what nature does, so to speak, by instinct. The two apothegms, "Art imitates nature" and "Nature is unconscious art," are thus equivalent. How familiar are we with

nature's artistry? What inkling have we of its afflatus or direction? Nature's "final causes" are purely supposititious, construed as analogous with those to which objects of human contrivance owe their inception and fruition. Human artists produce artifacts out of nature's material by fashioning it in accordance with forms antecedently conceived to express or to realize desired ends. Artifacts have such forms as are grafted upon them by the purpose or design of human artificers. Now, nature's material, out of which artifacts are produced, have forms of their own, not created by human agents. How understand or explain these forms? These forms, Aristotle asserts, owe their being to the same purposive activity creative of the forms of artifacts. Observe the paradox: nature's creativity, first established by analogy with human creativity, becomes in turn the model after which artifacts are patterned. Is this not a flagrant case of reasoning in a circle? To explain nature, we must apply to it principles drawn from the creation of art; and to explain art, we must interpret its creation as emulating that of nature. Do you really find such a fallacious argument convincing? Can you honestly maintain that between the formations of art and the formations of nature there is a discernible resemblance? The formations of art are transformations of nature's material by voluntary effort and skill; the formations of nature are not due to a laboring mind similarly engaged in the process of transforming raw material into finished products. Nature is self-formative; art is formed by a self. To take the comparison between art and nature seriously, we must impute creative purpose not to nature itself, but to a

deus ex machina, as it were, working in a preformed and
preëxisting medium to produce the formations which na-
ture displays. And this, my dear Hardith, is the mythology
of popular religion, the source of superstitious credulity
and facile optimism.

HARDITH: Do you deny, then, any continuity of nature and
art? Is the gulf between them ultimately impassable? Both
imagination and reason balk at a bifurcation so absolute.
The mythology of popular religion is a perversion of a
profound truth. It is not superstition to approach nature
with piety and art with reverence, and to see in both a
propulsion to create beauty and perfection. The affinity
between nature and art, as perceived by poets and as con-
ceived by philosophers, may be easily exposed to criticism
or laughter. I know that Hume exhibited, and that Voltaire
ridiculed, the notorious fallacies of the religious argu-
ment from design. It is indeed futile to embark upon a
logical proof that the formations of nature are those of a
divine artist, revealing in all their infinite details a benevo-
lent purpose and a coherent plan. Nevertheless, the kin-
ship between nature and art cannot be lightly dismissed
because a prosaic mind, deceived by appearances, looks
upon them as strangers. The aesthetic attitude toward
nature is a *poetic* attitude, involving appreciation of na-
ture's forms and patterns as if they were formed and pat-
terned by a creative artist. Call this a fiction, if you will;
it is nevertheless a fiction that enriches and enhances the
enjoyment of nature's transporting splendors. And the
conception of art as imitative of nature is a *philosophic*
conception, showing that artistic products exemplify the

same union of matter and form to which all things in the universe owe their individual structure and character. Call this a hypothesis; but it is a hypothesis that makes intelligible the unity of nature of which art is the crowning achievement. The search for a homogeneous principle of creation in all nature, creative man being a creature of nature, is not fruitless. Of this principle the poet has an impassioned and the philosopher a speculative vision. And some awareness of this principle I regard as an essential and integral part of aesthetic experience in relation to art as well as nature.

MEREDY: No, Hardith, I am not disposed to defend the dogma that the breach between nature and art is absolute. The two lend themselves to various kinds of speculative assimilation. Many philosophers, inspired by different visions, have advanced *different* hypotheses about the unity of nature and art. Aristotle's hypothesis is not singular or privileged. This, however, is a recondite matter, and should be left to the metaphysicians. But what, I ask, has metaphysics to do with aesthetic experience? You seem to argue that a particular metaphysical theory— namely, Aristotle's—is a prerequisite to aesthetic experience. Must one first become a learned Aristotelian, in order to enjoy in the fullest measure the creations of nature and of art? Is adherence to the doctrine of "final causes" a necessary condition for the perception of aesthetic values? But this doctrine is purely speculative, having no validity for those who refuse to interpret nature in terms of art, and art in turn as an imitation of nature. Nature and art may be enjoyed by all men, without a

special theory of their manner of creation. How and why
do nature and art produce their hedonic effects? This is
an *ulterior* question, not relevant to the pure experience
of these effects.

HARDITH: You have twisted my argument out of all propor-
tion. I should be foolish to demand technical mastery of
Aristotle's philosophy as a condition of aesthetic experi-
ence. You, not I, introduced into our discussion the Aris-
totelian idea of imitation. I have endeavored to meet your
challenge to defend it, not on metaphysical but on poetic
grounds. The mutual assimilation of nature and art, each
the mirror of the other, has its source in intuition rather
than reason. Poetic intuition of nature's artistry is prior
to the logical demonstration of it, and this poetic intuition,
I insist, is fundamental to the aesthetic experience of na-
ture's creations. Aristotle's theory is but a discursive ex-
pression of what every poet who loves nature feels in her
presence, being a dialectical version of an impassioned
insight. The poet beholds nature as the prototype of his
own fertile and exuberant fancy; he hears her myriad
voices singing to mortals

> Of their sorrows and delights;
> Of their passions and their spites:
> Of their glory and their shame.

Yes, Meredy, in looking upon nature as an unconscious
artist and upon himself as her conscious pupil, every poet
is an Aristotelian *malgré lui*. But his is an intuitive and
not an intellectual Aristotelianism. And this intuitive Aris-
totelianism, which is a universal characteristic of all great
poetry of which nature is the theme, we must bring to

nature if we are to enjoy and to appreciate in poetic fashion the aesthetic values of nature's profuse formations. What you call "pure experience" of nature's hedonic effects is vouchsafed only to a poetic soul who feels these effects as if produced to convey the moods and passions of an unseen spirit.

MEREDY: Ingenious, Hardith, very ingenious! So poets are Aristotelian at heart if they project into nature a fabled artistry! It is a nice *tour de force*, and not without a grain of truth. For all I know, enraptured poets in contemplating the glories of nature contemplate them as works of art, embodying purpose or design, and expressive of intended values or effects. But do they really fathom nature's creative genius—her inspiration, her methods, her technique, her style? Do they actually divine the plan and the execution of a "house not made with hands"? Everything they see in nature is but theirs—their visions, their dreams, the similes and figments of their imagination. What you describe as their intuitive Aristotelianism, anthropologists call "animism" and philosophers "anthropomorphism." Poets are indeed often affected by nature as if her ways were analogous to human ways, a congenial spirit or soul lurking behind her sensible appearances. This is a primitive approach to nature, and one not confined to the poets. In speaking of it as "Aristotelian," you are simply giving a euphemistic name to a primordial myth. A captious critic might interpret Aristotle's doctrine of "final causes" as being itself an echo and prolongation of early animism or anthropomorphism. The importation into nature of purpose or design, though achieved with all logical refinement

and dialectical skill, is ultimately a recrudescence of an ancient belief that the propulsive forces of nature are animated by desire or governed by volition. Science has taught us to banish final causes from nature. The analogy between nature and art, the source of Aristotle's doctrine of final causes, modern science has definitely abandoned, and its abandonment marks the beginning of accurate and precise knowledge of natural facts and events. The artistry of nature, be it envisaged by poet or philosopher, remains but an engaging myth. Fervid entertainment of this myth by some minds may increase for them their joy in nature's beauty. What I challenge is your view that a belief discredited by science is the basis for the aesthetic experience of nature.

HARDITH: No, Meredy, knowledge of nature is not attained exclusively by the canons of science. Artists and philosophers approach nature by different methods, and the insights into nature which they afford, though not amenable to scientific tests, are important adjuncts of human knowledge. It is dogmatic to identify all knowledge with science, and hence to stigmatize as mythical the intuitions of poets and the conceptions of philosophers. You have charged me with idolatry of art. Are you a worshiper of modern science? Do you deny that there are aspects of nature which, though impervious to scientific observation and experiment, come within reach of artistic perception and speculative reason?

MEREDY: Of course I do not make knowledge synonymous with science if science is construed in too narrow a sense. I am not one of those who hold that all cognition is a matter

of direct observation and exact measurement. The great
achievements of science—or rather, the achievements of
the great scientists—have their source in the bold and im-
aginative hypotheses, originally inspired by some sort of
divination either intuitive or speculative, which nature
has later confirmed. Every great scientist, by the intensity
and sweep of his vision, is next of kin to poet and meta-
physician; and the *aperçus* of artists and philosophers
often indicate new vistas of nature and thus open new
avenues of inquiry. It would be fatuous to idolize science,
and to enshrine it in a compartment insulated from the
insights given by poetry and speculation. Yet, while many
of these insights are imaginative anticipations or exten-
sions of scientific hypotheses, others are but imaginary
alternatives or substitutes for them, and Aristotle's doc-
trine of final causes is precisely such an imaginary sub-
stitute or alternative. There is no evidence for it such as
the sciences rely upon for the verification of beliefs initi-
ally proffered as tentative. The evidence adduced for it
is not observed at all, but merely inferred, and inferred
by analogy with artistic creation. To say that nature is an
artist is to indulge in a figure of speech masquerading as
a demonstrable truth. The alleged artistry of nature is
plainly a myth, although a beautiful one, because it rests
on a confusion between facts and artifacts, demanding
that we draw nature to the human scale, something all
science eschews, and that we impute to the phenomena of
nature a volitional origin comparable to the origin of
works of art. To offer this fable as a foundation for our
aesthetic experience of nature is to mistake an interesting
jeu d'esprit for a serious principle.

HARDITH: I am not prepared to champion Aristotle against
his scientific critics. There is much to be said, no doubt,
in rebuttal of your argument. But this is a task I must
leave to men better skilled than I am in philosophy and
science. The abstruse reasoning with which you attack my
aesthetic theory does not convince me. Both of us have
departed from our main theme, and carried the discussion
beyond the field of aesthetics. Let me return to the major
issues that divide us. One is purely a matter of definition.
You maintain that the word "aesthetic" is equivalent to
the word "hedonic," and hence that aesthetic experience
is simply experience of pleasure or delight in the presence
of works of art and of nature, understanding of the mode
and purpose of their construction forming no part of that
experience. I, on the other hand, employ the word to cover
both enjoyment and understanding: the experience called
"aesthetic" is not only hedonic, but also cognitive, involv-
ing comprehension of the *objects* prompting it, compre-
hension of the method and meaning of their creation. Our
different use of the word "aesthetic" entails as a corollary
a more important question. Whose aesthetic experience is
more genuine or more authentic, the experience of those
who are trained connoisseurs of its objects, or of those who
are ignorant amateurs of them? Requiring as you do that
the objects of such experience be affectively apprehended
rather than intelligently comprehended, you reduce all
aesthetic judgments to judgments of hedonic preference,
and you confer upon everyone an inalienable right to pro-
nounce them. I cling to the view that aesthetic judgments
are informed and critical judgments, presupposing refined

taste, mellowed feeling, abundant learning. Our debate
was at first confined to works of art with which the subject
of aesthetics is primarily concerned. But you expanded the
subject by shifting the inquiry from art to nature. How,
you asked, is aesthetic experience of nature possible, and
in what way does it resemble that of art? There again we
part company. Identifying aesthetic experience with he-
donic experience, you contend that the feelings of pleasure
or delight following upon perception are qualitatively the
same, whether the perception is that of a fact or of an arti-
fact. I reject the equation of aesthetic experience with
hedonic experience; consequently, if there is to be equality
in kind between aesthetic experience of nature and that of
art, natural creations must be comprehended as analogous
to artistic creations. And who comprehends them thus? I
appeal to most poets; and I appeal also to those philoso-
phers who take seriously Aristotle's doctrine of "final
causes," in spite of the aspersions cast upon it by the vo-
taries of modern science. It is nature as understood that
is fully enjoyed, just as art when comprehended affords
the greatest satisfaction. Pray note that I speak of under-
standing or comprehension instead of knowledge, since
you make knowledge signify what science aims at by its
meticulous methods of investigation. Scientific knowledge
is not germane to aesthetic experience. The term "knowl-
edge" in relation to that experience must be used with a
certain latitude. Aesthetic judgments are cognitive in a
broad sense; they are not logical conclusions from ante-
cedent premises or reasoned inferences from stubborn
facts. Aesthetic statements are statements of value, to be

heeded only if distilled out of long and intimate acquaint-
ance with the formations of nature and of art. What the
critics say about the intrinsic beauty or excellence of arti-
facts has behind it a fund of accumulated wisdom, result-
ing from their expert familiarity with the media in which
artists work and with the ends which artists are intent
upon. Hence the prestige of the critics of art. And that
which poets and philosophers declare to be the inner
meaning and significance of the creations of nature is
equally expert and authoritative, their aesthetic judgments
of nature being certified by pure intuition or sustained
speculation. Away, then, with your punctilios! Strictures
drawn from science do not disturb me. I refuse to admit
that human knowledge must be either ploddingly induc-
tive or rigidly deductive. The kind of knowledge pertinent
to aesthetics is that of artists, critics, and philosophers.
Such knowledge is subject to its own canons and cannot
be measured by those of science. No wonder our views are
so antithetical. You deny that knowledge, whatever sense
be given to it, has any relation to aesthetic experience,
aesthetic judgments having reference not to the objects
perceived but only to what is felt in perceiving them. I
affirm that aesthetic experience must take cognizance of
its objects, and that aesthetic judgments, being judgments
of hedonic as well as of extrahedonic values, are subject
to standards laid down by experts. You are certainly con-
sistent in applying to aesthetics the principles of democ-
racy: if aesthetic judgments express nothing more than
hedonic experience undergone in the presence of natural
and artificial creations, the freedom to indulge in them

must be accorded to everyone. But I am equally consistent in my aristocratic view, in emphasizing the "rule of the best" in aesthetic matters: the right to formulate aesthetic judgments, I relegate to minds superior in taste and cultivation; for their appraisal of aesthetic values is based upon competent study of the objects embodying and sustaining them. Your democratic theory gains plausibility from the contention that aesthetic experience of nature is prior to that of art, aesthetic experience of nature being for you purely hedonic, devoid of understanding. According to my view, the order is reversed: love and knowledge of art condition the ascription of aesthetic values to nature; for the word "aesthetic" has primary application to artifacts, and to attach it to other facts demands the exercise of a poetic imagination. To say that nature is an artist is not to speak in parables. It is a profound truth, but only for those who are themselves artists, or for those who are familiar with the works of artists. As a layman, I humbly turn to men conversant with the arts to reveal to me the aesthetic values which nature makes manifest to their more perfect sense and understanding. Such, then, are our respective positions. I trust I have restated them fairly. And if I have done so, I see no possibility of effecting any compromise between them.

MEREDY: You have summarized the contrast in our attitudes with admirable completeness and lucidity, though you have unduly exaggerated some points concerning which our disagreement is not so sharp. But on the main issue the difference between us remains irreconcilable. It boils down to the question whether aesthetic experience is that

of pleasure or delight accompanying the perception of natural and artistic creations—in which case the experience is universal; or whether aesthetic experience includes also knowledge of the methods and aims of these creations—in which case the experience is exceptional. I extend to every man the right to voice his aesthetic judgments on the basis of his indefeasible experience; you accord this right only to those whose authority as experts must first be established. Yours is an authoritarian view of aesthetics, mine a libertarian one, and between liberty and authority, in any domain of human interest, the antithesis is not only acute but chronic. Nevertheless, our conversation has served the purpose of clarifying our minds and of bringing into focus points of view that have always been opposed. We have pursued the theme of aesthetics along different paths of inquiry. The lines that lead to it are often parallel; alas, like parallel lines in geometry, they may never meet! Although I cannot help believing that my mode of approach is the more adequate one, there is much in yours that I am unwilling to ignore or neglect. We have by no means exhausted a subject so rich in provocation to theory. Let us both reflect on what we have said, and return afresh to a further exploration of this fertile field.

IV

Nature and Art

HARDITH: I have thought long and deeply on what you said in our last conversation. Although reflection on your aesthetic view has not shaken my conviction, I see now more clearly the crux of our controversy. The chief difficulty confronting any account of aesthetic experience lies in its relation to both art and nature. A valid conception of aesthetic experience should be relevant alike to human and nonhuman creations. Consider, for example, a sunset in the sky and a sunset painted on canvas. In terms of your vocabulary, one is a "fact" and the other an "artifact," the two words denoting the difference between what is produced without human agency and what is produced by means of it. It would be absurd not to recognize the importance of the distinction between objects that do not owe their genesis to man and those that issue from his creative endeavor. Aesthetics can neither ignore nor neglect this distinction. Is aesthetic experience the same, whether induced by a natural sunset or by an artificial sunset? And if not the same, in what consists the dissimilarity? Until this question is settled, our debate will proceed along parallel lines; and like such lines in geometry, as you so aptly said, they can never meet. If our debate is not to remain

fruitless, it must at some point converge. I can imagine an impartial judge comparing our respective theories and commenting on them as follows.

"You, Hardith," he might declare, "have an aesthetic theory applicable solely to works of art. You demand that aesthetic experience include knowledge of the technical and cultural values of its objects, and the greater the knowledge the richer the experience. But such knowledge is possible only of artifacts, for they alone, like painted sunsets, embody human skill and human purpose. The more we understand the craftsmanship and significance of an artifact, the more pleasure we derive from its contemplation. You are thus committed to the thesis that all aesthetic objects are primarily artistic objects. Since natural facts, such as sunglows in the heavens, are not artistic objects, not being indebted for their inception and completion to a laboring mind, they are excluded from the class of aesthetic objects. But this is a flagrant paradox. To bring natural facts within the compass of aesthetic experience, you must look upon them as if they were artifacts, in violation of the commonly accepted difference between art and nature. And this is sheer sophistry. In other words, Hardith, your theory of aesthetic experience is more convincing than Meredy's if applied exclusively to works of human contrivance; it breaks down when viewed in relation to natural phenomena."

"But your argument, Meredy," our impartial judge would contend, "is more valid than Hardith's where the aesthetic experience of nature is concerned. You identify aesthetic experience with the hedonic experience accom-

panying the perception of any object, knowledge of the
mode and aim of construction not being requisite for that
experience. The pleasure or delight taken in the rhythms
and patterns of nature is indeed universal, and this pleas-
ure or delight, though varying in intensity in different
individuals, owing to the variations in their sensitivity and
feeling, cannot be intensified by an understanding of the
objects inducing it. We cannot understand a natural sunset
as we may understand a painted sunset, namely, as the
execution of a definite plan, as the result of a special
method, as the expression of a particular style. You are
right, therefore, in insisting that a natural sunset, though
an aesthetic object, is not an artistic object, ignorant as
we are of the means and purport of its construction. But
you are wrong in arguing against Hardith that all aesthetic
experience is independent of knowledge of its objects.
There are degrees of pleasure or delight taken in artifacts,
owing not merely to differences in sensitivity and feeling,
but also to differences in understanding of their technical
and cultural values. A man conversant with these values
will derive a higher pleasure or a greater delight from the
contemplation of a painted sunset than a man unaware of
them. Your theory of aesthetic experience, though ap-
posite to nature, is not true of art; Hardith's, pertinent to
art, is inapplicable to nature."

What shall we say to our imaginary Solomon who would
thus divide the honors between us? Shall we accept his
judgment that each of us has a valid but limited view of
aesthetic experience? Can we rest content with his criti-
cism that your theory is relevant to nature alone and mine

to art alone? Is it impossible to give an account of aesthetic experience comprehensive enough to fit equally facts and artifacts?

MEREDY: Your appeal to a wise judge, giving to each of us the palm of victory, is ingenious: it brings into clear focus the crucial issue of our debate, and I am glad that you have attributed to him the wisdom of speaking in concrete terms. It is easy to lose sight of a problem when it is stated generally instead of illustratively. One may argue without end, and without profit, as philosophers often do, whether art is an imitation of nature or whether nature is unconscious art. Reference to definite examples avoids the fallacy of disputing about mere abstractions. Let us emulate the wisdom of your judge in eschewing a polemic that is verbal rather than real. In speaking of the contrast between works of nature and works of art, and of the corresponding aesthetic experience they induce, we must never fail to exemplify the contrast by individual but representative instances. Only thus can we prevent our imagination from floundering in the void. The two sunsets, one in the sky and the other on canvas, indicate precisely the difference between two kinds of aesthetic objects. Now the two sunsets are undeniably aesthetic objects: each affects our senses and emotions in specific ways, and each does so in virtue of the spread and configuration of a color complex. Indeed, an aesthetic object is anything which exhibits qualities in such relation that the perception of it affords sensuous pleasure and emotional satisfaction. Yet, though both the colored horizon and the pigmented canvas belong to the class of aesthetic objects, only one of them

is a member of the class of artistic objects. The engaging
belief that nature is an artist, whether held on poetic or
speculative grounds, loses its force when tested in relation
to a particular concrete phenomenon. The atmospheric
effects accompanying the descent of the sun, admittedly
aesthetic, are not effects such as those produced with brush
and pigments. An artistic object is an object formed by
human effort and skill. An artistic object is a "handiwork"
emerging from the exercise of some bodily organ or of
some instrument ancillary to it, being the creation of a
human self, his creativity consisting in his deliberate
manipulation of some raw material to express or to realize
some end antecedently intended or desired. When the
Psalmist says that the firmament showeth God's handi-
work, he speaks in parables. The glowing sky is a meteor-
ological fact and not a painted artifact. Only that which
issues from the hands of man can be properly spoken of
as a "handiwork." Tell me, Hardith, if you accept my
inclusive definition of aesthetic objects and my exclusive
definition of artistic objects, the former comprising all
formations whether natural or artificial, the latter em-
bracing human formations only. If we agree that the term
"aesthetic" has a more catholic meaning than the term
"artistic," our attitudes would not seem so divergent to
your supposititious judge.

HARDITH: Whatever poets may feel or philosophers think
of nature as a whole, it is obvious that no particular phe-
nomenon, such as an actual sunset, is an artistic object.
If works of art are literally handiworks, then works of
nature, not being made with hands, constitute aesthetic

objects of a different order. But since you include works
of nature in the class of aesthetic objects, they must have
some relation to works of art. What is the relation? What
have works of art and works of nature in common if their
origin and significance are so heterogeneous? Why do
actual and painted sunsets exemplify the same genus,
though each belongs to a separate species? I readily agree
that in genesis and meaning human handiworks represent
a class of aesthetic objects markedly unlike the class of
natural phenomena. But they must have some similarity
if they are to be designated as equally aesthetic. What is
the similarity?

MEREDY: Your question touches the nerve of my theory. Of
course, there must be some similarity between any two
distinguishable species to be "subsumed," as the logicians
say, under a single genus. If man's handiworks and na-
ture's phenomena were incongruous in every respect, we
could neither compare nor contrast them. It is usually
forgotten that comparison and contrast are mutually im-
plicative. The things we ordinarily compare are also dif-
ferent, possessing qualities of their own apart from those
they have in common. Comparison and contrasts are rela-
tive to some chosen standpoint or attitude. Things com-
pared retain each their own properties in virtue of which
they may be contrasted, and things contrasted leave a resi-
due of shared properties with respect to which they may
be compared. Are lions and wolves similar, or different?
We may compare them as mammals, as quadrupeds, as
beasts of prey; we may also contrast them with reference
to their appearance, their habits, their behavior. They are

like and unlike one another in sundry ways, as are all observed and observable things; the point of view or interest guiding the observation determines the emphasis upon their resemblances or idiosyncrasies. Now works of art and works of nature may be equally compared and contrasted, since they are similar in some respects but different in others. Works of art and works of nature, if I may revive a distinction made in a previous conversation, differ in their *mode of production* but are similar in their *mode of operation*. Actual sunsets and painted sunsets, our selected examples of facts and artifacts, have in common the capacity to affect us in cognate ways—by their form or configuration, by the distribution of the various colors in their composition, by the gradual or sudden transition from one color to another, by the brilliance of some colors and by the faintness of others. In their total effects both chromatic schemes or designs excite our senses, stir our feelings, move our imagination, heighten or deepen our moods, stimulate exaltation or pensiveness of our spirits. Works of art and works of nature, though differently *made*, are similar in what they *do* to us whenever we find ourselves in their presence. What they do to us is to breed in our minds qualities of experience that are sensuously pleasurable and emotionally satisfying. These qualities of experience I call "aesthetic"; and any object, whatever its mode of production, is an aesthetic object if its mode of operation on us is such as to engender these qualities.

HARDITH: I have often admired the felicity of your expressions. The antithesis between the mode of production and

the mode of operation of an object is certainly arresting, and it explains admirably your aesthetic theory. But, granting the validity of your antithesis, does it follow that knowledge of what goes into the making of an object has no bearing upon its enjoyment? Those who understand how and why an artist paints a sunset derive more pleasure from its perception than those who are unfamiliar with the method and aim of artistic creation. What the painting does to trained connoisseurs it cannot do to mere amateurs: the aesthetic experience of the former is surely more intense or more profound or more subtle than that of the latter. I appeal again to an imaginary judge: he would prefer my view on the ground that knowledge of the mode of production of art enhances its mode of operation upon our senses and feelings. I am in a conciliatory mood, Meredy, and I want to concede that aesthetic experience *is* hedonic experience, provided only that you enlarge its scope. I shall meet you more than halfway if you admit that the highest degree of aesthetic enjoyment is vouchsafed to those who can comprehend discriminatingly and appraise critically the formation and significance of artistic objects.

MEREDY: I too am in an irenic frame of mind, and am willing to make such concessions as are not inconsistent with what I deem to be essential. Essential for me is the view that no object, whether natural or artificial, is aesthetic unless the perception of it gives rise to the experience of pleasure or delight. If *you* agree in identifying the aesthetic quality of an object with the hedonic experience supervening upon its contemplation, then *I* agree that knowledge of its mode

of construction may often serve to increase that experience. The criterion of aesthetic quality being pleasure, I should be foolish to rule out as negligible whatever may be shown to contribute to its richness or depth. I admit that there are degrees of aesthetic pleasure; the highest degree might well be attained by those who are exceptionally gifted with acute sensitivity as well as with expert knowledge. But observe that in my view knowledge must be subordinated to pleasure and not pleasure to knowledge. Only when knowledge *is* a source of greater pleasure can knowledge of the formation of objects be considered as relevant to the aesthetic experience of them. For you, however, knowledge is not merely accessory to aesthetic experience, but is the basis of it. Here I emphatically demur. My principal reason for doing so is the fact that natural objects, such as sunsets in the sky, give us aesthetic pleasure of the highest degree, to which knowledge of their mode of production adds no increment. And may we not supremely enjoy painted sunsets, as we do natural sunsets, in complete ignorance of their methods of creation? Besides, knowledge of the creative process either of nature or of art is no index to aesthetic pleasure; it may have for its concomitant no pleasure at all, or no greater pleasure than is enjoyed by those who lack it. Of the difference between knowledge and experience, one possible without the other, I find a striking expression in a short poem by Walt Whitman. Do you recall the lines beginning, "When I heard the learn'd astronomer"?

HARDITH: I remember them but vaguely, since I have no ear for Walt Whitman. I do not appreciate his verses; they

are too amorphous. But I always like to hear you recite poetry. Let me hear the poem you have in mind.

MEREDY: The piece is terse but expressive, having a characteristic form of its own; it is quite pertinent to our discussion, running like this:

> When I heard the learn'd astronomer,
> When the proofs, the figures, were ranged in columns before me,
> When I was shown the charts and diagrams, to add, divide, and measure them,
> When I sitting heard the astronomer where he lectured with much applause in the lecture-room,
> How soon unaccountable I became tired and sick,
> Till rising and gliding out I wander'd off by myself,
> In the mystical moist night-air, and from time to time,
> Look'd up in perfect silence at the stars.

Yes, Hardith, astrophysics and astroaesthetics are altogether different things. Understanding of celestial mechanics will not by itself open the heart to the beauty of the constellations. "From the intense, clear, star-sown vault of heaven, / Over the lit sea's unquiet way," to quote the more conventional lines of Matthew Arnold's, radiate influences felt in solitude and in silence which astronomical knowledge may fortify but cannot evoke. To perceive the studded firmament as an aesthetic object requires only an imagination touched with emotion; the learned astronomer, with all his "charts" and all his "diagrams," if his mind is but intent upon physical bodies and their gravitational forces, will see no jewels in the evening sky nor will he be stirred by the glory of their shining. And this is true also when we turn from works of nature to the works

of man. There are learned critics whose knowledge may
deepen for them their aesthetic experience of those human
handiworks which they can so competently "measure and
divide." There are others, however, for whom artistic
objects exist not to be taken a joy in, but to be taken pains
with. Works of art supply themes for laborious discourse:
they are either parted by analysis or colligated by classi-
fication. So many pundits, lecturing "with much applause"
in our lecture rooms, are chiefly concerned with the
contentious labels of school or fashion: what they are
ultimately interested in is to affix to a work of art its
appropriate etiquette, to give it a local habitation and a
name. Erudition, though often the companion of percep-
tive acumen, no less often sits cheek by jowl with incredi-
ble anesthesia. In speaking of knowledge in relation to
aesthetic experience, we must thus distinguish between
knowledge contributing to pleasure and knowledge which
is but adventitious to it. Here as elsewhere, a little learning
is dangerous, but more perilous is its excess. Pedantic
learning blunts and precious learning enervates the spirit.
Formal knowledge pursued either by rote or with bias
may blind our eyes or deafen our ears to those aesthetic
qualities of an object of which the perception must be im-
mediate and the enjoyment spontaneous. So while I con-
cede that knowledge of art bred in a sensitive mind may
open channels of delight closed to the ignorant, knowledge
as such will not make a mind sensitive, nor is knowledge
generally indispensable to aesthetic experience.

HARDITH: I am glad to discover at last the major issue be-
tween us. We seem to be disputing about degrees of

aesthetic experience. We agree that an aesthetic object, owing to its form or design, its composition or structure, is a thing of joy to the perceiver. Is knowledge a component of this joy? When the aesthetic object is a natural phenomenon, great joy may indeed accompany its contemplation in the absence of knowledge. But the joy taken in it will be greater when perception is mated with understanding. The astronomer caricatured by Whitman is not typical. The alleged antithesis between scientific knowledge and aesthetic experience, epitomized in his poem, is far from universal. To be sure, astronomical knowledge is not requisite for aesthetic contemplation of the "vault of heaven," yet to him who truly comprehends the constitution and the motion of the celestial bodies, unless he is incorrigibly prosaic, this vault will appear as more beautiful or more transporting than it does to the ignorant multitude. A joy that comes from knowledge will be added to the joy derived from experience, and this combined joy is certainly deeper and more satisfying than the joy of the ordinary stargazers. If this is true of natural phenomena, it is truer still of human handiworks. I do not deny the uselessness and sterility of much that masquerades as knowledge of art conveyed by philistines and aesthetes; pseudo-knowledge has a deleterious effect, deadening or perverting a man's spontaneous joy in beautiful things. But not all knowledge of art is that of pedants or prigs. There is knowledge born of experience, fed by imagination, under the tutelage of taste, balanced by criticism, and reaching maturity through reflection. And such knowledge, as it occasionally comes to fruition in some minds,

begets a delight in art not dreamed of by the layman or amateur. Even the layman or amateur finds that his aesthetic pleasure acquires a new quality when, instead of merely staring at a work of art, he brings to it some learning gleaned from an authoritative historian or an acute critic. If you admit all this, where is the divergence of our points of view? Does it not boil down to a matter of emphasis? We both assume that an object is not aesthetic unless it induces hedonic experience: you denote the experience by the word "pleasure," I by the word "joy." I prefer the word "joy," covering as it does sensuous as well as intellectual delight. You are reluctant to include knowledge as an essential part of aesthetic experience because knowledge of the wrong sort does not augment pleasure or may even attentuate it, and because varying degrees of pleasure are possible in the absence of knowledge. Although I grant this, I contend that the joy in a work of art grows with the growth of true understanding, and that the highest degree of joy is the reward of that critical scholarship which avoids the Scylla of pedantry and the Charybdis of preciousness. Come, Meredy, acknowledge that our views are one in principle, since we both recognize a hierarchy of aesthetic experience. There are gradations of pleasure or joy, reaching its climax, as it were, in a mind of imagination as well as of knowledge all compact.

MEREDY: I am not sure that our views can be so simply harmonized. They converge indeed on one point, but this point, though important, hardly provides sufficient ground for their mutual accommodation. We agree that only in a mind possessed of the right kind of knowledge may the

quality of aesthetic experience attain a maximum degree; proper understanding of an object may intensify or enrich the pleasure or joy supervening upon its perception. But this agreement does not carry us very far. For what constitutes right knowledge or proper understanding? This is a difficult question, subject to endless debate. It is easy to state verbally or abstractly that the learning germane to aesthetic experience must be such as will fructify the imagination, refine taste, sharpen discernment, discipline the emotions, ripen judgment. And it follows as a matter of course that when a man approaches an aesthetic object with learning *as thus generally described and prescribed,* his pleasure or joy in it will be incomparably greater than that of a man who perceives it with no learning at all or with the pseudo-learning that kills or corrupts the spirit. But what concrete program of specific learning will inevitably accrue to the benefit of aesthetic enjoyment? Can we determine in advance that one definite course of study will uniformly quicken sensitivity and feeling, and that another will invariably deaden them? We are confronted here by two formidable problems. One problem is theoretical: by what principle can we mark off the kind of detailed knowledge that will serve as a help to aesthetic pleasure from the sort that will prove a hindrance? The other problem is practical: by what means can we cultivate useful learning and curb the useless sort? Suppose, however, we could fix the boundaries between beneficial and harmful learning, and suppose we could indicate how to foster the former and how to eschew the latter, yet the learning requisite for the enjoyment of human handiworks

is on a different plane from that demanded for the enjoy-
ment of natural phenomena. *We can never understand a
work of nature as we might understand a work of art.* I
regard this proposition as axiomatic. In your eagerness
to reconcile our two views you have lost sight of the fun-
damental distinction between natural and artificial objects
of aesthetic experience. All objects, whatever their mode
of production, are aesthetic in virtue of their mode of
operation upon our senses and feelings; but artificial ob-
jects alone exercise their aesthetic function in accordance
with *ascertainable* methods of creation. There is a radical
difference in status between the aesthetic values of nature
and those of art: the aesthetic values we ascribe to an
actual sunset are its *by-products*; the aesthetic values are
attribute to a painted sunset are its *chief products*. A
meteorologist looks upon a sunset in the sky as an atmos-
pheric phenomenon, due to various and complex con-
ditions, its aesthetic qualities being accidental and not
strictly pertinent to his investigation; an art critic views
a sunset on canvas as a chromatic design, made with pig-
ments and brush, its aesthetic qualities being the essential
qualities he is ultimately concerned with. Accordingly,
in a scientific study of a natural sunset we may safely
eliminate from our consideration the pleasure or joy we
feel in its presence, since this pleasure or joy is not one
of the links in the chain of its physical causes and effects.
But in a critical study of a painted sunset, which is an
artifact created *for the very purpose* of embodying and
sustaining aesthetic values, what is central is the question
whether it does or whether it does not cause pleasure or

joy, hedonic experience being the main effect of an artistic object. In other words, knowledge of nature pursued by science is not the same thing as knowledge of art which criticism is intent upon. Knowledge of natural facts, however accurate or complete, can never reveal the artistry to which they owe their aesthetic values; the artistry creative of the aesthetic values belonging to artifacts is precisely one of the major themes of criticism. While I do not dispute your general thesis that aesthetic experience may gain in richness or depth with adequate knowledge of its objects, the knowledge apposite to artifacts has no bearing upon natural phenomena, namely, knowledge concerning the different methods of workmanship or craftsmanship. Artistic objects represent a distinct class of aesthetic objects because the values they enshrine may be traced to the assiduous labor, the technical skill, the deliberate intent of human agents.

HARDITH: I have often heard you expatiate on the distinction between facts and artifacts. The importance of this distinction is undeniable. Works of nature have a different origin from works of art. But admitting the difference between human and nonhuman creation, how fundamental is it for aesthetic theory? And is critical knowledge of art so incommensurable with scientific knowledge of nature? You are importing into aesthetics a subtle antithesis derived from a philosophical theory of cognition. Although they are distinguishable, the two kinds of knowledge which you discern are not separable. Each involves the other. All things fall within the jurisdiction of science, and all things come within the purview of aesthetics. Thus a

painted sunset, being a physical object, is amenable to scientific description and explanation; and a natural sunset, since it is an object of hedonic experience, lends itself to aesthetic analysis and judgment. The two sunsets are equal in their claims upon knowledge and enjoyment. The aesthetic values of both being *perceived* values, does it greatly matter whether upon subsequent reflection we *conceive* the aesthetic values of the one sunset as direct products and those of the other as by-products? How much does comprehensive understanding of these products increase the felt joy in them? This is the major point in our controversy. You recognize grudgingly, and I unreservedly, that the highest degree of pleasure is the reward of learning and criticism. In support of Walt Whitman's superficial distinction between the learned astronomer and the lyrical stargazer, you said, with your usual penchant for the neat phrase, that astrophysics and astroaesthetics are not the same. Of course, they are two different things: one is a discipline concerned with the intrinsic nature of the stars, the other a discipline having to do with their effects upon our sensibility and feelings. There is a distinction here, but no antithesis. The antithesis rests upon the ambiguity of the term "aesthetics." You seem to use the term as a synonym for hedonic experience rather than as a name for a theory of it. The noun "aesthetics," unlike the adjective "aesthetic," denotes a branch of learning: it has for its data the various objects that occasion joy as well as the various degrees of joy felt in their presence; its method consists in analysis and description; and its aim is to afford understanding of both the specific experi-

ence which is called "aesthetic" and the objects which in-
duce this experience. Does the adjective "aesthetic" refer
primarily to the experience, or does it refer also to the
objects of the experience? This is indeed a crucial ques-
tion. If the adjective is descriptive of the objects, and not
merely of the experience of them, then knowledge of their
constitution or formation can alone determine whether
they are entitled to be called aesthetic or nonaesthetic. In
other words, aesthetics is an intellectual discipline not
differing in principle from any other intellectual disci-
pline in virtue of its special subject matter, definite proce-
dure, and cognitive function. Aesthetics is the science of
aesthetic experience and aesthetic objects, just as physics
is the science of physical bodies and physical changes, or
just as economics is the science of economic activities
and economic relations. In all these, there should be no
confusion between the noun naming the theory and the
adjective defining the area of facts or data germane to
the theory. It is trite but necessary to insist that not every-
one is an aesthetician who merely enjoys sunsets or stars.
A man is not a physicist because he is aware that his body
is acted upon by another body and in turn reacts to it, nor
is one an economist who is engaged in the production or
consumption of certain commodities. Your Walt Whit-
man, rebelling against astrophysics, leaves the lecture
room to look up in perfect silence at the stars, but this
silent vision, no matter how much instinct with joy, is not
equivalent to expert insight into astroaesthetics. The word
"astroaesthetics," strange though striking, connotes a
theory regarding human enjoyment of the stars, and this

theory is no less analytical or discursive than the theory
of "astrophysics" with which you contrast it. No, Meredy,
Walt Whitman is not an authority on aesthetics; his aes-
thetic experience, like the aesthetic experience of any
other man, is but a particular datum for that science. A
student of aesthetics is not an ineffable mystic: what he is
intent upon is a reasoned and reasonable view of the com-
plex conditions governing our subjective sense of beauty
and the objective forms of beauty, one of the moot ques-
tions being whether a higher sense of beauty is not caused
by an adequate study of the forms of beauty. The relevance
of knowledge to aesthetics is thus twofold: aesthetics is
itself a department of knowledge, and upon that discipline
devolves the problem of ascertaining to what degree
knowledge of the objects enjoyed contributes to their en-
joyment. To make absolute *à la* Whitman the divorce
between knowledge and experience is to deny outright the
possibility of aesthetics and to assert dogmatically and
absurdly that the learned astronomer, just because he *is*
learned, can have no aesthetic experience of the stars. I do
not dismiss lightly the difference you harp upon between
facts and artifacts, and between scientific knowledge of
nature and critical knowledge of art. But these refined
distinctions, pertinent perhaps to philosophy, have little
bearing upon aesthetics. Aesthetics is an autonomous field
of inquiry, and within that field objects are deemed aes-
thetic if by their sensuous qualities and formal designs
they affect with joy those who contemplate them, this joy
being perfectible, the most perfect joy resulting from the
marriage of experience with knowledge.

MEREDY: I certainly concur in all that you say about aesthetics as an autonomous branch of learning, and I do not propose to inject into it problems or distinctions drawn from other disciplines. You are mistaken, however, in viewing as irrelevant to aesthetics the difference between scientific knowledge of nature and critical knowledge of art. In a general sense, all serious knowledge is both scientific and critical, if by the term "scientific" we mean methodical and if by the term "critical" we mean problematic. Every investigation must be pursued in accordance with a definite procedure, and the result of the investigation must be subject to tests such as will allay justifiable suspicion of its validity. Indeed, the conclusion of any inquiry may be criticized both on the basis of its agreement with the facts from which the inquiry proceeds and on the basis of its consistency with the principles by which the inquiry is guided. Aesthetics is no exception: a particular aesthetic theory may be impugned either because it is not true to all the pertinent facts or because its reasoning from the chosen data is infected with contradiction. But there is a special sense of criticism employed in the knowledge of art that cannot be employed in the knowledge of nature. The physicist, who understands the causes of a natural sunset, does not criticize the sunset: he cannot judge it to be good or bad, original or conventional, significant or trivial, a work of expressionism or of impressionism. Scientific knowledge of any natural phenomenon is not criticism of its mode of construction, its merits or defects not being a matter of dispute. Who could speak of today's sunset as well contrived and of yesterday's as ill

contrived? But this is precisely the function of criticism in relation to painted sunsets: one artifact is judged to be better than another—more deeply conceived, more skillfully executed, more perfectly designed, superior in technique or purer in style. In other words, criticism of art is valuation of it, valuation of excellence in craftsmanship and valuation of purpose in creation, and criticism in this sense is altogether inapplicable to nature. Art criticism is an important human vocation; criticism of nature is exercise in futile supererogation. A critic of art possessing the requisite knowledge can readily indicate the blemishes that mar a given artifact, but always on the assumption that these blemishes might have been avoided if the artist had been more competent or more dexterous or more painstaking. But where is the man, be his knowledge ever so complete, who could show how the creator of a natural fact might have been more proficient in the use of material, in the choice of form, in the adaptation of means to end? "Declare, if thou knowest it all." This ancient challenge hurled at Job may be thrown in the teeth of those who presume to be critics of nature. Yes, Hardith, I admit that knowledge is essential, not for aesthetic experience, but only for aesthetic criticism. Nature, though a perennial source of aesthetic experience, is not open to aesthetic criticism. It is strictly and exclusively in relation to art that aesthetic criticism has meaning and relevance, for an artifact alone invites and permits understanding of the method and purpose of its creation. Let me rephrase the main issue between us in this form: how far must one be an adept in aesthetic criticism to derive the fullest joy

from the contemplation of works of beauty? Observe that this issue can never be raised with respect to products of nature, but solely with respect to products of art. Thus fundamental for aesthetics is the difference between artifacts and facts, and the distinction between kinds of knowledge appropriate to each.

HARDITH: It is unfortunate that the adjective "aesthetic" has to do such yeoman service for us. We speak of aesthetic *objects*, aesthetic *experience*, aesthetic *theory*, aesthetic *criticism*. We have here too embarrassing a wealth of connotations. No wonder the adjective is a source of much confusion, its meaning shifting and changing as we pass from context to context. Thus, in the context of objects, whether natural or artificial, the word "aesthetic" is descriptive of their intrinsic qualities and relations, and there is no better synonym for it than the word "beautiful," things aesthetic being ultimately things of beauty; but in the context of experience the word "aesthetic" describes pleasurable states of mind supervening upon the perception of beautiful objects. Its synonym is the word "joyful" (or "hedonic" if we must have a term of Greek origin), for things of beauty are a joy forever. In the context of theories, the adjective "aesthetic" defines a specific field of inquiry: its data consist of things that are beautiful and of the feelings engendered by them, and its aim is to give a precise description and a systematic interpretation of these data. Hence the name "aesthetics" as a name for a special or scientific discipline concerned with a definite area of facts which demand, for an understanding of them, painstaking analysis as well as perspicuous

synopsis. But in the context of criticism, considered as
normative in distinction from *descriptive* aesthetics, the
term "aesthetic" pertains principally to judgment the
function of which is to discriminate between good art and
bad art. Aesthetic criticism is judicious appraisal of works
of art involving standards assumed or proved to be canon-
ical. Given such standards, however derived and justified,
a critic will affix to an artifact the label "good" if it con-
forms to them, the label "bad" if it fails to do so. Here we
have four different synonyms for the adjective "aesthetic":
an aesthetic object is a beautiful object, an aesthetic ex-
perience is a joyful experience, and an aesthetic theory
is either descriptive aesthetics or normative aesthetics.
You are smiling, Meredy! Does my play with synonyms
strike you as amusing? My naïve excursion into semantics
is intended to break down your dichotomy between facts
and artifacts. The disparity between them may perhaps be
granted when the adjective "aesthetic" is attached to judg-
ments of appraisal regarding the proficiency or purpose
of modes of creation—when, in other words, aesthetic
criticism is made synonymous with normative aesthetics.
It is true, of course, that we cannot criticize works of nature
in accordance with the *same* standards to which works of
art are subject. With respect to the other meanings of the
word "aesthetic," when we replace it by its other appro-
priate synonyms, the antithesis between facts and artifacts
becomes less fundamental. Any definition of beauty with
which we begin or at which we arrive must cover natural
as well as artificial objects. Beauty is beauty of colors or
sounds, in a certain order or arrangement, discernible

alike in nature and in art. And all beautiful things afford
joy and delight; if aesthetic experience is synonymous
with hedonic experience, it matters little whether this
experience is occasioned by facts or artifacts. Likewise
aesthetics, purporting to be a doctrine of the beautiful or
a theory of taste, must be comprehensive; its categories
and principles are not truly scientific or descriptive unless
they embrace the beautiful in nature as well as the beauti-
ful in art, and unless they apply to the taste for both. Even
criticism as equivalent to valuation, though in a strict
sense pertinent solely to works of art, is not altogether
inapposite to works of nature, for works of nature are not
all on the same plane of perfection or excellence, nor do
they equally engender in us the same quality of hedonic
experience. A discerning critic, without presuming to cor-
rect nature, since he is not familiar with the secret of her
creative genius, may nevertheless perceive aesthetic dif-
ferences in her creations, some being less beautiful or less
enjoyable than others. Valuation of nature is not pre-
cluded if it is but valuation of the varying degrees of
beauty she exhibits in her lavish formations, and of the
varying degrees of joy these formations produce in us.
Criticism of beauty and of taste is no more the work of
supererogation in relation to nature than it is in relation
to art. In short, Meredy, I insist that an aesthetic theory
be not only analytic but also synthetic. And for a theory
aiming at synthesis nature and art are coequal though not
coeval.

MEREDY: Admirable, Hardith, admirable! I smile because
I am pleased. I am willing to go with you a long way, and

I applaud your attempt to bring some order out of a prevalent linguistic chaos. When the learned speak, for example, of "aesthetic quality" or of "aesthetic judgment," I am never sure what the quality is a quality of, or the judgment a judgment about. They affirm that an experience is aesthetic and they assert that an object is aesthetic. Does the adjective called by the same name indicate an identical character or attribute? In ordinary parlance, we often say of a man that he has aesthetic taste and that he lives in aesthetic surroundings. There is no confusion here if we substitute for the term "aesthetic" the synonyms you suggest. A man's taste is aesthetic if he has a sense for the beautiful and a love of beauty; his surroundings are aesthetic if the objects they comprise, whether natural or artificial, exhibit beautiful aspects and forms. Pleasure or delight in beauty is one thing; the structure or design of creations, whether of nature or of art, is quite another. Aesthetics, by which you rightly understand a discipline concerned with both aesthetic experience and aesthetic objects, as physics is a science related to both our observation of bodies and the constitution of bodies, cannot obliterate the distinction between subjective enjoyment of beauty and objective manifestation of beauty. The distinction between subjective pleasure and objective form remains, in spite of laborious efforts to derive one from the other. It is indeed legitimate to ask whether our hedonic experience of objects is determined by their intrinsic beauty or whether the statement that things are beautiful hinges upon our liking and enjoying them. Whatever the answer, the sense in which the epithet "aesthetic" applies

to states of mind is not the sense in which it applies to the formations of nature and of art. For my own part, I see no advantage in blurring the difference between the subjective and the objective meaning of the epithet, or in reducing the meaning of the one to the meaning of the other. Aesthetics, being intent upon a theory of taste *and* upon a theory of beauty, must pursue a double inquiry. When taste is its theme, the inquiry is focused on states and acts of mind—states of pleasure or delight undergone in the presence of certain objects, and acts of sensuous discrimination and intuitive discernment of such values as are embodied in the objects. But when beauty is the subject matter of aesthetics, the direction of the inquiry shifts from states and acts of mind to the forms and patterns of things, the locus of beauty being sought and found in the juxtaposition or arrangement of their constituent parts. In other words, beauty lies on the surface or in the context of an object, and taste has its roots in the mentality and culture of a person. The ambiguity of the label "aesthetic," generally affixed to the taste for beautiful objects as well as to the beauty of the objects themselves, is inherent in the twofold task of aesthetics: this discipline is preoccupied, on the one hand, with the perceived and felt values of facts or artifacts, and on the other, with the values resident in their given or constructed configurations. The ambiguity is incorrigible but significant; it shows that between taste and beauty the relation is intimate. Taste can be distinguished but not separated from the objects that nourish it. The greater the area of beautiful things that come within one's ken, the more cath-

olic his taste becomes; and the beauty of things, though intrinsic to them, requires taste for its enjoyment and discernment. All beauty shines unseen or sings unheard until taste discovers and celebrates its nature and meaning. But there is a profounder reason for the affinity between taste and beauty—and here I broach the ultimate difference between facts and artifacts, and the proper office of aesthetic criticism. Taste is not only the basis for the enjoyment of beauty, it is also requisite for its creation. But if taste is required for its creation, the only kind of beauty which can be said to exemplify taste is that created by human artists. Consider again our old example of the sunset in the sky. Here is a work of nature the beauty of which impinges on taste but does not proceed from taste. Indeed, without taste for color and form the phenomenon would not be perceived as beautiful; but who can say that taste for just *these* colors or just *this* form superintended its production? A human handiwork, a canvas coated with pigments, reflects the taste of its maker, and in criticizing it we either admire or deplore the taste which governed the selection of the material, the choice of method, the execution of the design, the organization of the details, the elaboration of the technique or style. A work of art is beholden for its beauty to the taste of an artist. Does this not lend justification to my view that aesthetic criticism has no bearing upon works of nature? For in the last analysis, aesthetic criticism is valuation of products of taste in terms of standards of taste: it is the taste of the judicious critic, guided by established canons of taste, which discriminates between good art and bad art. To

works of nature the epithets "good" and "bad" have no pertinency: not being incarnations of taste, they are not subject to criteria of taste. In saying that "nature and art are coequal though not coeval," you ignore the role of creative taste, central in art but absent in nature. You have coined a nice epigram the truth of which will not withstand careful analysis.

HARDITH: You have clarified in your own fashion the issues I raised in connection with the equivocal uses of the term "aesthetic." Much of what you set forth is sound doctrine which professional students might well take to heart. In modern books on aesthetics, written with an affected but jejune precision, taste and beauty have become sadly neglected if not forgotten words. I am glad to find that you share my desire to restore them to their original dignity. No discipline is autonomous without principal concepts peculiarly its own. Taste and beauty should be as fundamental to aesthetics as are "organism" and "environment" to biology or "wealth" and "labor" to economics. To jettison taste and beauty from the vocabulary of aesthetics, and to replace them by concepts drawn from other disciplines, is to distort a definite subject matter, with the result that aesthetics is everything but aesthetics, tending instead to be an adjunct of psychology or sociology or metaphysics. But with taste and beauty reinstated as concepts basic to aesthetics, art and nature may be defended as "coequal," for both are equally open to perceptive taste and both are equally prodigal of works of beauty. What you call "creative taste," germane to artificial but not to natural beauty, is indeed important, and reference

to it is especially apposite when the theme of inquiry is the "psyche" of an individual artist, the subject of psychology or biography. An inquiry strictly aesthetic is concerned chiefly with perceptive taste of beauty and with all the forms of beauty affording enjoyment. May we not distinguish (if I may use the idiom of the economists) between "consumers" and "producers" of beauty? The different products of beauty, consumed, so to speak, with varying degrees of relish and acumen, are extant objects, the consumption of them being uninfluenced by their method of production, whether the method be intentional as in art or without deliberation as in nature. Of course, there are differences in taste and in beauty, but these differences are not absolute. Thus the taste for painting is distinct from the taste for music, and the visual beauty of the one is distinct from the auditory beauty of the other, yet this distinctness, which no aesthetic theory can ignore, is no bar to the discovery of similar conditions upon which the two arts depend for their hedonic and formal values. It is the function of a comprehensive theory to formulate general principles applicable to all tastes for all manifestations of beauty and to all forms of beauty open to all tastes. All the arts and all the tastes for them, though distinct, are also cognate, and to reduce them to a common basis is the principal task of aesthetics. If you admit that aesthetics is preoccupied with taste and beauty in their universal aspects, differing minds exemplifying a generic *sense* of beauty, and differing objects a generic *character* of beauty, you must admit that the separation between art and nature forfeits its absoluteness. Although distinct,

nature and art are also comparable: they both possess in common *generic* traits of beauty which impinge upon a *generic* taste for beauty. Where, then, is the *indelible* line which aesthetics is bound to draw between facts and artifacts?

MEREDY: If aesthetics is a theory of hedonic experience, "hedonic" being one of our synonyms for "aesthetic," there is no line at all, delible or indelible, between facts and artifacts. *Immediate* enjoyment of beauty is the same whether the beauty enjoyed is that of nature or of art. As long as we limit the word "aesthetic" to the quality of pleasure or delight accompanying the perception of a beautiful object, we need not accentuate the difference between a natural phenomenon and a human handiwork; but in limiting it thus, we must distinguish enjoyment from knowledge, for if knowledge is intrinsic and not adventitious to enjoyment, enjoyment of a natural product can obviously not be the same thing as enjoyment of an artistic product. Facts and artifacts are indeed "coequal" if we identify aesthetic experience with pleasurable feeling, varying in kind and intensity in accordance with the taste of the individual. Here we seem to be in perfect agreement: art and nature cannot be contrasted in terms of the affective states of mind resulting from their perception. And if aesthetics is a theory of the beautiful, another of our synonyms for the adjective "aesthetic," the contrast between facts and artifacts may likewise be disregarded; for beauty is beauty of form, and form may be studied in abstraction from its specific content and in independence of its particular genesis. The beautiful in its objective

manifestations, reducible to formal elements and formal relations, is the same whether existent in nature or existent in art. General principles of beauty, which aesthetics seeks to formulate, are applicable alike to facts and artifacts. Here again my agreement with you is complete, so much so that I may buttress it by a fanciful hypothesis. Suppose there were no art at all, but only nature. Imagine a world so constructed as to preclude the creation of artifacts. Could aesthetics flourish in such a world? The answer is, of course, Yes. Men might construct an aesthetics of nature, dealing with hedonic experience governed by taste and with forms of beauty subject to analysis and description. There would always be the glories of sky and earth, and the pleasure or delight that men take in them. And even aesthetic judgments would not be impossible—that is, valuation or appraisal of degrees of taste and of grades of beauty. How, then, does aesthetics of art differ from aesthetics of nature? Is art but a reduplication of nature? Does art but add to the surplusage of enjoyment afforded by the redundancy of nature's pleasing configurations and designs? Art would be superfluous if its sole purpose were to create beautiful things for the satisfaction of our hedonic needs. These needs are abundantly met by nature—by all the perfumes and colors of flowers, by all the shapes of mountains and patterns of clouds, by the prospects of the boundless seas and the vistas of the star-studded heavens, by the melodies of autumn breezes and summer brooks, by the stillness or murmur of forests, by

> All vital things that wake to bring
> News of birds and blossoming.

No, art cannot compete with the plethora of nature's splendors. What function pertains to art that is a function not appropriate to nature? As soon as this crucial question is reflectively raised, the radical difference between facts and artifacts comes into full view; for of art alone can we significantly ask whether pleasure is its sole aim, and, if so, what kind of pleasure its creation is intent upon. Pleasure varies in quality. We cannot demand of nature that it minister to higher rather than lower pleasures. What sort of joy we derive from the formations of nature depends altogether on our sensitivity and taste. Although this is true also in relation to artifacts, when we take the standpoint of individual "consumers," criticism of works of art has primary reference to the sensitivity and taste of their "producers." There are products of art the titillations of which are cheap and tawdry, and for these we censure the artists. Art criticism is ultimately criticism of artists; for art has a mission, and if this mission is to dispense pleasure—and I am far from saying that this is its only mission,—criticism is called upon to pass judgment on the quality of pleasure which an artist's artifact is designed to induce in us. There are qualities of pleasure "objectified," as it were, in works of art which judicious criticism may pronounce to be coarse or fine, shallow or profound, sordid or noble. The dispensation of pleasure as the *deliberate* function of art is a sufficient basis for the contrast between facts and artifacts. But art is more than a dispensary of pleasure; when deeply conceived and expressed, art is a messenger of the spirit, a vehicle of human faiths and hopes, a servant of humane ideals

and aspirations. We find in art and not in nature a sum-
mary and vindication of the great ends of civilization;
and these ends condition the standards by which criticism
is guided in its valuation of art, assuming as it must that
significant art is created by minds for the elevation of
minds. The statement that art exists for its own sake is
meaningless; if art is to be justified, it must be justified
for the sake of the things which men supremely cherish as
men. Critical valuation of art is inseparable from cultural
justification of it. Nature needs no justification and is thus
not amenable to genuine criticism. But art is justifiable
only when art is "good," the task of adjudging its "good-
ness" devolving upon aesthetic criticism, which is at the
same time a criticism of life. Here, my dear Hardith, is
the incontestable reason for drawing an "indelible" line
between facts and artifacts: nature cannot be justified, but
art must be justified.

HARDITH: What you say, and you say it with impressive
rhetoric, follows from that method which a modern phi-
losopher has called the "method of partition." To this
method you are peculiarly addicted. How great in your
view is the separation of art from nature! A bifurcation so
extreme leaves no room for general aesthetics. You are led
astray by your penchant for sharpening relative distinc-
tions into absolute antitheses. There are many differences
between facts and artifacts which aesthetics should take
cognizance of, but they fall (as the logicians say) within
the same "universe of discourse." Our discourse is about
aesthetics and not about ethics or metaphysics. The differ-
ence between nature and art such as a moralist or a phi-

losopher would dwell upon is here irrelevant. When you speak of the justification of art, a justification not pertinent to nature, your language is hortatory and doctrinaire. You employ, if you don't mind my saying so, the vernacular of the preacher rather than the idiom of the critic. For criticism, viewed in a strict sense, "good" and "bad" are categories limited chiefly to taste and beauty: there is perfect taste and there is imperfect taste, perfect beauty and imperfect beauty. And with degrees of perfection, whether of taste or of beauty, aesthetic criticism is primarily concerned. "Criticism of life" is a didactic exercise in which neither creators nor judges of art should be overtly engaged. Why burden aesthetic criticism, which is complicated enough, with problems extraneous to it?

MEREDY: I note with amusement that you are making use of the same "method of partition" which you accuse me of resorting to. Does the autonomy of aesthetics require its complete insulation from morality and philosophy? You have run away from one sort of antithesis only to run into another. You assimilate nature and art in behalf of aesthetic interests, but you consider these interests as exclusive and divorced from all other human interests. Is this not jumping out of the frying pan into the fire? The method of partition is unavoidable and unexceptionable. One can escape one partition by substituting for it another, as you have done; or one may aspire to a synthesis of all partitions, as some philosophers have attempted, but attempted in vain. Some partitions will always remain: the partitions between the physical and the nonphysical, the living and the nonliving, the human and the nonhuman, the measur-

able and the immeasurable, the actual and the possible, the possible and the impossible. But I do not wish to weary you with speculations for which you pretend to have neither head nor stomach. My own pet partition between facts and artifacts, though defensible on philosophic grounds, I defend entirely in relation to aesthetics when this discipline, reaching the level of full-fledged criticism, becomes normative instead of descriptive. This partition is implicit in your own felicitous distinction between "consumers" and "producers" of beauty. Let me repeat: if we approach beauty with reference to its "consumption," we are under no necessity of dividing facts from artifacts; nature and art are "coequal" in their modes of operation upon sensitivity and feeling. It is only in relation to the "production" of beauty that the dichotomy of nature and art becomes imperative; the beauty of nature is a gift of the gods, the beauty of art is a creation of men. What the gods give us is deeply unintelligible: we do not know by what means and for what ends beauty appears in nature. The artifacts that men create, upon which they lavish their love and skill, owe their beauty to definite methods of construction. Human handiworks have their genesis in conscious adaptation of means to ends and in deliberate execution of previsioned plans. Criticism of artifacts is valuation not only of their beauty as perceived and felt, but also of their beauty as conceived and expressed. The beauty of art, unlike the beauty of nature, has an intelligible form and an intelligible significance because it is born of the known creative power of men who infuse into what they create differing technical proficiency and vary-

ing spiritual aim. Criticism of art is thus ultimately criticism of its producers: it is valuation of the craftsmanship and the culture which their works make manifest. In other words, art is a specific *practice* the results of which are subject to judgments concerning excellence of performance and relevance to human civilization. The works of nature, not being achieved by artistry in behalf of human interests, are beyond good and evil, as these pregnant categories apply to the handiworks of artists. You have reproved me, Hardith, for talking like a preacher, so you will not object to my quoting Scripture. "Render to Caesar the things that are Caesar's, and to God the things that are God's." Yes, Hardith, the beauty of things made by men has its birth and consummation in passions and ideals; to the beauty of things displayed in nature, desire has lent no impetus and purpose has given no significance. Art and nature, though comparable, are, strictly speaking, incommensurable.

HARDITH: Our prolix discussion has yielded some fruitful results. We are in essential agreement that there is no rift between art and nature if we look upon their forms from the standpoint of "consumers." Their surface beauty, so to speak, is open to hedonic perceptions, and as purely hedonic these perceptions are "coequal." Descriptive aesthetics embraces both facts and artifacts, since it is concerned with the formal beauty they have in common, and with the degrees of joy felt in the presence of all beautiful things. You even admit my contention that aesthetic judgment has equal relevance to nature and to art so long as the judgment is restricted to valuation of the grades of

surface beauty and to the grades of individual taste. If we
could but stop here our differences would be only differ-
ences in emphasis. Our disagreement begins when, going
behind the surface forms of things to their modes of for-
mation, you exchange the interest of the "consumers" of
beauty for that of its "producers." You insist on a critical
or normative aesthetics applicable solely to the taste req-
uisite for the creation of beauty, and since nature has no
taste, taste being a human propensity or acquirement,
nature defies criticism. And criticism of nature becomes
all the more impertinent if, besides being valuation of
creative taste, criticism is also valuation of artistic crafts-
manship and cultural import; for, unlike works of art,
works of nature are neither fruitions of technical skill nor
reflections of a state of civilization. Hence the antithesis of
nature and art. I confess that you have made out a strong
case for their antithesis within the narrow limits of your
special theory of aesthetics. Granted that criticism of art
as art is literally inapplicable to nature. Does this fact out-
weigh the unity of nature and art which a more general
aesthetics would tend to emphasize? I look upon unity as
more fundamental than difference. It is possible that in
doing so I am only yielding to a congenital bias. Francis
Bacon observes, in one of his aphorisms, that "some minds
are stronger and apter to mark the differences of things,
others to mark their resemblances. The steady and acute
mind can fix its contemplations and dwell and fasten on
the subtlest distinctions: the lofty and discursive mind
recognizes and puts together the finest and most general
resemblances." Yes, Meredy, you are certainly gifted with

a "steady and acute mind," and your vision is sharpened
to discern everywhere diversity and contrast; my mind is
more "synoptic," and I have an eye for likeness and anal-
ogy. You are struck, for example, by the Biblical opposi-
tion of God and Caesar; I should attempt to overcome the
opposition either by deifying Caesar or by humanizing
God. And so with nature and art: with your bent of mind
you are predisposed to accentuate their contrast; my bias
leads me to lay stress upon their similitude. Come, Mer-
edy, let us be honest with each other; let us acknowledge
that our intellectual dispute disguises but thinly the clash
of our temperaments.

MEREDY: I do not deny that arguments are often colored by
the temperaments of those who advance them. Neverthe-
less, some arguments are more plausible or more tenable
than others. The dictum that all opinion or belief is a
matter of personal bias is an affront to reason and an invi-
tation to skepticism. We are too much in earnest about our
different persuasions to look upon them merely as expres-
sions of idiosyncrasy. Our debate would be futile if it
were but a clever exercise in matching prejudices. At the
beginning of our debate you wisely invoked an imaginary
judge; in doing so, you assumed that an impartial verdict
could be rendered concerning the claims to validity made
by both of us for our respective views. Which of our two
views is the more valid? I am willing to leave the decision
to a fair-minded arbiter who, instead of delving into our
temperaments, would scrupulously balance our arguments.

V

Art and Morality

HARDITH: I have known you for a long time, Meredy, and familiarity with your subtle mind has not diminished my admiration for it. You have much to say on many things, and you always say it with force and clarity. But my own mind, which is less acute and more pedestrian, cannot often accommodate itself to your love of paradox and your penchant for dialectic. I am apt to take distinctions at their face value, and am reluctant to push an argument to extreme lengths. You puzzle me when you erect barriers between distinctions until they become antitheses, and when you pursue an argument with such uncompromising logic that all good sense seems to go by the board. Our minds being what they are, no wonder our conversations have tended to be diffuse and inconclusive.

MEREDY: You are running counter to your own temper of mind in accentuating so sharply the difference between us. It is true that we don't approach all subjects from the same point of view, and that our ideas are often at loggerheads. But we are frequently also in substantial agreement. Conversations would be tedious and unprofitable if carried on for the sake of reaching complete unanimity. There are moot questions, especially in aesthetics, concerning

which reasonable men are entitled to hold different opinions. Some of our opposite notions are complementary rather than antithetical. And a discussion is inevitably prolix if its aim is to move slowly from point to point, to keep arguments alive by continual challenge and criticism, to develop fully the implications of crucial issues, and to draw clearly the lines between possible agreements and ineluctable disagreements. Yet a conversation involving a free trade in ideas need not be inconclusive: a candid exchange of opinions may culminate in their mutual enrichment. By being matched or opposed, thoughts may grow in meaning and gain in significance. And perhaps the most important consideration is this. We may apply to our controversies about art what David Hume said concerning polemics in religion, namely, that "reasonable men may be allowed to differ, where no one can reasonably be positive." Come, Hardith, unburden your soul and tell me what opinions of mine make you strike so discouraging a note.

HARDITH: I am not only discouraged, I am bewildered. I do not understand how you can reconcile your view of aesthetic experience with your view of artistic creation. The distinction between art as experience and art as creation you turn into a separation. When you speak of art in relation to experience you speak as a hedonist: you identify aesthetic values with hedonic values, the ultimate basis of aesthetic judgments being sensuous pleasure and emotional satisfaction. Thus no work of art can be deemed "good" if it fails to delight or to charm the mind. And since everyone knows when he is delighted or charmed

by a work of art, everyone is virtually an art critic. If criticism of art is nothing else than valuation of it in terms of personal enjoyment—and personal enjoyment differs in different individuals,—there are no standards governing aesthetic judgments, for no man can cede his judgment to the judgment of another, the judgment of each being a law unto itself. *Laissez faire* in aesthetic judgments, everyone being free to criticize a work of art on the basis of the pleasure he derives from its contemplation, is a direct consequence of your hedonistic theory of aesthetic experience. But you are not consistent in your hedonism; you are willing to maintain that the chief end of art is to give pleasure. When you speak of art, in relation not to its perception but to its production, you speak as a moralist: you demand of art that it be more than a dispensary of pleasure. You abandon hedonism altogether when you assign to art a lofty mission, the mission of being, as you expressed it in an earlier conversation, "a messenger of the spirit, a vehicle of human faiths and hopes, a servant of humane ideals and aspirations." Art, you said, needs justification, and you justify it in ethical terms. You insist that great artists be also great men, celebrating and vindicating through their works the highest interests of civilization. Good art is thus art which enhances human life and enriches human culture. The epithet "good" as applied to art is, therefore, essentially equivocal: good art must be at once pleasing and ennobling. The judgment that it is pleasing is immediate; the judgment that it is ennobling, reflective. The immediate judgment has reference to *felt* values; the reflective judgment, to *intended* values. Hence

the double task of the professional critic: in his valuation
of a work of art he must assume the point of view both of
the aesthetic "patient" and of the artistic "agent." What
is central to the one is pleasurable perception, but what
is fundamental to the other is creative purpose. Conse-
quently, the appraisal of the hedonic effects supervening
upon contemplation of art is on a different plane of criti-
cism from the appraisal of the intent that inspired and
guided its creation. And this intent, you hold, must be
amenable to moral standards if art is to be considered as
contributing its increment to the growth of human culture.
What, then, is the ultimate aim of art? Is it to afford pleas-
ure, or is it to minister to the good life? I repeat that you
are both a hedonist and a moralist: you are the one when
you take up the cudgels in behalf of the "consumers" of
art, and the other when you criticize its "producers." And
the sense in which you can be both baffles me exceedingly.

MEREDY: You have broached a topic of perennial contro-
versy. The problem of the distinction and the relation
between art and morality is a difficult one. Here if any-
where we must employ our terms with scrupulous care.
Art and morality are mutually exclusive only if we take
these terms, as you put it, at their face value. If art signifies
the application of taste and skill to the production of
beauty in any material or medium, and if morality is a
name for rules of rectitude or virtue needed for the con-
duct of life, then the difference between them is indeed
obvious. The artist is a creator of beauty to be enjoyed;
the moralist, a teacher of precepts to be followed in indi-
vidual and social behavior. On this view, moral art con-

stitutes a particular species, commonly called didactic,
not autonomous but ancillary to the customs or practices
of a given group or a given age. Of course, I do not demand
that art to be moral should be didactic, that its deliberate
aim should be to offer instruction regarding formation of
character or choice of action. Nevertheless, I cannot rest
content with the usual dichotomy between art and moral-
ity; upon a deeper analysis, they prove to be allied rather
than antagonistic. The deeper analysis I have in mind pre-
supposes the contrast between art as experience and art
as creation, or, as you have phrased it so neatly, between
the aesthetic patient and the artistic agent. Yes, Hardith,
we are all patients in the presence of art, suffering it to
impinge upon our senses and to play upon our emotions;
the agents are not we, but the artists who, in fashioning
their works, breathe into them their souls and suffuse them
with their ideals. We are moved and *affected* by what
artists have so painstakingly *effected*. I may indicate what
I mean more clearly by the contrast between impression
and expression. To perceive a work of art is to receive
sundry impressions radiating or emanating from its sen-
suous qualities and formal relations, and these impres-
sions are either enjoyed or not enjoyed; but to create a
work of art is to express through these qualities and rela-
tions some vision or mood or passion or interest, and what
is thus expressed may be deemed significant or meaning-
less, important or trivial. Even the kind of art called "im-
pressionism" has to be expressed in a particular medium,
through a definite technique, and for the sake of producing
a desired effect. The impressions embodied in an "impres-

sionistic" picture or a musical composition are the feelings of an artist "recalled in moments of tranquillity"; subsequently shaped and ordered, these felt impressions find their expression in and through a created artifact. And if of the expressed impressions of an artist we say that they are without significance, what we mean is that they signify nothing else than fugitive sensations or floating images gathered together in retrospect by a sensitive mind and preserved for posterity in an appropriate form. Yes, all impressionism is expression when seen from the point of view of the artistic agent, and all expressionism is impression when looked at from the standpoint of the aesthetic patient. But I do not wish to quarrel over words coined by sectarian artists and critics in behalf of their windy doctrines. Whatever words we use, we must never lose sight of the difference between a *state* of experience and an *act* of creation. The experience called "aesthetic" is a state of mind characterized by pleasure or delight felt with varying degrees of intensity in the immediate presence of a natural fact or an artifact. The creation called "artistic" is labor of skillful craftsmanship exerted in the formation of some material under the guidance and control of some purpose. Valuation of the "aesthetic" aspect of a work of art requires reference to the state of mind engendered in those who contemplate it; valuation of the "artistic" merit of a work of art demands criticism of the technical proficiency and the intended aim of its creator. Thus aesthetic valuation is "hedonistic" and artistic valuation "moral"; the category of pleasure is ultimate for the one and the category of purpose pertinent only to the other. But the

two kinds of valuation, as I am prepared to show, are complementary rather than antithetical.

HARDITH: Pardon me for interrupting you. Before you go much farther, I must interject a comment here. I see, of course, what you are driving at. By preëmpting the category of pleasure for aesthetic experience and the category of purpose for artistic creation, you provide a double basis for the valuation of art. Pleasure is one thing, and purpose quite another. Art, you insist, must give pleasure to those who contemplate it; if it fails to do so, then, from the point of view of the aesthetic patient, art certainly fails of its purpose. The aesthetic patient alone, it seems, can afford to be a hedonist; he alone is free to look upon pleasure as an end in itself, and upon art as the means of its gratification. You will recall your defense of "aesthetic freedom," the freedom of everyone to judge a work of art, not on its merits, but solely with reference to its mode of operation upon his senses and feelings, his lack of knowledge of its mode of construction not precluding knowledge of what he likes, and what he likes being ultimate and impervious to criticism. Hence your doctrine of *laissez faire* in aesthetic judgments. But you will not allow the artistic agent to be a hedonist. When you approach art from the standpoint of those who create it, you are unwilling to define its purpose in terms of pleasure. You repudiate the principle of *laissez faire* in relation to artists, questioning *their* liberty to produce what *they* like. You want artists to be spokesmen of civilization, apostles of culture, lovers of the good life. You demand of their works that they dispense sweetness and light. You hold artists morally re-

sponsible for what they achieve as if their creations were
to be inspired by a consciousness of duty. This conscious-
ness, alien to aesthetic experience, becomes essential for
artistic creation. There is, of course, no obligation to enjoy
a given artifact, but in fashioning it the artificer *ought* to
be governed by a high sense of his mission, the mission of
using his art as a vehicle for the civilized or cultural values
of mankind. Now I do not deny that many artists have this
exalted conception of their office. But do the creations of
artists forfeit significance unless they are incarnations
of a moral conscience? Must a painting or a symphony be
deemed great only if it is an expression of what ethical
teachers glorify as the good life? Here is where I demur.
The moral purport of art is not its main purpose; this is,
as it were, but one of its by-products. None but didactic
art owes its origin and meaning to a moral purpose. Your
fundamental mistake is to suppose that, because the pro-
duction of art is governed by purpose, the purpose govern-
ing it must be ultimately ethical. Yet you confer upon the
aesthetic patient the right to judge a work of art in hedo-
nistic terms as if its sole purpose were to afford him pleas-
ure. Why not say that this is precisely the purpose of the
artistic agent? To dispense pleasure is the final aim of his
creation. Besides, in making pleasure the key to aesthetic
experience, you forget that the pleasure of artistic creation
is one of its mainsprings. There is joy or delight in paint-
ing a picture or composing a symphony. To the artist, too,
may be extended the privilege of being a hedonist: he
works for his own pleasure (the pleasure of creation) as
well as for the pleasure of others (the pleasure of those

contemplating the created products). The phrase "art for art's sake," which you have often satirized, is simply an elliptical declaration of independence from moral hegemony. Substitute for it "art for pleasure's sake," and you have a forthright avowal of consistent hedonism. The attitude toward art "for pleasure's sake" is the legitimate attitude of the aesthetic patient. This you frankly concede. In the last analysis, it is also the legitimate attitude of the artistic agent, if the autonomy of art is to be properly safeguarded.

MEREDY: Far be it from me to dispute the fact that pleasure is an ingredient in artistic creation. In the exercise of their creative powers most artists certainly rejoice. Yet, art is born of the pains as well as the joys of labor. Great artists speak more often of the pangs than of the raptures attending the birth of their masterpieces, and to say that the throes of creation are pleasurable is like saying, as certain philosophers have done, that evil is a part of the good. At any rate, the pleasure of artistic creation, however intense, is but incidental and secondary, whereas for aesthetic perception pleasure is essential and primary. Remove from the perception of art its hedonic quality, and the perception ceases to be aesthetic. Artistic activity, on the other hand, may not be accompanied by pleasure at all, and if it is thus accompanied, the accompaniment is not so integral to it as it is to aesthetic contemplation. Moreover, is the pleasure of creation of the same kind as the pleasure of perception? The question is crucial. If we grant that art exists "for pleasure's sake," whose pleasure is to serve as criterion, the pleasure of the artist or the pleasure of the

spectator? Of the pleasure of creation the spectator can have no inkling: his pleasure is but passive or quiescent. The joy of producing a work of art is markedly different from the joy felt in seeing or hearing it. Beethoven, for example, may have had much pleasure in writing his Ninth Symphony, but alas, his deafness prevented him from sharing the pleasure of the audience; and even if he could have heard his own music, his creative enjoyment and his auditory enjoyment would have been dissimilar in kind. Yes, Hardith, the pleasure of the artistic agent and the pleasure of the aesthetic patient are not comparable in quality, and if pleasure for the sake of which art is said to exist is that of the artist, it is a pleasure to which the spectator is a stranger. And can it be said that a great masterpiece, such as the Ninth Symphony, is nothing but "objectified pleasure" (as an eminent philosopher has defined beauty), that its form and its structure are simply the expression of the creative joy of the artist? Beethoven's symphony, we know, is the embodiment of purpose that is essentially spiritual or moral. And this is true of any other significant work of art.

HARDITH: I am aware that pleasure varies in kind, and that active pleasure differs from passive pleasure. But pleasurable action and pleasurable passion, though distinct in quality, are complementary. That they are mutually implicative, each requisite for the other, is pregnantly illustrated by the psychology of love. And the illustration is not inapposite, for the Muses and Eros have been friends of old, bound each to each by natural sympathy. The predilection of artists for erotic subjects, though a perennial

scandal to the moralists, is conspicuous; and lovers may draw from art ultimate sanction for their sweet dreams and ecstatic triumphs. Yes, there is a deep affinity between art and love. As the lover's pleasure has its complement in the pleasure felt by the beloved, the distinctive experience of each enhancing that of the other, so the pleasurable action of the artist finds its counterpart in the pleasurable reaction of the spectator, a work of art being indeed "objectified pleasure"; but the pleasure it objectifies is artistic as well as aesthetic. The work of art, which is the result of pleasurable creation, becomes the source of pleasurable perception; the creative action which it embodies induces a specific reaction, action and reaction having as concomitants particular qualities of delight. So, when you ask me whether pleasurable action or pleasurable reaction is the standard for a hedonistic theory of art, my answer is that action and reaction are not alternatives, but correlatives. As in love, so in art, the pleasure of the agent and the pleasure of the patient are related reciprocally; the work of art disseminates delight because delight attended its production; and with the artist's joy of creation is mingled the correlative joy which he anticipates that others will experience from the fulfillment of his creative effort. Unalloyed pleasure, without admixture of moral purpose, is thus the essence of art as it is the essence of love, a pleasure at once divided and shared, and the hedonic experience called "active" and the hedonic experience called "passive" depend upon each other for their complete fruition.

MEREDY: The analogy between art and love is a seductive one. I once played with the notion, under the influence of

psychoanalysis, that a common craving or *libido* is the inspiration of both love and art. But I have long since abandoned such fanciful speculations. Against the comparison between love and art there are at least two serious objections. In the first place, love is a relation between persons, and even if we reduce love to pleasure, the pleasure of the lover and the pleasure of the beloved are in direct communion, the experience of one being immediately shared with that of the other. In art the relation between agent and patient is not intimate; the pleasure of each is felt independently, prompted, as it is, not by a person but by a thing. An artist's handiwork is the sole source of pleasure: its production occasions one kind of delight and its contemplation quite another, and between these two kinds of delight there is no immediate and reciprocal influence. The artist is concerned chiefly with the creation of his artifact, all his attention and effort being lavished upon it, and whatever joy he derives from the act of creation, the joy is complete without reference to the joy the artifact may give to others; conversely, the spectator's senses and feelings are excited mainly by the artifact, and the joy involved in its perception is a self-sufficient one, upon which the artist's joy in its production has no bearing. After all, love is a partnership, lovers seeking and finding pleasure in each other; in art, agent and patient are strangers, and their pleasure is not a consequence of their actual union. So even if we justify both love and art "for pleasure's sake," the pleasure in the one case supervenes upon the relation between persons, and in the other is felt only in relation to an intermediary

object. Where, then, is the analogy between love and art? In the second place, the analogy breaks down if the hedonistic view of love and art is seriously challenged. Do we understand the full meaning of love by equating it with pleasure? Can psychology or psychoanalysis completely explain that universal experience? The roots of love are biological, and its efflorescence is spiritual. Not for pleasure's sake but for the sake of life does love endure, for love is a condition for the survival of the race, and is also the basis for a complete marriage of souls through which men and women achieve a fusion of interests, a concord of sentiments, a harmony of aspirations. Yes, there is a purpose in love to which delight is ancillary, and this purpose is at once natural and moral. The natural purpose of love has to do with the reproduction of the species, the moral with the consummation of a significant form of cohabitancy, namely, men and women living together, bound by mutual amity, sympathy, and tolerance. And what may be said of art in comparison with love? It is true, of course, that art, like love, exists for the sake of life, but life understood in a spiritual rather than in a biological sense. Not upon art does the continuity of the species depend. Our race is beholden for its survival to lovers and not to artists. Life could go on without art, though it would be a life denuded of charm and grace, but universal cessation of love would be followed by life's extinction. Love has a biological importance to which art cannot lay claim, and this fact weakens the force of their analogy. If there is an analogy between them, it can be expressed only in terms of moral values. Love, besides being requisite for

the survival of the race, is also a condition for its spiritual elevation. Love, though it has an animal basis, is humane in objective: those who have yielded to its bonds may rise to a level of life governed by friendship, confidence, generosity, and loyalty. It is indeed the ultimate civilizer, softening and refining our natural harshness and grossness, and liberating and fostering our latent kindness and tenderness. And such an ultimate civilizer is also art. Its mission, too, is to nourish what is humane in human life, and to celebrate through works of beauty those mental dispositions by which pure love is sustained. The names for these dispositions are ancient and honorable. They are faith, hope, and charity—faith in our potential goodness, hope that our baser impulses may be subdued, and charity in the face of our follies and foibles. Without these spiritual propensities love is but lust and art an idle pastime. Great art is analogous to perfect love in the sense that it aspires to raise man from savagery, and it is this aspiration, transcending hedonism, which lends moral dignity to artistic creation. An artist, when the creative impulse stirs within him, does not say to himself, "I shall follow this impulse because its gratification will give me pleasure." Could such hedonism account for the afflatus of artistic genius—that of a Michelangelo, a Shakespeare, a Beethoven? No, the great artist does not work for pleasure: he creates because some significant theme or subject enthralls his imagination and cries out for expression in a significant way and for a significant end. The joy of creation is incidental to his main purpose to embody in his chosen form a momentous aspect of life or a universal

quality of experience. Hedonism is incompatible alike
with the higher reaches of art and the deeper manifesta-
tions of love. Only they extol pleasure as an end in itself
who are self-indulgent as lovers or as artists. It is true,
however, that pleasure is primary and ultimate for aes-
thetic contemplation; here hedonism is triumphant. In
perceiving an artifact, the spectator does not declare:
"Here is a creation that exalts my spirit because it epito-
mizes an artist's impassioned vision of the eternal values."
After profound study of a work of art truly great he may
indeed arrive at such a judgment. But his immediate or
purely "aesthetic" reaction to it, if expressed at all, would
be worded thus: "I like it, I enjoy it; I feel in its presence
sensuous delight and emotional satisfaction." Hedonism,
in short, is indeed valid when confined to the analysis of
the perception of art; it is not adequate in relation to the
production of art.

HARDITH: Any analogy if pressed too hard becomes absurd.
It was far from my intention to carry the comparison be-
tween love and art to extreme lengths. I am aware, of course,
that love has a biological aspect absent from art, and that
spiritual influences radiate from both. The analogy sug-
gested is a limited one, referring merely to the hedonic
states of mind to which love and art give rise. Who can
deny the experienced pleasure of lovers? Whatever be its
purpose, the pleasure felt by lovers is felt by them as an
end desired for its own sake; and though erotic pleasure
is necessary for the fulfillment of other ends, it has a value
independent of them. Similarly, whatever the purpose
that art may be said to serve, prior to the purpose is the

pleasure experienced in its conception and perception. Although pleasure is not descriptive or explanatory of all that love or art signifies, without pleasure love would be the mating of automata and art the drudgery of mechanics. If I justify love and art "for pleasure's sake," the justification is but psychological, in the sense that the emotional satisfaction afforded by erotic and artistic experience is felt by those who undergo the experience as possessing an intrinsic worth. I do not know what love and art would mean if their votaries were disembodied spirits, but for lovers and artists of flesh and blood, pleasure will always appear as desirable for its own sake and not for the sake of anything else.

MEREDY: If you descend to the psychological level, as I do also, but only with respect to "aesthetic" values, your argument is not implausible. "Gefühl ist alles," as Goethe said in one of his moods. Yes, for the aesthetic patient, the feeling of pleasure seems to be everything. The pleasure he derives from a work of art is the only standard he has for its immediate valuation. No object can be called aesthetic if it fails to evoke a direct hedonic response. This I take to be axiomatic. But when you extend hedonism to the creation of art, I object, not only because artistic production is too complex to be brought under its principles, but mainly because the pleasure of creating and the pleasure of perceiving beauty are incommensurable feelings. I must remind you that you have not met my point regarding the differences between these two kinds of feeling. And unlike love, art provides no basis for the intimate and reciprocal relation between pleasurable action and pleasurable reaction.

HARDITH: If the analogy between art and love demands that
correlative feelings of pleasure be always mutual, then
the analogy is obviously invalid. But the absence of direct
mutuality, which I grant in the case of art, is not impor-
tant. What is important is the fact that the creation of the
artist, which embodies or "objectifies" his active pleasure,
is the condition for the receptive or responsive pleasure
of the spectator. I am willing, however, to abandon the
illustration from love, since you find it impertinent. Per-
mit me to offer another and less objectionable example.
Consider any game; football, let us say. Here is a grand
spectacle composed of agents and patients. The pleasure
of watching the game is not the same as the pleasure of
playing it. Yet different as these two pleasures are, they
are correlative and equally essential. And the sole justi-
fication of the game is a hedonistic one: football does not
open or awaken the mind to moral or spiritual issues; its
purpose is not to spread sweetness and light; its aim is not
to present a criticism of life and an interpretation of its
destiny. The spectators enjoy the game simply because
watching it is attended by sensuous and emotional excite-
ment, and the more they understand the technique of the
game, the greater and richer the enjoyment. Their pleas-
ure, though receptive, is manifest by its vociferousness.
And the pleasure of the players, if not so vocal, is equally
acute, the pleasure they are chiefly intent upon being
dynamic pleasure, the pleasure of action. Yes, there are
subsidiary motives actuating them, such as ambition to
excel, desire for acclaim and renown, love of prowess,
loyalty to the group, but the driving force is sheer delight

in strenuous and skillful sportsmanship. Here literally the play is the thing, a thing of "objectified" pleasure, active pleasure serving as the occasion for passive pleasure, and the two correlative pleasures constitute the sum and substance of the game. Now I submit that art bears a striking resemblance to sport. Art, like sport, serves no moral interests; indeed, art provides a haven of refuge from the importunities of the "good life," an escape from the commands of duty, that "Stern Daughter of the Voice of God," using her "rod to check the erring and reprove." Nor are the pleasure of the artistic agent and the pleasure of the aesthetic patient mutually exclusive. The artist, who experiences the joy of creation, derives pleasure from perceiving his own finished work, thus partaking of the pleasure which others feel in its presence; and these others, though their own pleasure is passive, may appreciate imaginatively the creative delight of the artist. Pleasurable action and pleasurable reaction, in art as in sport, require no moral sanctions. They are ends in themselves: the pleasurableness of each is its only excuse and final reward.

MEREDY: You amaze me, Hardith. So art resembles sport in being practiced for the sake of pleasure, in complete detachment from moral values! Does not such a view of art detract from the seriousness of it? Think of a Dante or a Bach bent upon sportive fun in the exercise of his genius! After all, as compared with art, sport belongs to the lighter side of life, demanding little exertion of the higher mental faculties. Yet your comparison is not inept if art and sport are considered merely from the standpoint

of the spectators. Neither group of "patients" can help
being hedonists: an athletic or artistic production must
give them pleasure to engross their interest, and failure
to excite their pleasure is tantamount to a forfeit of its
value. From the point of view of the "agents," however,
no matter how pleasurable the activity, some standard
other than pleasure determines the value of an art or a
sport. Even in a sport what is at stake is not just the pleas-
ure of the players, but the excellence of the game, to be
played in accordance with fair rules, and played to win
with honor and distinction. The term "sportsmanship"
denotes a moral ideal, involving as it does fidelity to
prescribed norms, aspiration after superb performance,
self-discipline in losing with good grace. There are pan-
egyrists of sport who justify it as the moral equivalent of
war; for sport releases energies in behalf of the heroic
virtues, eliciting valor and fortitude, magnanimity in
victory and resignation in defeat. Our perfect athletes
are our "happy warriors"; as the exemplars of the martial
spirit not bent upon cruelty and destruction they are the
true friends of civilization. Devotees of sport, the agents
ardently engaged in it, are not idle pleasure seekers; if
they were they would leave the field, as spectators often
do, when fatigue or satiety precludes further gratification
of their delight. What keeps them at work—for their play
is labor—is a sense of obligation to exert all their powers,
often to the breaking point, in order that the game be
judged as one consummate of its kind, redounding to their
glory and to the glory of the institution they represent. If
morality is not alien to sport, can it be said that morality

is foreign to art? Unlike sport, art is the deepest expression of the human spirit, reflecting in its masterpieces men's noblest dreams and visions; the mirror which the masterpieces of art hold up is not to nature but to mankind in perpetual search for indefectible goodness, beauty, and truth. Yes, our greatest artists are also our greatest men, who labor at their art to bring something perfect into the world which is not only a thing of joy but also an image of the heart's invincible desire.

HARDITH: I should be foolish to deny that there is a moral side to sport and sportsmanship. But this side is just a side issue, so to speak, which you treat as if it were the main issue. In the economy of human culture, sport has an intrinsic worth, and the standards of sportsmanship are dictated by certain conventions in conformity to which a game must be played if the pleasurable end it serves is to be attained. It would amuse players of football to hear your eulogy of them: they do not look upon themselves as pseudo-soldiers waging a mock war to provide a moral channel for the fighting instincts of mankind. No, their motives are not essentially moral; what incites them to play is chiefly the impulse to engage in an exhilarating activity. Clean sportsmanship is part of the game; to win unfairly or to loose boorishly "just isn't cricket." The purpose of the code by which sportsmen are guided is to promote not the interests of the good life, but the interests of good sport; the code, which lends significance to the game, defines the requisite conditions under which prowess and skill are to be exercised, their codified exercise alone being the source of supreme pleasure alike to

players and spectators. What is or what is not "cricket"
is primarily an athletic and not an ethical question. Even
a solitary game of cards is based upon a self-imposed
code of honor. The player may, and occasionally does,
cheat to his heart's content. If he refrains from cheating,
it is not because he fears detection or because his con-
science disapproves of deception. Is a man guilty of moral
turpitude if he actually enjoys playing a little confidence
game with himself? We should call the swindle merely
absurd, exemplifying an idiot's delight. Even children,
whose moral sense is still inchoate, insist on honorable
conduct in the playing of their games, precisely because
the pleasure derived from the games is conditioned upon
faithful observance of definite rules. The very desire for
pleasure for the sake of which a game is played dictates
compulsion to play it in accordance with prescribed stand-
ards, the standards being framed not as a tribute to virtue,
but rather, if I may so so, as the price of virtuosity. In
short, when we play a game we are engaged in a pleasur-
able activity, and requisite for its pleasurableness is vol-
untary submission to those formalized conditions which
are epitomized under the word "sportsmanship." Now
just such a pleasurable activity is artistic creation, and the
pleasurableness of its exercise depends upon deliberate
obedience to exacting standards, scrupulous craftsman-
ship being analogous to punctilious sportsmanship. The
difficulty of an art, like the difficulty of a sport, contributes
to its value; the more difficult it is, the greater the joy in
its achievement. The artist rejoices in giving definite form
to a recalcitrant material by the use of a special technique

or a particular style. He glories in producing something
perfect, not in spite of the limitations of his chosen me-
dium or his chosen method, but because of them. May I
quote Wordsworth? You know, of course, his two sonnets
in praise of the Sonnet:

I

Nuns fret not at their convent's narrow room,
And hermits are contented with their cells,
And students with their pensive citadels;
Maids at the wheel, the weaver at his loom,
Sit blithe and happy; bees that soar for bloom,
High as the highest Peak of Furness-fells,
Will murmur by the hour in foxglove bells;
In truth the prison unto which we doom
Ourselves no prison is: and hence for me,
In sundry moods, 'twas pastime to be bound
Within the Sonnet's scanty plot of ground;
Pleased if some souls (for such there needs must be)
Who have felt the weight of too much liberty,
Should find brief solace there, as I have found.

II

Scorn not the Sonnet; Critic, you have frown'd,
Mindless of its just honours; with this key
Shakespeare unlock'd his heart; the melody
Of this small lute gave ease to Petrarch's wound;
A thousand times this pipe did Tasso sound;
With it Camöens sooth'd an exile's grief;
The Sonnet glitter'd a gay myrtle leaf
Amid the cypress with which Dante crown'd
His visionary brow: a glow-worm lamp,
It cheer'd mild Spenser, call'd from Faery-land
To struggle through dark ways; and when a damp
Fell round the path of Milton, in his hand
The Thing became a trumpet; whence he blew
Soul-animating strains—alas, too few!

What unexampled delight an artist must experience in embodying within the confines of a sonnet or a fugue a rich and harmonious concatenation of images or themes! How complete must be his joy in making a canvas or stone the vehicle of a fervent vision or mood! We significantly speak of a *work* of art; it is indeed the fruition of the most painstaking labor, but it is the labor of love. Moral considerations are as extraneous to art as they are adventitious to sport. Artists and sportsmen are, indeed, governed by standards, but these standards are standards of excellence, and in excellence of performance under arduous conditions lies their deepest pleasure.

MEREDY: You have a curious conception of pleasure. Can assiduous labor be called pleasurable, and is felt pleasure subject to standards other than itself? Onerous activity is often fraught with pain; and if excellence of performance is a criterion, it is a criterion not purely hedonistic. The critic of an art or a sport judges excellence without regard to pleasure, for excellence is manifest in objective form, and pleasure is a state of mind; if he speaks of pleasure, the pleasure implied is his own and that of other spectators. To make everything subservient to pleasure, including desire for perfection and the effort requisite for its attainment, is to carry hedonism to absurd lengths. True artists and good sportsmen are perfectionists rather than hedonists: the aim of their endeavor is indeed the achievement of excellence, and this achievement involves struggle, application, and discipline. I repeat that the only hedonists are the spectators, whether of art or of sport. They toil not, neither do they spin; their pleasure is caused by the exer-

tion of others, the display or the result of this exertion
being the object of their hedonic experience. Yes, art
or sport is "objectified pleasure" when viewed from the
standpoint of spectators; looked at from the point of view
of artists or players, an art or a sport is rather "objectified
effort." As far as spectators are concerned, the criterion
of hedonism is ultimate; the passive enjoyment of an art
or a sport serves no extraneous interest or distant aim. It
is foolish to demand a purpose for immediate pleasure
beyond the gratification of it. But human action is not
usually regarded as an end in itself, and some ulterior
object is thus required to give it impetus and direction.
Why should men run and not be weary, walk and not be
faint? Artists and sportsmen are exemplars of the strenuous
life; they are so resolute in spending their powers. Hard-
ships do not dishearten them, nor do obstacles turn them
aside. Why so much labor and strain? For what purpose
such voluntary zeal and perseverance? To account for all
this in hedonistic terms, we must maintain one of two
extravagant theses, either that artists and sportsmen work
for their own pleasure, or that they work for the pleasure
of others. The first thesis involves an absurd attenuation
of hedonism: if artists and sportsmen are intent upon their
selfish pleasure, then they must find pleasurable what we
ordinarily experience as unpleasant and often painful,
such as travail of soul or body, fear of failure, severe
self-discipline, discouraging lassitude or fatigue. No less
absurd is the second thesis. Are artists and sportsmen
fatuous altruists, using their gifts and skills to dispense
pleasure to their fellow men? The hedonistic explana-

tion that art or sport exists for pleasure's sake leads to a dilemma: if artistic or athletic activity is itself pleasurable, then all the pains attending its exercise become constituents of pleasure, and this is a paradox; and if the pleasure for the sake of which this activity is justified is not the pleasure of the "agents," but that of the "patients," then artists and sportsmen exert themselves benevolently to satisfy the hedonic needs of others, and this too is an anomaly. On which horn of the dilemma do you choose to be impaled? Can you seriously contend that artistic or athletic activity is either purely pleasurable or purely altruistic? Now I want to give hedonism its due: pleasure is indefeasible for contemplation of art or sport, there being no imperative compelling the contemplation; and if a man enjoys what he contemplates, his enjoyment is an experience valued for its own sake. No man is deterred by any scruple from turning his back on a work of art or an athletic game if its contemplation induces boredom or vexation. Where is the obligation to like a given thing, and has it the power to arouse delight where none is felt? Not of pleasure, but of work, may conscientiousness be legitimately demanded. Artists and sportsmen are not heedless of scruples—scruples of method, of technique, of style, of intent,—striving as they do to conform to the most exacting standards of excellence. I am, of course, not speaking of tyros and dabblers whose interest is sporadic and whose zeal is intermittent. The masters and votaries of an art or a sport are imbued with a "professional conscience," so to speak, an inner compulsion to put into their work all the skill they possess, a goading

impulse to approximate perfection in their achievements,
a spirit of devotion to a task worthy of their pains. You are
so concerned about the autonomy of art—and this is the
reason why you liken it to a sport—that you fail to recog-
nize its moral aspect, and when this aspect is forced upon
your attention, you include it within a strained conception
of pleasure, not seeing that the criterion of hedonism,
appropriate for passive spectators, is inapplicable either
to creative artists or to busy athletes.

HARDITH: You are accusing me of straining the notion of
pleasure and of bringing within its scope artistic creation.
Do you recall the declaration of Wordsworth that "there
is a pleasure in poetic pains which only poets know"?
With pleasurable pains, those epicene feelings which you
call paradoxical, creative artists, it would seem, are quite
familiar. Of course, if pleasure is but momentary pleas-
ure, pleasure felt at each moment of a continuous activity,
then artistic creation, which is admittedly a long and
arduous process, may indeed contain instants of experi-
ence not separately felt as pleasurable. Who can deny
this? But why should pleasure be a feeling narrowed down
to the immediate present? Even the aesthetic patient, the
spectator of an art, if the art is sufficiently complex, such
as a painting on a large canvas or a symphony of extended
duration, may find that his continuous contemplation of
it is not a continuity of pleasurable or equally pleasur-
able moments. And this is true also of the contemplation
of an athletic game; spread out over a period of time, the
contemplation has moments in it of flagging interest, low
intensity, and downright weariness. Yet we do not hesitate

to describe the contemplation of art or sport as "hedonic"; we mean by its pleasurableness the fact that the experience as a whole is exciting and satisfying. The term "pleasure" need not necessarily connote an experience which is either instantaneous or enduring without change of quality or intensity. The synonym for pleasure, in its wider meaning, including alteration or alternation of feelings, is the word "happiness." A happy experience is not confined to the immediate present, nor does it in its total duration exclude moments felt separately as disagreeable or unpleasant. Happiness, taken as a totality of diversified sensations and feelings, is characteristic not only of aesthetic contemplation but also of artistic creation. The analogy between art and sport must not be pressed too hard. Art is a creative activity, and sport a recreational one. And many values intrinsic to each defy comparison. If I look upon them as analogous, it is only with respect to their independence of moral ideas and precepts. The activity of sportsmen is spontaneous, not prompted by a sense of duty, a consciousness of benevolence, a passion for justice, a desire for social reform. This activity is truly an end in itself, the only justification and reward of it consisting in the happiness that comes from its skillful performance and successful consummation. I conceive of artistic activity in a similar fashion: it is free and exhilarating. The hardships it entails are willingly accepted, and the moments of exertion, some of which fraught with pain, find their sublimation, as it were, in the ecstatic happiness of creation. Happiness of creation, to which works of art owe their inception and completion, requires

no moral incentive or moral sanction. The analogy be-
tween art and sport remains unexceptionable; neither
artists nor sportsmen are moral agents or moral teachers.
One must have a strange and sweeping notion of morality
to bring art and sport under its auspices and jurisdiction.
MEREDY: How clever of you, Hardith, to pay me back in my
own coin! You meet the charge that you have a strained idea
of pleasure with the retort that my conception of morality
is sweeping. It is true, of course, that both pleasure and
morality must be broadened to explain in their terms the
nature of artistic creation. If pleasure is but pleasure of
the moment, hedonism thus narrowly conceived is mani-
festly inapplicable to artistic creation, so you speak not
of the pleasure but of the happiness of creation, happiness
being a name for a complex and prolonged experience,
including changing and shifting affective states. And if
morality signifies specific injunctions and imperatives for
human behavior, only that art which is undisguisedly
didactic can be called moral, and my opinion of that sort
of art does not differ from yours. Let us admit that a jejune
moralism, as well as a superficial hedonism, is inapposite
to art. It is preposterous to demand that the morality of
art be judged in accordance with the Ten Commandments
or the Golden Rule. Why should morality be preëmpted
for the hortatory dicta of a special dispensation? In a uni-
versal and profound sense, morality is a name for a well-
ordered life, a life that exemplifies wholeness, integrity,
and coherence. In its natural or nonmoral state, life is full
of sound and fury, subject to the chaos of desires and the
strife of passions, at the mercy of immediate pleasures

and pains, governed by capricious appetites and wayward
impulses, no controlling purpose giving form and direc-
tion to its diverse interests. Natural life, however, is sim-
ply the raw material for the good life, for out of this
material may be fashioned civilized individuals and civil-
ized societies. In the last analysis, morality is synonymous
with civilization, presupposing as it does an original state
of nature susceptible of conscious transformation. And
what is artistic activity if not creative transformation of
natural material? What the artist does is not to create a
new nature. He creates a new dimension of nature, as it
were, by forcing the facts of nature to echo or to image
his own visions and passions. Yes, there is a deep affinity
between morality and art. The moral life is comparable
to a work of art, involving purposive transformation of
human nature in behalf of humane ideals; and a work of
art, if intentionally created to celebrate these ideals, is
an adumbration, in a sensuous medium and imaginative
form, of the essence and spirit of the moral life. Where,
then, is the antithesis between morality and art? They are
opposed only if all morality is identified with casuistry
and all art with aestheticism. Great art draws its greatness
alike from beauty and from goodness, but goodness un-
derstood as embracing all those noble aspirations to
which humanity is beholden for its spiritual perfectibil-
ity. These aspirations, in the words of Tennyson, are "the
great world's altar-stairs, / That slope through darkness
up to God." The masterpieces of art are such "altar-stairs"
wrought for the elevation, yes, for the salvation, of man-
kind.

HARDITH: Your rhetoric, Meredy, is admirable, but alas, it
is only rhetoric. Your enlarged notion of morality runs
counter to usage. You identify morality with civilization,
but civilization is a complex term; it covers various forms
of human culture, diverging in accordance with historical
circumstances. One nation's god is another nation's devil.
Who can dispute the fact that at different times and in dif-
ferent places different men have erected different "altar-
stairs" for their spiritual ascent to their different heavens?
Each age has its special Jacob's ladder; and in each par-
ticular culture, to quote Emerson,

> The word unto the prophet spoken,
> Was writ on tables yet unbroken.

Where, I ask you, do you find moral unanimity among the
impassioned artists of the world? No, the genius of art and
of morality is not the same. I am a plain man, and I take
morality in a plain sense. Morality has to do with the
mores of a given group in a given age: it prescribes rules
of rectitude and virtue to be followed in daily conduct in
the interest of the good life, the good life being conceived
as rooted in tradition and as embodied in prevailing laws
and institutions. Moral judgments are primarily judg-
ments of approval or disapproval regarding human char-
acter or human action in accordance with persuasions
fixed by custom and fostered by instruction. The demand
that moral judgments be applied to works of art is tanta-
mount to the demand that they be approved or disapproved
with reference to the opinions of decency and propriety
which happen to be endemic in a particular society.

Should artists be required to glorify in their works the accepted mores of their nation or their age? Should they be intent upon edification or propaganda? By surrendering artistic creation to moral judgments you open the floodgates of fanaticism and bigotry. You evade this danger by a singular subterfuge; morality, you say, should not mean what it ordinarily does mean. After all, morality does denote the preceptive customs and laws of a people rather than the lofty aspirations and spiritual ambitions of all mankind. Here, it seems to me, you abandon not only usage but also argument. Your peculiar conception of morality can provide no valid standard of judgment, for spiritual values, as I have said, are many and conflicting, there being no work of art of which approbation is general and complete. What is spiritually significant to some men may be regarded by others as downright revolting. You cannot defend your view of morality as a criterion of art unless you are prepared to show that there is a hierarchy of moral values, and that the greatest works of art are symbols or compendia of the highest of these values. Could such a hierarchy be established, and would it commend itself as universal? Hedonism, in divorcing art from morality, is on firmer ground. Pleasure is human just because it is natural. All art has its inception in the natural joy of creation and finds its complement in the natural delight of contemplation. Hedonism applies its principle alike to agent and patient, thus bridging the gap between artistic production and aesthetic perception. And if the word "pleasure" be deemed objectionable because it may erroneously connote a momentary state of mind,

the production as well as the perception of art not being
a uniformly pleasurable experience, hedonism offers the
more comprehensive word "happiness," not as an alterna-
tive to pleasure, but as a legitimate extension of it. For
happiness is a synonym of pleasure characteristic of a
continuing experience in which the successive moments
may fluctuate in quality and intensity. In making happi-
ness the measure of art, hedonism does not revoke its
cardinal principle; the happy experience, whether crea-
tive or contemplative, though not evenly pleasurable when
analyzed into the individual instants during which it en-
dures, is nevertheless a sustained experience of feelings,
the pleasurableness of which is pervasive and cumulative.
A happy state of mind is always a composite of different
pleasurable feelings; the feelings immediately present are
enriched by those remembered and suffused with those
anticipated. But if morality be taken as the measure of art,
a quite different situation ensues. The escape from didac-
ticism is possible only by making morality assume an
unwonted meaning, a meaning which is not an enlarge-
ment or extension of the familiar one but an alternative or
a substitute for it. The moral standards you invoke for
judging artistic creation are not such as govern human
comportment in a particular community; they are spir-
itual aspirations after human perfectibility. Between these
two kinds of standards there is no necessary or intimate
relation: prescriptive or proscriptive rules of behavior
may be spiritually corrosive, and universal ideals of
spiritual growth may be subversive of the established
mores. The advantage of hedonism over moralism is obvi-

ous: hedonism has but one standard for judging artistic creation, and that standard is pleasure broadly conceived as happiness.

MEREDY: I do not wish to be captious, and I am disposed to accept your comprehensive conception of hedonism if it is made to apply solely to aesthetic perception. Yes, the word "happiness" is sufficiently elastic to cover the variety of feelings which protracted contemplation of a great work of art engenders. It is strange but not inappropriate to speak of an aesthetic experience as a happy one. To be sure, certain works of art, notably those dealing with tragic themes, induce sorrow, pity, and fear, and to describe as "happy" the experience of these and similar emotions does not exactly accord with usage, by which you set so much store. Yet, if beauty is "objectified pleasure" viewed from the standpoint of the aesthetic patient, the total experience of a beautiful thing, including such isolated moments as are not felt to be pleasurable, may indeed be called a happy experience, just as a beautiful thing often contains features which, though themselves ugly, enhance its beauty when seen in organic relation to the whole. But admitting for the sake of argument that the experience of artistic creation is an equally happy one, is this experienced happiness an adequate criterion for determining the greatness of a work of art? Do we judge a work of art as exemplary simply because the artist derived happiness from its construction? Can we establish any correlation at all between the value of an artistic creation and the state of mind of its creator? The subjective standard of happiness, necessary and sufficient for aesthetic perception, is

neither necessary nor sufficient for artistic production.
There must be objective standards if the line is to be drawn
between superior and inferior production. Now one such
objective standard is technical, and the other moral. I am
concerned at present not with the technique of art, with
art as a craft, but with the content of art, with art as ex-
pression. Craftsmanship has to do with means, not with
ends, involving the question *how* rather than *why* art is
created. What is the purpose of which a work of art is the
expression? Is artistic creation nothing else than the em-
bodiment of its creator's joyful activity? If I insist upon
describing my criterion for art as "moral," it is because
no other word so clearly conveys earnestness of intent and
dignity of aim. Great art incarnates in beautiful form
momentous intuitions of human destiny. I am well aware
that the intuitions commonly called moral are local or
temporary, relative to a given culture, and mistaken by
their protagonists as fixed and absolute. But even these
intuitions, when expressed by men of genius, assume a
significance transcending their sectarian or provincial
character. In genuine masterpieces the prevalent mores
of a people reflect its fundamental ethos, symbolizing
values universal in import and universal in appeal. Think
of ancient art and think of medieval art; and think, for
example, of the Greek tragedies and the Christian cathe-
drals. Consider the highest creative achievements in most
of the arts among all the civilized nations; if dated and
characteristic, as they cannot help being, they are also
timeless and catholic. The supreme creations of all the
ages, though they manifest a particular ethos in the choice

of themes or symbols, ideas or images, forms or styles, reveal nevertheless men's essential and typical humanity, and men everywhere, widely separated by different cultural boundaries, may recognize the authenticity of the revelation. From these creations, in spite of their difference in national origin or social context, emanate kindred visions and kindred passions; the radiance they shed is on life as it might be lived or should be lived under the benign influences of love and beauty, justice and truth. All great art affirms and exalts those universal ideals in the realization of which consists man's spiritual vocation. The "classics," so called because by consentient criticism they have become the archetypes of supreme art, constitute the ultimate bases of judgment, and new artistic creations deserve the epithet "great" only if in formal beauty and moral content they emulate these extant and treasured models of perfection. Inferior art is art inferior to these perfect models, when, as compared with them, it exhibits but beauty of surface, or formal patterns or structures without moral significance, or when the morality it enshrines is merely tribal or parochial. For measuring artistic greatness we must invoke the standards set by the world's masterpieces, which have been acclaimed masterpieces because they are works of consecration to perfect beauty as well as to perfect goodness. Yes, Hardith, my conception of morality, far from being extraneous to art, is one derived from its consummate expressions. The hedonistic thesis that art is inspired by a craving for happiness may be true of its lower but not of its higher manifestations.

HARDITH: As you well know, Meredy, I am not at all a hedonist, if a hedonist is one who lives or glorifies the life of a voluptuary. I have defended hedonism in terms of happiness—and happiness is compatible with all the refined, yes, with all the spiritual, joys—as a possible theory that might serve as a basis for safeguarding the autonomy of artistic creation. To make art subservient to morality is to deprive it of its freedom and independence. You are partial to the word "morality" on account of its connotation of seriousness and sobriety; I find the word distasteful because of its odor of sanctity and suggestion of prudery. How notorious are the offenses committed against art in the name of morality! On the behalf of morality, art is often stifled by censorship or forced to conform to smug respectability. Even your civilized view of morality does not preclude suppression of the arts. Let us not forget the austere Plato, who rejoiced in the banishment of the poets from his ideal Republic. He was the enemy of all artists save those willing to lend their talents to the purposes of propaganda, their sole function being to buttress through wholesome imagery the official doctrines and policies of the State. My defense of hedonism against you and Plato, though a deliberate *jeu d'esprit,* is a covert attack upon every form of Grundyism and comstockery. Because I have the deepest reverence for art, I must rebel against any attempt to set decorous limits to its expressions. Away with the figleaf! Fie upon every shameful device to make art palatable to the virtuous and the sanctimonious! I want artists to enjoy complete liberty of creation, not for the purpose of fostering the good life, but for the sake of pro-

ducing good art, as good art is conceived by its expert
votaries and competent critics. What more needs to be
demanded of good art than that it give us

> More joy to sing and be less sad,
> More heart to play and grow more glad?

You have no scruples in suffering the aesthetic patient to
be a hedonist, his freedom to judge a work of art in terms
of pleasure being indefeasible; but the artistic agent, you
insist, must forswear hedonism. An artifact, though in-
ducing pleasure, may not be induced by pleasure; it can
achieve greatness only if the artist's impulse to create is
a moral impulse. Why this stark antithesis between the per-
ception and the production of art? You should renounce
hedonism altogether, denying that pleasure is basic to
aesthetic experience, or you should accept my expanded
theory of hedonism, deriving art from the happiness of
creation. If I were a philosopher, I might be tempted to
challenge the contrast between pleasure and morality.
Must we conceive of all pleasure as immoral, and of all
morality as joyless? Are we obliged to acquiesce in the
choking dogmas of a sour or stern puritanism? But we are
not bound by these dogmas: in advancing a spiritual con-
ception of morality you speak as a liberal, and my view
of pleasure as happiness is not that of a libertine. No,
Meredy, happiness and spirituality are not necessarily
opposites. The deepest spiritual life is a blissful one;
even the saints in heaven are said to enjoy eternal felicity.
Why not admit that the happiest condition of life is also
the most spiritual? To experience delight and diffuse it,

to seek and to share blessedness, is perhaps the highest
aim of man, and in the service of this aim lies the jus-
tification, not only of all art, but also of all science, all
religion, all government. The quest for happiness is a
universal and spiritual quest, and though the happiness
sought differs in quality and intensity, it is ultimately the
only valid standard for measuring all human aspirations
and achievements, the greatest happiness to the greatest
number being the supreme ideal. But let philosophers
wrangle over the meaning of morality or spirituality, and
let them settle the question of its relation to human happi-
ness. As for me, I still contend that artists as a class are
not interested in saving souls or reforming the world. They
are sensitive, imaginative, passionate; their artistic im-
pulse is free and spontaneous, stirred by love of beauty
and sustained by the pleasure of creation. And what artists
produce, embodying their taste, their feeling, their power,
their skill, may become a thing of joy forever, an object
of ineffable delight, but also, alas, an object of moral criti-
cism for those who ascribe to art the lofty mission of re-
generating mankind.

MEREDY: Ah, Hardith, what superb eloquence and irony!
How strong is your zeal to bolster the shaky tower of ivory
in which you would establish the artists! I have suspected
from the beginning that your hedonism was but a mask
for your old belief in "art for art's sake." Your reverence
for art is tantamount to idolatry. You grasp at any theory
that would permit you to worship the artist as if he were
a sort of demiurge intent upon nothing but the exhilarating
exercise of his creative power. The issue between us is

clear: you confer upon the artistic impulse an absolute
and I only a relative autonomy; you value artistic creativ-
ity as an end in itself, and I in relation to the whole of life.
Hence your tendency to view art as analogous to love and
sport; each is said to aim at the gratification of pleasure,
and the pleasure which each affords, alike to agents and
patients, is supposed to be sought for its own sake, in com-
plete freedom and independence from moral purposes.
Who can deny that many artists, like so many lovers and
sportsmen, are bent upon pleasure; that they are imbued
with the desire not only to seek but to share happiness? My
chief point is—how often must I repeat this?—that these
are not the great artists. The greatest of them would re-
pudiate hedonism, the theory that a craving for pleasure
is the mainspring of their creative endeavor. Their master-
pieces, they would insist, are impelled by a deeper pas-
sion, the passion to enlighten, yes, to regenerate, mankind.
Let me reiterate that I speak not of every artist, but of
the greatest only, and in imputing to them a moral pur-
pose I honor them more truly than you do. The reverence
due to art is reverence for a responsible vocation charged
with an important mission. The mission of art is not unlike
the missions of religion and philosophy, and art often
surpasses them in clarity and wisdom. Yes, Hardith, our
greatest artists are our greatest teachers. Through crea-
tions of indefectible beauty they proclaim their fervid
devotion to the enduring ideals worthy of human alle-
giance, vindicating triumphantly the unflagging striving
of man's unconquerable soul. The images they create,
though contributing to the adornment of life, are intima-

tions of objects fit for our adoration. After all, pleasure is not a fixed aim that can be pursued directly; being a congeries of sensations and feelings, pleasure may attend the pursuit of any end; but the profoundest happiness might well be the reward of the aspiration after those things of the spirit by which alone men could rise to ever higher levels of moral excellence or perfection.

VI

The Paradox of Tragedy

HARDITH: I owe you an apology, Meredy. In much of what
I said in the course of our last conversation I was not alto-
gether candid. My belief in the autonomy of art remains
indeed unshaken, and I still insist that artistic creation is
not amenable to moral judgments; but the argument in
which I couched my defense of artistic freedom was a de-
liberate *tour de force*. I was rash in yielding to the tempta-
tion of emulating your manner of reasoning, seeking to
be ingenious rather than ingenuous. And since I do not
possess your subtlety of mind, the conclusion I reached
was lame if not impotent. In feigning to be a hedonist, I
made extreme statements upon which you could easily
direct the shafts of your dialectic. My simulation of hedon-
ism was transparent and lacking in verisimilitude. Al-
though it served the purpose of clarifying some of the
issues concerning the relation of morality to art, our dis-
cussion ended abruptly and in a sort of *impasse*, each of us
maintaining and retaining a partial point of view. Today
I will be true to my character, advancing only such ideas
as I can defend with honest conviction.

MEREDY: You underestimate your histrionic powers, my
dear Hardith. I truly admire the skill with which you

championed a doctrine not your own. The case for hedonism could not have been presented with more eloquence or with greater persuasiveness. You imparted to hedonism a fresh cogency. And you strengthened my view that pleasure is ultimate for aesthetic experience. Yes, hedonism is indefeasibly valid in relation to the perception of art. I opposed you only when you played with the notion that artistic creation must be likewise interpreted in terms of pleasure.

HARDITH: I am glad to know that in your estimation my *jeu d'esprit* was not entirely inept. The aim of my hedonistic pose was simply to force you to be consistent. If pleasure is a principle requisite for explaining the contemplation of art, why is it insufficient to explain its creation? But in reviewing in my mind the hedonistic position, I came to doubt its adequacy to aesthetic as well as to creative experience. We are in the habit of speaking of art inclusively, of art in general, forgetting that no theory, however plausible, can apply equally to all the arts. Is it true to say that the perception of every artistic creation is invariably the reception from it of certain hedonic impressions, and is it reasonable to assert that, if beauty is pleasure objectified, the pleasure is not only the spectator's but also the artist's? To be sure, illustrations are not wanting—indeed, are easily chosen at random—to bolster the hedonistic hypothesis: many works of art owe their being to the sheer joy of creation, and their sole purpose is to serve as objects of a delight desired for its own sake or as an end in itself. Who can deny this? But these examples, be they ever so numerous, are no warrant for the thesis that pleasure is

the origin and aim of all art. There are other examples, and crucial ones, to which a hedonistic theory is not apposite. Certain works of art, because of their profundity or complexity, cannot be accounted for in terms of pleasure either with respect to their inception or with respect to their appeal.

MEREDY: With half of your contention I am, of course, in complete agreement. Hedonism is manifestly inadequate for the explanation of art viewed in its creative aspect. The great artists, though pleasure givers, are not pleasure seekers; they are perfectionists rather than hedonists, exercising their creative powers to construct beautiful and expressive objects, beautiful in formal structure and expressive of some impassioned vision or momentous intuition. This, as you will recall, I attempted to show in our previous discussion. But the other half of your argument, namely, that aesthetic experience, the perception of a beautiful object, is not generally pleasurable, I must reject. The pleasurableness of an aesthetic experience is its chief if not its sole characteristic. Of what object of beauty is contemplation unattended by pleasure?

HARDITH: There is one of the arts of which the experience, though undeniably aesthetic, is not essentially pleasurable. The art I have in mind is that of tragedy. If the contemplation of tragedy is said to give pleasure, what kind of pleasure is it? It is certainly not a pleasant pleasure. To speak of an "unpleasant pleasure" is to utter a paradox. All the synonyms of pleasure—delight, delectation, gladness, joy—suggest congeries of agreeable sensations and feelings. Indeed, most of the pleasures we seek are those

that supervene upon gratification of desire, and the experience of satisfied desire is normally one of positive contentment. Such, for example, are the familiar pleasures of daily life—the pleasures of food and drink, of love and sport. Literary expressions of hedonism abound in many images, typifying characteristic objects of desire the attainment of which is assumed to afford unalloyed happiness. Whatever images poets employ in praise of hedonism, they all evoke premonitions of sensuous and emotional satisfactions which the enjoyment of the imaged objects entails. And if aesthetic experience is spoken of as pleasurable, its pleasurableness must be cognate with the sort of experience upon which hedonism lays stress, an experience susceptible of varying degrees of pleasantness, the highest degree culminating in rapture or ecstasy. No doubt, the perception of many works of art is "hedonic" in the pleasant sense of the term. When we consider tragedy, however, we must either abandon hedonism altogether or radically alter its ordinary meaning. For the content of a tragedy, Greek or modern, is hardly one that we should single out as an object of pleasant contemplation, involving as it does conflict, misery, torment, and defeat. The "hero" of a tragedy, owing to his character or circumstances, brings destruction upon himself and others. He is the vehicle and instrument of misfortune; his action, leading to his doom, is represented as necessary and inevitable. And we, the spectators, witness the unfolding of a plot in which human beings struggle in vain to arrest the inexorable march of events and to avert the imminence of a predestined catastrophe. If we speak of

"tragic pleasure," the pleasure occasioned by the contemplation of tragedy, is it pleasure in the familiar sense of the word? Do we take delight in suffering and pain? Are we happy in the presence of sin and crime? Can we rejoice in affliction and death? Tragedy is a paradox if pathos, which is its essence, is said to be the cause of pleasure.

MEREDY: Whatever paradox tragedy implies, the paradox is not an aesthetic one. You seem to forget that tragedy is an art, and that we enjoy pathetic situations not in their literal but in their literary manifestations. The same situations, not conveyed through an imaginative medium or form, would indeed arouse horror. If, for example, we reduce the plot of *Hamlet* to a bare recital of facts, and a recital in the vocabulary of the marketplace, would it not become a sordid tale of crime and punishment, inspiring aversion and repugnance? Our newspapers almost daily contain reports of monstrous deeds in which but a mind justly described as pathological could find a modicum of pleasure. What delights us in Shakespeare's tragedy is not the hideous subject matter but the charm of its presentation—the noble diction, the skillful characterization, the imaginative power, the dramatic development, the moral dignity, the poetic justice, the profound wisdom, the universal truth. In a word, *Hamlet* is a thing of beauty, and therefore a joy forever. "Tragic pleasure" is of course an ellipsis for the phrase "pleasure taken in that *genre* of dramatic art which has the form of tragedy." In this elliptical manner we might speak analogously of epic pleasure, symphonic pleasure, pictorial pleasure, statuary pleasure. It is not pleasure which is lyric or elegiac, comic or tragic;

these and other adjectives denote different kinds of art inducing hedonic responses appropriate to them. And the more generalized expression "aesthetic experience," under which we epitomize the pleasurable reaction to each and every art, is likewise elliptical: an experience is aesthetic when a feeling of pleasure is felt in the presence of a natural or artistic object possessing formal or expressive beauty. Pleasure is the genus of which aesthetic pleasure is a species, varying in quality and intensity in accordance with the differences of its stimuli. When we describe pleasure by a certain adjective, such as musical or graphic, what we do is specify some organ upon the stimulation of which the feeling of delight ensues, or some object capable of arousing and sustaining it. Indeed, there is no other way of describing pleasure; for pleasure, like its opposite, pain, is indefinable. The description of pleasure in terms of the organic and objective conditions requisite for its experience presupposes the indescribable experience itself, the immediate quality and intensity of which must be felt by each individual *in propria persona*. The word "pleasure" would mean nothing at all to a man whose physical and mental constitution precluded the experience of this feeling, and no description could bring it within his ken. Tragic pleasure, therefore, is no misnomer, but the term is intelligible only to those who feel this pleasure. Many aver that they do have a feeling for it. It is a pleasure following upon the stimulation of sense and imagination by the beauty of a specific mode of art, cognate with the experience produced by any and every beautiful object. Where, then, is the aesthetic paradox of tragedy?

HARDITH: I grant, of course, that pleasure is not susceptible of exact definition, and that the argument for its experience is ultimately an argument *ad hominem*. Yet it would be foolish to speak of pleasure if its experience were altogether ineffable. We indicate our experienced feelings in sundry ways, words and gestures being the means we rely upon for the communication not only of pleasure but of all personal experience. But I do not wish to be sidetracked by the abstruse subtleties of the philosophers. If we assume the standpoint of common sense, we understand quite well what we mean by an agreeable state of mind, following upon certain occasions and prompted by them, in distinction from a state of mind marked by distress or suffering. Some stimuli we receive with indifference, others with aversion or relish. We turn away from the things that displease and welcome those that please us. The feelings that accompany certain sensations and perceptions, ranging from acute anguish to consummate joy, are thus no mysterious facts: everyone knows what is meant, for example, by suffering the pain of intense heat or enjoying the pleasure of savory food. And when, according to hedonism, all values are said to have reference to the avoidance of pain and the search for pleasure, the pain and the pleasure evoked are those elemental and elementary states of mind with which all of us are familiar. In making central the ultimate value of pleasure, absence of pain being an integral aspect of it, a hedonistic theory of life is indeed plausible, but only of life at its sensuous or animal level. As biological organisms, we are so constituted that our sensations and perceptions have their appropriate affective

concomitants. Now if hedonism is extended to include the contemplation of art, the pleasantness of the contemplation must be like the pleasantness felt by any organism in relation to its environment, such as supervenes upon the excitement or stimulation of the senses, for this is the only kind of pleasantness that is general or pervasive and can thus serve as a standard for measuring the "hedonic" nature of aesthetic experience. I shall not deny the fact, if it is a fact, that the aesthetic experience of some individuals, in the presence of some works of art, may resemble in pleasantness the normal experience of tasting an orange, smelling a rose, seeing a rainbow, or hearing a meadowlark. Elements of such pleasantness are probably contained in anyone's aesthetic perception of any artistic creation, tragedy not excepted. What you call the charm of presentation of a pathetic theme is certainly a source of pleasure, and if its charm alone constituted tragic art no anomaly would pertain to it. But tragic art, however pleasing its form, is tragic on account of its subject matter, involving a fateful course of events precipitated by human action under the dominance of folly or vice. Characteristic of tragedy is the presentation of evil, and though its "unhappy ending" may be construed as insuring the ultimate triumph of the good, what chiefly moves and excites us is the havoc wrought by deeds irrational or ignoble. If the contemplation of evil as presented in tragedy is said to give pleasure, it must be a pleasure *sui generis,* one radically unlike the pleasant experience enjoyed in relation to the normal objects of sensuous desire. And if tragic pleasure resembles in pleasantness the standard pleasures

of hedonism, it will be thus felt only by minds essentially morbid. Is it compatible with sanity to take delight in the exhibition of misery and disaster?

MEREDY: Your contention would be sound if the evils exhibited in tragedy were drawn in photographic fashion from everyday life. Of course no sane person rejoices in actual misfortunes and calamities. Like the materials of any art, those of tragedy must undergo transformation to assume the aspect of beauty and thus to afford pleasure. While it is true that most of the arts are composed of materials which may be intrinsically beautiful or pleasing, the materials of tragedy are devoid of inherent pleasantness, if we mean by its materials not the musical words or the poetic images through which pathetic situations are conveyed, but the pathetic situations themselves. The content or theme of a tragedy, dealing as does with the baneful conduct of evildoers, must be presented as remote or ideal, though not lacking in verisimilitude, if it is to achieve the appropriate hedonic effect. To enjoy misfortune we must be able to contemplate it from afar; and what we enjoy is not misfortune for its own sake, but misfortune deeply and dramatically conceived. The vehicle of tragic art, as of any other art, must be *imaginative*, its particular medium being euphonious and emotive language in verse or prose; its subject matter, however, must be *imaginary*, in the sense that the characters and circumstances depicted are either fictitious or so distant in time and place as to appear virtually unreal. This synthesis of the imaginative and the imaginary is the essence of any of Shakespeare's tragedies; the evil which is the theme of *Othello* or *Macbeth*

has but a tenuous poignancy because it is only fancied, and the artistic sublimation of evil renders it safe for detached contemplation. We are bidden to witness a moral conflict of universal import, and because the conflict *is* universal the compassion and awe felt in its presence are purely impersonal. Hence tragic emotion is a complex of tension and relief: tension in the face of possible misfortune, and relief that the misfortune is not our own.

HARDITH: Yes, tragic emotion is profound as well as sublime. And compounded as it is of different feelings, this emotion cannot be reduced to the level of pleasure. How can we derive pleasure from the contemplation of evil? However imaginary its nature and imaginative its treatment, evil remains evil, perceived and felt as evil. No "artistic sublimation" of it can turn evil into its opposite. Your hedonistic view of tragic emotion implies that evil is not evil at all when presented through the medium of art. I know that certain philosophers have argued that evil is a part of the good, or even the good itself, but I could never make head or tail of their fanciful speculations.

MEREDY: Your fastidious refusal to go beyond the distinctions of common sense hampers your understanding of my argument. Good and evil, taken at their face value, appear indeed to be opposites, and so do pleasantness and unpleasantness. Thus you contend that if the evil depicted in tragedy is to be experienced as pleasant it must cease to be evil; or else, if the evil remains evil the emotion caused by its perception cannot be pleasurable. This is the dilemma with which you confront me. And in this dilemma you pretend to find the aesthetic paradox of tragedy. But

there is no dilemma, and hence no paradox, when good
and evil, as well as pleasantness and unpleasantness, are
viewed as inseparably mingled rather than as mutually
exclusive. In a mixture of contrasts consists the very es-
sence of tragedy. The ideal tragic hero, in virtue of the
grandeur of his consuming passion, instead of wreaking
destruction, might have served as the instrument of a benef-
icent purpose, for a consuming passion is not evil in itself,
but only in relation to what it is bent upon. The lethal
action in tragedy is the action of a strong character losing
balance under the stress of circumstances, a character both
admirable and culpable. A person utterly feeble or de-
praved is no tragic figure, nor is one who is enrolled among
martyrs and saints. Milton's Satan, for example, being a
fallen angel, is one of the greatest tragic heroes. And
Shakespeare's tragic personages—Timon, say, or Lear,
Macbeth, Othello, Antony,—though not Satanic in stature,
are generally conceived as superior individuals gone
astray. We lament the ruin of natures cast in a mold so
prodigious. But this lament is only a part of our aesthetic
response. Tragic emotion, like the spectacle that arouses
it, is also a fusion of contrasts. We feel repugnance and
sympathy, sadness and elation, grief and awe, "pathos"
being the summary name for these different and mixed
sentiments. And all our faculties are variously tinged and
suffused with this pathos—our senses, our imagination,
our reason. Yes, Hardith, tragic emotion, far from being
a paradox, is perhaps the most complete kind of aesthetic
experience, since it engages the whole mind and exempli-
fies a synthesis of contrary feelings.

HARDITH: I concur with most of what you say in praise of
tragic emotion. But I notice in your description of it a
studied avoidance of the word "pleasure." Is this a con-
cession to my point of view? In dispensing with the word,
however, you do not settle the matter. How pleasurable is
tragic emotion if by pleasurable we mean the same as
agreeable? This is the issue between us. And the issue is
important, involving as it does the adequacy of hedonism
to explain in its terms the aesthetic experience of tragedy.
My chief point is this: tragic emotion, though a blend of
many elements, some undeniably pleasurable, is not as a
whole a pleasant experience. By fusion, I take it, you do
not mean confusion; in the synthesis of an experience,
some elements will always predominate, and the dominat-
ing feelings in tragic experience are not such as would
ordinarily be described as "happy." In the presence of a
tragedy we are deeply moved and shaken; our minds are
swayed by sadness, sorrow, and grief. Are these the feel-
ings that commend themselves for their intrinsic pleasur-
ableness? And do they cease to be the feelings they are in
conjunction with others experienced as "hedonic"? Is
there anything joyous in pity and fear (to use Aristotle's
description of tragic emotion) when pity is felt for an-
other's misfortune and fear that the misfortune might be
ours? Pity and fear cannot be awakened save by what is
objectively pitiable and terrible, namely, the suffering of
men and their inevitable doom; and just as the pitiable
and the terrible are evil, which no dialectical alchemy can
transmute into the good, so the subjective feelings of pity
and fear are essentially unpleasant, often indeed quite

painful, and no theory of "catharsis" can make them pleasant. If we were consistent hedonists, shunning pain and intent upon pleasure, would we deliberately choose to undergo those perturbations of mind which are caused by things piteous and dreadful? And even if we grant the "purgative" effect of tragic art, in affording a pleasurable relief from the mental anguish it produces, would we not rather forego a pleasure that can supervene only upon pain? A sick man, for example, admittedly feels a certain kind of pleasure resulting from the curative action of a medicine that purges his body. Should we therefore court sickness in order to enjoy the pleasure of recovery? If the alleged "catharsis" characteristic of tragedy is a medical metaphor, is it not a curious hedonism that requires voluntary submission to pain for the sake of the pleasure attending its purgation? No, Meredy, in a world made up of hedonists tragedy would not be one of the flourishing arts; it would hardly occur to men concerned with their happiness to select the pathetic as a source of pleasure.

MEREDY: Your irony, though perhaps not intended, is superb, gaining appositeness from your perverse notion of hedonism. Are the pleasures countenanced by hedonism merely sensuous? There are pleasures of the mind as well as of the body. Tragic emotion *is* tragic pleasure; in using the two expressions as equivalent, far from avoiding the issue you raise, I am meeting it squarely. Aristotle, for whose philosophy you usually evince such partiality, speaks of the pleasure aroused by all the fine arts as "rational enjoyment." And this is particularly true of the art of tragedy: the delight it causes is elevated and refined,

and requisite for the experience of this delight is a mind capable of profound thought and sentiment. Not everyone enjoys tragedy, because not everyone can rise to the high level of contemplation which this art demands; for what we are made to witness is the collision of values and forces conceived as typical or universal, the operation of justice vindicating the dignity of laws deliberately challenged, and suffering and disaster on a grand scale. Our consciousness in the presence of events so grave becomes heightened and enlarged; we are imaginatively transported from the stage to the world and from individual selves to mankind. By this transference of consciousness we are induced to forget our own misfortunes and to gain a more intense awareness of a pervasive destiny. In this expanded vision we feel indeed pity and fear, but pity purified into glowing compassion and fear into reverential awe. Feelings are painful or pleasurable only in relation to the things to which they are attached, or, as Spinoza put it, happiness or unhappiness depend on the quality of the objects to which we are bound by love. By changing the quality of what is to be pitied and feared, pity and fear, without ceasing to be the feelings they are, may undergo purification or "catharsis." And when pity and fear are experienced in connection with the ideal and noble themes of a tragic poet, they are not only purged of ordinary unpleasantness, but become transformed into ecstatic emotions. Commensurate with the exalted subject matter of tragic art is the exalted mood it engenders, and this exaltation of mood gradually swelling into spiritual exultation is what I mean by tragic pleasure.

HARDITH: Your description of tragic emotion as an exalted
mood growing exultant is a beautiful piece of condensa-
tion, and I am not disposed to find fault with it. But I still
demur when you identify tragic emotion with pleasure.
If my notion of hedonism is narrow or strict, yours is too
loose and sweeping. Everyone, according to you, is a he-
donist, and a hedonist *malgré lui,* who is in pursuit of
objects the attainment of which would give him the deepest
spiritual satisfaction. You mention Spinoza. Does it make
sense to speak of this saintly thinker, a man inebriated
with God, as a "pleasure seeker" because he found bless-
edness in his love for a thing eternal and infinite? The
mystic or stoic, as we know, is intent upon "purging" his
mind of its ordinary commotions in order to achieve a
rapturous intuition or a serene vision of the nature of
things. Is the mystic or the stoic a "pleasure seeker"?
When men glorify, in religious or secular expressions,
those things of the spirit consecration to which affords
true felicity, do they glorify the life of pleasure? The he-
donist, in the accepted sense of the term, is not concerned
with those exalted and exultant joys which require for
their fruition renunciation and discipline. Tragic emotion,
one of the profoundest, is akin to a religious emotion,
stirred as it is by the exhibition of the perpetual struggle
between good and evil, and to say that this emotion is
valued for the sake of the pleasure it entails, as the word
"pleasure" figures in the vocabulary of hedonism, is to
utter a paradox.

MEREDY: A philosopher has laid down the maxim that we
must speak with the vulgar but that we should think with

the learned. In all discourse we employ words and expressions that have plebeian associations, but we are able to curb or to transcend these associations in the interest of clear and cogent thought. The term "pleasure" in particular has suffered from flagrant misuse and abuse, a hedonist or epicurean being popularly regarded as a sensualist or libertine, a stranger if not an antagonist to all spiritual joys. Pleasure, if we attribute to it a more careful meaning, is a *concept,* covering the entire range of felt satisfactions, sensuous as well as rational, coarse as well as refined. Every satisfying experience, whether carnal or spiritual, is essentially "hedonistic," the experience of tragic emotion forming no exception. Aristotle, no hedonist in the vulgar sense, made pleasure central in his learned treatise on poetics; but, recognizing specific differences in pleasure, he defined the pleasure derived from tragic emotion, and a pleasure valued for its own sake, as "rational enjoyment." What are the scruples that make you reluctant to admit that there are pleasures of the mind, and that tragic emotion is one of the most transporting of them?

HARDITH: If I refrain from including tragic emotion within the gamut of hedonistic experience, it is because I refuse to stretch the concept of "pleasure" to cover any and every felt satisfaction. My refusal is dictated by two scruples, one of usage and one of doctrine. The learned, alas, no less than the vulgar, are often reckless with words; they are notorious for giving peculiar twists to familiar meanings. If religious worship, for example, involves a felt satisfaction, is the satisfaction a "hedonistic" one? It is only by a

strange perversion of language that the felt satisfactions
of the voluptuary and the saint could be characterized as
just different kinds of "pleasure." One might as well
describe Dante's *Paradiso* as a poetic contribution to the
literature of hedonism and as an impassioned defense of
its philosophy. Who but a cynic or a sophist, playing fast
and loose with established terminology, would ever think
of perpetrating a description like that? Apart from usage,
by which I set great store, hedonism is a special doctrine
preëmpting the term "pleasure" for the satisfaction of
desire or appetite fundamentally sensuous; and such sat-
isfaction alone, in life and in poetry, has been glorified
as appropriately "hedonistic." In a sequence of three
sonnets by Rossetti, entitled *The Choice,* we have in the
first a typical expression of the "pleasure seeker":

> Eat thou and drink; to-morrow thou shalt die.
> Surely the earth, that's wise being very old,
> Needs not our help. Then loose me, love, and hold
> Thy sultry hair up from my face; that I
> May pour for thee this golden wine, brim-high,
> Till round the glass thy fingers glow like gold.
> We'll drown all hours: thy song, while hours are toll'd,
> Shall leap, as fountains veil the changing sky.
> Now kiss, and think that there are really those,
> My own high-bosomed beauty, who increase
> Vain gold, vain lore, and yet might choose our way!
> Through many years they toil; then on a day
> They die not,—for their life was death,—but cease;
> And round their narrow lips the mould falls close.

This is hedonism, and hedonism with a vengeance! Here
all genuine satisfactions are staked upon the classic trilogy
of "wine, woman, and song," with *laus veneris* as the dom-

inant theme. No ambiguity here: the particular images chosen evoke with perfect clarity the characteristic sensations and emotions connoted by the word "pleasure." To be sure, there are other felt satisfactions, intimated by Rossetti in the remaining two sonnets, and conceived by him in opposition to those experienced by the "pleasure seeker." Yes, hedonism has always had significant rivals. The protagonists of doctrines antagonistic to hedonism, be they poets or philosophers, have sought to demonstrate that the richest satisfaction is the reward of consecration to the civilized values of mankind, such as are embodied, for example, in the achievements of religion, the results of science, the fruits of art, and the institutions of society. If the search for satisfaction through devotion to any ideal were synonymous with the search for pleasure, then alternatives of hedonism would be pseudo-alternatives, ultimately but species of it, on the ground that every commendable satisfying experience is by definition a pleasurable experience. What an egregious mistake not only of language but of theory! I am incorrigibly distrustful of a definition or doctrine that extravagantly claims to be all-inclusive or absolute. Hedonism is only one view among many from which it may be distinguished both logically and historically, and distinguished from them by these three propositions: that pleasure is the highest good, that pleasure is satisfaction of desire or appetite, and that desire or appetite is basically sensuous. If hedonism be thus understood—and I don't know how else to understand it,—tragic emotion is certainly not a hedonistic experience; this tremulous emotion is undeniably satisfying, but the satis-

faction it affords is radically different from the satisfaction of desire or appetite. Have we an organic craving for tragedy? Are we athirst for pity and fear, sadness and grief?

MEREDY: Ah, Hardith, you really are, as I have always suspected, a puritan at heart. Your attitude toward hedonism is singularly biased. That "sty" of Epicurus, in which pleasure seekers are said to wallow, is a grotesque image. Is it ignominious to have natural appetites, and is it ignoble to derive pleasure from their gratification? You seem to associate pleasure with but physical desires, and sensuousness with sensuality. It is an old puritanical device to discredit hedonism by identifying the sensuous with the sensual. There are desires, however, which are essentially of the mind and yet dependent for their satisfaction upon the service of the senses. The hunger for beauty, in all its forms, is a normal human appetite, and though that craving cannot be appeased unless the senses are antecedently stimulated, the pleasure its appeasement affords is a pleasure *through* the senses and not a pleasure *of* the senses. Aesthetic experience, such as is induced by the fine arts, is a spiritual delight in which imagination and thought participate, the senses functioning as vehicles or messengers of immediate impressions that must be held together and somehow fused. The pleasure that is felt in the presence of a complex work of art is not a titillation of the senses, but an inward excitation of the soul. If the description of aesthetic experience accommodates itself to the language of hedonism, it is not the voluptuous hedonism condemned by its critics. The pleasure produced by

the contemplation of art is indeed a supreme good, valued
for its own sake, and following upon gratification of de-
sire, but the desire is a desire for beauty, a desire of the
whole mind, the senses being the servants and not the
masters of it. The natural avidity of the mind for pleas-
ure—the central thesis of hedonism—finds in aesthetic en-
joyment positive and irenic fruition; not seeking to devour
or to possess its object, the appetite for beauty cannot be
stifled by satiety, nor corrupted by overindulgence. Being
a *contemplative* pleasure, which is another way of saying
that it is a pleasure of the mind, aesthetic enjoyment is
the very paradigm of hedonistic experience, and no other
hedonistic experience can rival it in purity and self-
sufficiency. Hedonism stands or falls in accordance with
the kind of pleasure chosen as standard: if all satisfactions
are measured by those called "animal" or "carnal," a
hedonistic theory of aesthetic experience appears to rob
it of depth and dignity, but it is quite otherwise when aes-
thetic experience itself is the criterion for all other satis-
factions. On this hinges the issue between us regarding the
pleasure of tragic emotion. This feeling, and any other
of like aesthetic elevation, is certainly not amenable to a
gross hedonism, the sort denounced by puritans; but of
a spiritual hedonism, based upon aesthetic experience,
the enjoyment of tragedy is a perfect example.

HARDITH: My dear fellow, to what lengths you can go in
defense of a shaky position! Your rhetoric, though im-
pressive, is not convincing, depending as it does upon a
strange juxtaposition of words. What am I to make of the
expression "spiritual hedonism"? The epithet "spiritual,"

no less question-begging than the epithet "carnal," is de-
signed to raise pleasure to the highest plane of experience,
in rebuttal of its detractors who reduce it to the lowest.
But why should pleasure be either disparaged or eulo-
gized? You are mistaken in supposing that I am in secret
alliance with puritanism; my view of pleasure is not a
jaundiced one, nor do I make a virtue of its frustration.
I employ the term "pleasure" without prejudice as de-
scriptive of the limited range of felt satisfactions in which
the senses are acutely involved, and these are organs of the
body, so that when we speak of appetite, such as that for
food or drink or sex, the reference is primarily to the body
and its organs, the experience of pleasure being condi-
tioned partly by what stimulates the desire and partly by
the adequate response of the requisite organ in gratifying
the desire. Appetite or desire, in short, is related to those
needs and wants upon the satisfaction of which an organ-
ism depends for its survival. Yes, Meredy, there is a sense
in which hedonism is universal; all organisms are bent
upon pleasure if pleasure is a concomitant of satisfied de-
sires or appetites such as are necessary for the preserva-
tion of life in the struggle for existence. But this hedonism,
which we may call "biological," pertaining as it does to
the primitive and subrational level of life, cannot be made
the basis of values that have no direct bearing upon
survival, and chief among these are aesthetic values.
Life would continue without their "rational enjoyment,"
neither artistic creation nor aesthetic contemplation being
"useful" in the biological meaning of the term. So when
you speak of a hunger or thirst for beauty, as if it were an

"organic" appetite, you avail yourself of a striking meta-
phor, licensed by poetry but not authorized by science. In
religious literature we find similar metaphors; the devout
are often depicted as avid or greedy of God, the object of
worship and reverence being likened to a pabulum that
nourishes the soul as meat sustains the body. "As the hart
panteth after the water brooks, so panteth my soul after
thee, O God." These are obviously figurative expressions
and are hardly adequate to reveal the depth or intensity of
religious longing and its spiritual satisfaction. Figures of
speech are hazardous: we are apt to mistake poetic alle-
gory for prosaic truth. Strange as it may sound to say so,
a hedonistic account of aesthetic experience is essentially
metaphorical; the word "pleasure," originally associated
with those animal needs and wants which biology connects
with the values of survival, is carried over or transferred
to the basically different domain of thought and imagina-
tion. Now I am not ashamed of my biological origin and
destiny; the pains inflicted by nature I do not rationalize
as salutary, and I relish the delights of the flesh without a
guilty conscience. I have a decided penchant for hedonism
if the term be understood as applying to the things com-
monly spoken of as "creature comforts." But when I am
in the presence of a great work of art, and especially a
work of tragic art, what I experience is a wonderful lib-
eration from animal passions, a marvelous expansion of
mind, a glorious stirring of generous thoughts and feel-
ings, a glowing recognition of values transcending those
centered in my little self or my little world. Aesthetic ex-
perience in its highest reaches, as I have said, is akin to

religious experience, and to annex to this experience the idea of pleasure, an idea derived from the appetitive level of animal life, is to push a metaphor to the limit of bathos.

MEREDY: I agree, of course, that language is full of similes: a term or an idea literally denoting one kind of thing may be imaginatively extended to whatever in any way suggests a likeness or analogy to it. How can we discourse at all without the liberty, and not merely the license, of using words as tropes? Even science, when the vehicles of its expression are not the symbols of mathematics, cannot dispense with metaphors. What but a figure of speech is a "force" of nature, or the "attraction" of one body for another? Do causes "generate" their effects, and are facts "stubborn" things? Suppose we grant that the primary meaning of pleasure is biological, does it follow that we must retain this primary meaning in any and every context in which the word is employed? Like a theme with variations, pleasure acquires a different sense with each mode of experience of which it is the quality, and the higher or deeper the mode, the richer or subtler the sense. And hedonism also, in which pleasure figures as the major trope, is a theme with variations: the variation called "biological" and the variation called "aesthetic" are at the opposite poles in a general scale of valuation, the satisfactions valued at one extreme being "appetitive" and at the other "spiritual," and between these two extremes lie intermediary satisfactions, partly of the senses and partly of the mind; but all felt satisfactions, though incommensurable in the quality of their pleasurableness, are analogous in meaning, precisely as incommensurable and yet as analo-

gous as are the panting of the hart after the water brooks
and the panting of the Psalmist after God. There is thus
nothing bathetic in characterizing tragic emotion, perhaps
the most sublime aesthetic experience, as a pleasure, and
those as spiritual hedonists who relish this emotion for its
own sake.

HARDITH: I admit that we may use words with a certain lati-
tude,—but always within the limits of propriety. If I am
to be labeled a "spiritual hedonist" because I value for its
own sake the experience of tragic emotion, by the same
token I should be also called a "spiritual ascetic"; for this
quasi-religious emotion, by stirring me into awareness of
the great moral forces that shape and control human des-
tiny, involves a sort of momentary renunciation of all
those "egocentric" values to which I attach so much impor-
tance in my daily life. Is tragic emotion compatible with
ascetism, as well as with hedonism? You will say, I sup-
pose, that a "higher" pleasure demands sacrifice of the
"lower"; but if one is a hedonist in seeking the former,
does he not abandon his hedonism in eschewing the latter?
And what should we say of those holy men whose highest
bliss consists in renouncing completely the flesh and the
world? Are the most austere ascetics perchance the only
genuine hedonists? Here, my dear Meredy, words cease
to have meaning, and all good sense goes by the board.
But I do not wish to dispute about words. If you insist upon
employing pleasure as a trope, stretching and straining its
meaning, all in the interest of your theory of "differential"
hedonism, you are in the position of Humpty Dumpty, who
said, as you recall, "When *I* use a word, it means just what

I choose it to mean—neither more nor less." However, the issue between us is deeper than words; it touches the nerve of aesthetic criticism and, with respect to tragedy, of literary criticism.

MEREDY: I like the expression, drawn from mathematics, by which you describe my view of hedonism as "differential"; it epitomizes exactly the many discernible variations of which pleasure is susceptible. Thank you for a wonderfully condensed simile. And as for Humpty Dumpty, I might be induced to take up the cudgels in his behalf. You remember that, when Alice wondered how words *can* mean so many different things, he retorted, "The question is which is to be master—that's all." Yes, Hardith, that is the question: Should we be the slaves or the lords of language? But enough about words. Let us return to our basic differences, which, as you say, are more than verbal. I have stated my theory clearly and, I trust, with some cogency—namely, that the end of all fine art, including tragic art, viewed from the standpoint of the spectator, is to afford sensuous and emotional satisfaction. This satisfaction I call "pleasure," but, in accordance with my differential hedonism, it occupies a high rank, perhaps the highest, in the continuum or scale of human pleasures, transcending them not in essence but in degree. My standard for measuring the value of tragedy—and concerning this art our dispute arose—is thus ultimately hedonistic. Tragedy would fall outside the realm of art if it failed to charm and delight the mind by its imaginary subject matter and imaginative presentation. Tragic emotion, being an aesthetic emotion of incompa-

rable depth and intensity, is one of the noblest and hence one of the most enjoyable of human experiences. But your criticism of this view has so far been mainly negative: you have indeed hinted at a nonhedonistic standard to be applied to tragedy, but you have not fully explained it. What is your positive conception of tragedy and of the emotion it engenders?

HARDITH: In attempting to meet your challenge, let me broach the matter by a striking illustration. The other day my attention was arrested by an advertisement in one of our magazines; it bore the caption, "Murders for Pleasure." What an amazing phrase, yet how apposite a description of a species of "literature" written and read for entertainment! Actual murders are subjects of horror; what pleases us in a detective story is not the crime, which is often gruesome, but the dramatic course of events following from it, for which the *corpus delicti* is merely the occasion and excuse, culminating through surprising and ingenious paths in the solution of the mystery. Neither the slain nor the slayer is the "hero" of this drama; the former soon becomes the forgotten man, and the latter remains until the end a person unknown. The central figure is the detective, for the display of whose devious analysis and methods of "deduction" the plot is constructed, all the characters and episodes falling into a definite pattern designed first to deepen and then to resolve a mystery. But the mystery is a delectable game of "hide and seek"; we are cozened to confuse strange coincidence with causal sequence, and are led by the nose to suspect the innocent in order that we may lose sight of the guilty. And this elabo-

rately contrived deception is just what we like and enjoy.
In detective or mystery fiction—and who but a literary prig
would deny it the name of art?—we have an imaginative
treatment of an imaginary theme, meeting the dramatic
demand for a beginning, a middle, and an end, the action
subject to the law of cause and effect, the fate of the crimi-
nal preordained at the behest of retributive justice, and
his catastrophe worked out by what Aristotle calls the sur-
prises of Recognition and Reversal of the Situation. A
detective story thus has some of the earmarks of a tragedy,
yet it arouses no pity or fear; it provides rational enjoy-
ment, an enjoyment of the mind, but no catharsis. We are
engrossed but not moved, stimulated but not transported,
thrilled but not elevated. What is the difference between
this kind of fiction and tragedy, for the latter too, as for
example *Othello* or *Macbeth,* is often but a murder story?
The difference, and it is a radical one, lies in the inap-
plicability of a hedonistic standard to tragedy. A tragedy
is not a "murder for pleasure." What distinguishes it from
a detective story, apart from technique and style, is the
religious motive by which it is inspired. The religious con-
sciousness is in its essence a consciousness of the sacred.
All religions set aside for veneration or adoration certain
objects or beings conceived as the mysterious source of
man's highest and deepest values, and their sacredness
consists in their serving as that source. Some things are
sacred: this, every religion teaches; and this, too, every
religion teaches: that offense against the sacred is pollu-
tion or violation of the ultimate principles requisite for
man's spiritual career. Of course, different religions de-

fine in different terms what is to be looked upon as sacred
and what constitutes its desecration. For the most refined
religions, human life itself possesses sanctity, because of
its divine origin and spiritual vocation, and sanctified and
thus inviolable are the seeds and fruits of this vocation,
such as piety and love, beauty and truth, honor and justice,
mercy and charity, and to destroy these is to destroy what
lends to human life its characteristic goodness and dignity.
Now, according to my view, tragedy moves on a religious
plane by showing evil to be destruction of something
sacred and suffering an expiatory sacrifice. The secular
interest, central in detective fiction, is but incidental in
tragedy. Both *genres* of art have to do with the general
theme of "crime and punishment"; but whereas in a de-
tective story the crime is merely the commission of an act
forbidden by a public law, and punishment is the appro-
priate penalty inflicted by an official court of justice, in
tragedy the same crime is exhibited as treason or sin
against the things of the spirit, and punishment as divine
retribution. I find it impossible to express what I mean by
tragedy without using the idiom of religion. There is
murder in *Macbeth,* for example, but what makes it tragic
is not that a man's natural or legal right to life has been
infringed upon, a matter of concern to the police, and a
litigious "case" to be brought to trial before a jury; the
tragedy lies in the sublime transformation of a common
act of violence into a monstrous "deed without a name."
Murder in *Macbeth* is not a secular catastrophe but a spir-
itual one, and is revealed so to the spectator as well as to
the murderer: his nobler self no less than our own con-

demns the evil genius in him, his misery and destruction being felt as a necessary atonement; for only thus can be restored the sanctity of life treacherously desecrated, and its sacred values sinfully flouted. Here the tragedy is that of a soul alienated from itself through a consuming and iniquitous passion, and from the spiritual world through action at the command of this passion. This struggle of good and evil in the soul of Macbeth is but an epitome and symbol of what is transpiring on a global or cosmic scale, the particular typifying the universal, but a struggle in which evil does not and cannot prevail. That there is a divine justice defeating evil and insuring the triumph of the good is the religious import of all great tragedy. And tragic emotion, corresponding with what engenders it, is equally and basically religious; though complex, the feelings of which it is all compact are reverence for the sacred, dread of its violation, pity for the transgressor, awe of the wondrous work of justice, and elation that evil is overcome and that good is reaffirmed and exalted. Such, Meredy, is my positive conception of tragedy and of tragic emotion. In a hedonistic view, tragedy is but a glorified detective story in dramatic form, and "tragedy for pleasure" is not a misnomer. But I see a profounder resemblance between tragedy and a solemn Mass, and to speak of a "Mass for pleasure" is indeed to reach the ultimate in paradox.

MEREDY: Your idea of the tragic is interesting but hardly tenable. Without its halo of the sacred, it would seem, tragedy sinks to the level of an ordinary detective story, dealing as it does, though by means of a different technique, with deeds of violence amenable to justice. Now

I am no snob in matters of art, and I do not hold detective fiction in disdain. It is true that the pleasure at which such fiction generally aims is not primarily aesthetic. What it provides is more in the nature of a pastime, affording relaxation to the sophisticated and excitement to the illiterate. Intended for idle moments, this sort of fiction, altogether unpretentious, satisfies the same need for amusement as the crossword puzzles and quizzes offered by every newspaper. If the fastidious treat this *genre* with contempt, it is because so few mystery writers have attained a high level of literary excellence. To compare tragedy with the usual thriller is, of course, preposterous. But if we compare it with the few notable "murders" of artistic distinction, such as give aesthetic and not merely diverting pleasure, there is no scandal in the comparison. So, if in the hedonistic view, as you say, tragedy is a glorified detective story in dramatic form, the description is not so absurd as you imply. Assuming that a tale of crime and its detection, as told by a creative artist, could charm and delight the mind by the beauty of its construction and style, a glorification of it, meaning a lofty manner of treating the crime, reaching the height of dramatic conflict and emotional intensity, would indeed be tragedy. Yes, tragedy is "murder for pleasure," when murder is its theme, if the murder is depicted as the inevitable result of a profound but demented passion, and if the pleasure felt is sublime, caused by the grandeur of the subject and the excellence of its presentation. Your attempt to impugn the hedonistic standard by a "religious" interpretation of tragedy is certainly a daring one, most venturesome being

your comparison between tragedy and the Mass. To associate pleasure with the Eucharist, you suggest, is a paradox tantamount to sacrilege, and the same anomaly adheres by implication to the hedonistic view of tragic emotion. In connecting tragedy with the idea of the sacred you achieve an impressive rhetorical effect, but the effect produced involves a blurring of important distinctions. No one will deny the great intimacy between religion and art, each drawn toward the other as if by a natural affinity. What religion has not enlisted the services of the arts as vehicles for its spiritual aims, and which of the fine arts has not often chosen for sensuous representation or imaginative expression themes or characters dear to religion? Although each may use the other as means for its own ends, art and religion cannot be made to coalesce without obliterating the line that separates the aesthetic from the holy. A work of art does not become hallowed because its subject is borrowed from the sacred story of a religion, nor is a religious ceremony, though pleasing to the senses, an artistic achievement in the pregnant sense of the term. In special cases, to be sure, the line between them cannot be sharply drawn. A picture or statue of the Virgin in a church may be a great work of art as well as an object of veneration. And the service or liturgy of the Eucharist must give some aesthetic pleasure even to the devout, while the same subject treated in music, as in Beethoven's *Missa Solemnis*, can sound spiritual depths even in the worldling. These are rare examples of the convergence of art and religion; here, and in instances like them, the sacred has a definite and conventional meaning appealing to the pious

imagination as well as to the aesthetic. When, however,
you speak of tragedy as concerned with the sacred, and of
tragic emotion as a religious experience, your words are
misleading, involving not a relation, but a confusion be-
tween two distinct domains of value. Tragedy, though its
subject were ever so hallowed, would still be a work of
creative fancy, comparable to a poem about Paradise Lost
or a painting of the Lord's Supper, to be enjoyed and
judged for its intrinsic excellence in conception and exe-
cution and not for its instrumental purpose of enhancing
the sentiment of piety or the blessings of faith. If this is
true of tragedy the content of which is a subject enshrined
in a particular religion, how truer still of tragedy, such as
Macbeth or *Othello*, which embodies a theme that can be
called "sacred" only in a loose or attenuated sense! In
saying, then, that tragedy vindicates the sacredness of life
and a divine justice avenging its mutilation, the feeling
for the sacred constituting the "religious" nature of tragic
art as well as that of tragic emotion, you speak in parables.
No, Hardith, you cannot in this manner refute the hedo-
nistic argument. Tragedy belongs to the realm of art—how
often must I repeat this? Although I may concede that the
idea of the sacred, as you understand it, is essential to
tragedy, this very idea, when garmented in the beauty of
a characteristic form and style, affords aesthetic pleasure,
not differing in kind from the pleasure attending the con-
templation of nontragic art.

HARDITH: You speak as if suffering and death lost their sting
when clothed in the beauty of form and style. In tragedy,
the delight we take in the *manner* of presentation accen-

tuates by contrast the poignancy of the *matter* presented. In any other art, the content may be so absorbed or dominated by the expression that it becomes almost secondary, the beauty of the expression alone engrossing and enchanting the mind. Not so in tragedy: here the content is the primary focus of interest, the beauty of the expression serving not to palliate but to dignify misfortune and disaster. When we look at tragedy from the outside, at the form rather than the substance, what pleases us is indeed the graceful literary garb in which grave events are arrayed, the feeling experienced being not unlike that induced by any other art. We could enjoy the surface beauty of a tragedy just as a stranger to the religious import of a *Requiem* might derive pleasure from its melodic sounds and harmonic strains. But tragic emotion, no less than religious emotion, is aroused by a spiritual subject matter to which the beauty of its expression is ancillary, designed to reveal and not to drape, to intensify and not to sweeten, its inner meaning. Yes, tragedy is an art, but an art which is singular, bordering on religion and deeply resembling religion, not in form but in substance, confronting us as it does with the ultimate issues of life and death, precipitated by the inexorable decrees of fate or by the free choices of human volition. In depicting the struggle of moral forces, involving torture and woe and somehow also triumphant righteousness, tragedy aims not to dispense pleasure but to reproduce in image, often seen only as through a glass darkly, the mystery of our world ever travailing for deliverance from evil and for the attainment of perfection; and in seizing this image inwardly, or rather

in being seized by it, with fear and trembling as well as with wonder and piety, consists tragic experience.

MEREDY: I dislike to break the spell of your eloquence, but I am impelled to make a brief comment here. You argue as if the beauty of tragedy were but the beauty of its expression and not of its content. This is not so. No art, least of all tragedy, can be reduced to mere external or surface beauty; any matter shares in the radiance of the form that embodies it. The subject of tragedy, though painful when taken apart from its artistic expression, becomes transfigured by means of it, a *thing* of beauty, not merely a *form* of beauty. Yes, suffering and death lose their sting when tragic art through the glory of words lends them grace and nobility, grandeur and significance. There is nothing upon which art cannot shed the light of beauty; a tragic content, made resplendent and incandescent, becomes supremely enjoyable. What I am saying is simply to reiterate my hedonistic view of aesthetic experience: all art, the art of tragedy included, has for its aim, when approached from the point of view of the spectator, the giving of immediate pleasure, a pleasure sought and valued for its own sake. But, of course, there is the creative side of art as distinguished from the contemplative. When art is understood as a purposive activity, a creation of objectified effort, involving technical skill as well as moral aspiration, its value is more than aesthetic, if by aesthetic we mean the same as "hedonic." But the nonhedonic value of art, be it named cultural or social or religious, falling within the purview of reflective or critical judgment, raises different problems, such as we expatiated on in our last conversa-

tion. Art for art's sake, signifying art for pleasure's sake, a principle ultimately valid for contemplation, cannot be applied, as I have argued repeatedly, to creation. Considered in relation to their nonaesthetic or extra-aesthetic importance, all great works of art, and especially those called "tragic," are amenable to a spiritual interpretation. Tragedy, being an art directly and deeply concerned with human fate or destiny, manifests indeed, if I too may employ the vernacular of religion, a faith in the substance of things hoped for and in the evidence of things not seen.

HARDITH: I do not wish to revive our old controversy over art as creation and art as experience. Since I do not admit that aesthetic values are merely hedonic, satisfactions reducible to pleasurable impressions and feelings, I cannot view as irrelevant to aesthetic appreciation the spiritual values embodied in a work of art, especially those which are inherent in tragedy. If pleasure were "the be-all and the end-all" of tragic emotion, should not a higher aesthetic value be accorded to Verdi's *Otello* than to Shakespeare's *Othello?* My comparison between tragedy and detective fiction was slightly whimsical; in opera, however, we have a resemblance to tragedy which is more apposite. Consider the librettos of opera. These are often literary tragedies, decked out in the splendor of theatrical spectacles, adorned with the seductive charm of music and song, and not seldom embellished with a ballet or two, so that the eye as well as the ear may be dazzled and bewitched. Yes, opera is tragedy made savory, condiments of beauty from different arts serving to turn it into a sumptuous feast of sensuous and unalloyed pleasure. All the

poignancy of life and death is here, but the poignancy
is a gorgeous one, conveyed with zest in recitatives,
arias, duets, and choruses, the orchestral modulations and
rhythms blending with the vocal, and the feelings of high
tension and culminating relief rendered enticing through
every device of melody and harmony. Tragedy trans-
formed into opera, though not the profoundest, is perhaps
the richest of all the arts. Being a synthesis of several kinds
of beauty, opera affords an enjoyment which is intense as
well as profuse. What art less lavish of means to achieve
its end can vie with opera in hedonic satisfaction? What
art so pleases the multitude? If pleasure is an ultimate
criterion, what art can excel opera in surplusage of aes-
thetic effect, and what tragedy metamorphosed into opera
would not, much as it might lose in spiritual earnestness,
gain in sensuous warmth and glamour?

MEREDY: Are you ironical or are you serious in your praise
of opera? Does a tragedy set to music retain in its new
medium the aesthetic value that belongs to it as a literary
creation? Is it not a distinctive work of art of which music
is the essence, the poetic and dramatic aspects being sub-
servient to aesthetic ends achieved mainly if not wholly by
vocal and orchestral means? An opera is not just a gilded
tragedy, sung rather than spoken, as if in hearing its con-
tent chanted we experienced a superadded pleasure. When
tragedy becomes transformed into opera, the transforma-
tion results in the creation of a new sort of beauty and not
in the embellishment or enhancement of the old. It is ab-
surd, therefore, to speak of Verdi's *Otello* as giving more
pleasure than Shakespeare's *Othello;* each, embodying a

special kind of beauty in a special medium, produces a
different hedonic effect. But I am no lover of opera, and
my point of view regarding it is prejudiced. Yes, opera
is "synthetic," but synthetic in the sense of artificial. It is
what the Germans might call an *Ersatzkunst,* a factitious
mixture of strange ingredients, a bizarre compound of
heterogeneous arts, representing, so to speak, an epicene
species, neither pure music nor pure drama, neither genu-
ine poetry nor adequate stagecraft. This conglomerate art,
with its gaudiness and pyrotechnics, its sentimentality and
bombast, its warbling climaxes and quavering crescendos,
luxuriates in human emotions and passions without sub-
tlety and without penetration. In opera, everything is on
the plane of the obvious and the superficial. What prodi-
gious energy is here, generating heat rather than light, the
energy of puppet characters displaying their stock feelings
and mock heroics! The beauty claimed for this exciting
spectacle of human marionettes, full of pomp and cir-
cumstance, rich in tinsel trappings, is merely the beauty
of surface. No wonder opera is popular. But how can it
be compared with tragedy? Tragedy has what opera lacks,
the dimension of depth. The emotion produced by this art
is refined and elevated because its beauty is pure and not
meretricious. It is not a sensuous pageant merely pleasant
to the senses, but a "feast of reason and a flow of soul,"
communicating impassioned but luminous ideas in the
expressive forms of euphonious speech. Tragic vision is
clear and sustained, embracing the fullness and signifi-
cance of human pathos, and when it is directly conveyed
through the medium of emotive diction, the high aesthetic

pleasure it affords affects and pervades all the faculties of the mind. No, Hardith, opera, viewed as musical tragedy, cannot engender tragic emotion. To be sure, many of the characters exhibited suffer misfortune and death, but their misfortune and death are transparently shammed, are picturesque and melodramatic, declamatory exuberance robbing every mood of sincerity and every passion of nobility. So much in opera is exaggerated and grotesque, preposterous and false, that this art might well be enjoyed for the comic effect it unwittingly produces. Operatic tragedy, judged by a critical aesthetic standard, is unintentional comedy. "The tragic as comic"—this, at any rate, is what I find in opera, and I take occasional pleasure in it for being so.

HARDITH: No analogy proposed can do full justice to the singular import of tragedy. We agree in according to tragedy preëminence among the fine arts. And we agree furthermore in recognizing in tragic emotion an aesthetic experience of supreme depth and dignity. Because of the spiritual quality and intensity of this emotion, closely resembling a religious emotion, I reject as a paradox the attempt to measure it by the hedonistic standard. I deny that aesthetic experience of any great work of art is synonymous with hedonic experience; the anomaly of their equivalence is particularly striking in relation to tragedy. If you see no paradox here, it is because you use pleasure as a name for any felt satisfaction, sensuous as well as spiritual, and because you apparently do not shrink from what to me is a greater paradox still—from interpreting the satisfaction afforded by religion in terms of hedonism.

This is the fundamental issue between us. But the hour is late, and I am weary. We have by no means covered all the aspects of tragedy; much more remains to be said of this challenging subject. Let us return to it later with fresh minds.

MEREDY: Yes, Hardith, there are further implications of tragedy to be explored, especially those having their roots in philosophy. On these we have hardly touched at all. For the present we may safely leave the matter in suspended animation.

VII

The Significance of Tragedy

HARDITH: Let me confess, Meredy, that our last discussion
has greatly disturbed, to echo the words of a famous phi-
losopher, my "dogmatic slumber." Until we broached the
subject of tragedy I was certaˑn I could defend the auton-
omy of art. My respect for art made me reluctant to judge
it by extraneous standards. Aesthetic values as well as
artistic, so it seemed to me, must be justified in their own
terms. To the principle of "art for art's sake" I was there-
fore inclined to attribute a validity almost axiomatic. This
principle, impugned by moralists, need not be associated
with retreat into an ivory tower; it does not imply an
artist's escape from life, but only fidelity to his own vision
or intuition of it. The true artist, I still like to believe,
must be his own master, free to choose his subject and
form, his technique and style, for the purpose of express-
ing, in accordance with his skill and taste, his peculiar
afflatus and personal experience. But the argument for
the self-sufficiency of art, in the sense that the values em-
bodied in its creations are intrinsic and not instrumental,
I can no longer apply generally, tragic art being the excep-
tion which disproves it. The paradox of tragedy, the topic
of our last conversation, does not merely consist in the

fact that its contemplation affords a pleasure commingled with pain, concerned as tragic art is with suffering and death. The paradox lies much deeper. If tragedy is a *genre* of art subject to aesthetic standards, it is also one amenable to nonaesthetic criteria. Here is art which is more than art, for tragedy deals with the ultimate issues of life; within its framework are embedded and held in solution the profoundest interests of the human spirit. In its preoccupation with good and evil, and with universal fate or destiny, tragedy has a content concentric, as it were, with that of morality and religion. Hence its unique importance. Although it stirs our passions and kindles our imagination, tragedy is likewise a challenge to our understanding, prompting us to accept and vindicate a world in which misfortune is inevitable, to insure the triumph of righteousness. In dramatizing as just and rational the struggle of moral forces, involving the necessity of human torture and woe, tragic art is subservient to the defense of that philosophic doctrine which declares evil to be requisite for the good. For this reason, criticism of tragic art transcends aesthetic or literary criticism. In the last analysis, what is here at stake is the validity of a particular philosophy of life and the world to which tragedy by the very nature of its content is clearly committed. You agree with this contention, do you not?

MEREDY: No, not exactly. All art, to be judged as art, is subject primarily to aesthetic principles. When art is viewed from the standpoint of the spectator, its function is to afford sensuous delight and emotional satisfaction. A work of art if it fails to please fails in its purpose.

Aesthetic autonomy signifies not the artist's but the spectator's freedom and independence; a work of art, whatever its content, must dispense pleasure by the charm of its form and expression; and whether it does or does not dispense pleasure is a matter of individual judgment, every spectator being an authoritative critic of any artistic product in relation to the hedonic effect it induces in him. For this sort of autonomy, which is absolute and universal, I have, as you will recall, argued repeatedly. Tragedy belongs to the domain of art the enjoyment of which depends upon the perceptive acumen, the emotional maturity, and the imaginative power of the spectator, many people averring that they have a taste for the form of beauty through which a great artist may present a pathetic subject. But the autonomy you speak of is not aesthetic but *artistic* autonomy. You contend that the artist who constructs a tragedy surrenders his freedom and independence because the content of his art prescribes the manner and spirit of its treatment. The true artist, you say, must be his own master; the tragic poet, it appears, is the exception, the nature of his theme predetermining its mode of construction. But, seriously, how far is any artist autonomous? Can he really do as he pleases? Is not his freedom curbed by the material or medium employed, the subject or form selected, the aim or effect intended? No musician can induce stones to sing, and by lifting his voice a sculptor is unable to add one cubit to his statue. Similarly, a painter is precluded from turning pigments into melodies, and what the poet evokes and conveys hinges on the cadence and meaning of words. Yes, in the fastidious choice of

achieving a limited thing consists the creative autonomy of any and every artist, a thing limited in its medium, subject, conception, purpose, reach, and scope. Tragedy, therefore, partakes of the limitation characteristic of all art, demanding an appropriate content and form in virtue of which it is distinguished as a particular *genre* of dramatic creation. The purpose of tragedy is to exhibit characters precipitating through their action catastrophic events, which are terrifying as well as sublime, and the aesthetic effect produced is imaginative awe and sympathy for individual misfortune on a grand scale and for the courage and sacrifice elicited under the propulsive influence of consuming passion. No special doctrine is here implied, unless it be the general notion, without which tragedy would cease to be the art it is, that suffering and death, though calamitous, have a glory of their own when discerned as inevitable in the larger context of human life. Why, then, do you consider tragedy as an art *sui generis,* one precluding the limited autonomy enjoyed by every other art?

HARDITH: Ah, Meredy, how cagey you are in avoiding the crucial issue! It would be foolish to construe as absolute the artistic autonomy I have in mind. I am aware, of course, that artists are free only under the limiting conditions imposed upon them by their chosen materials or media. And every work of art, being the result of a purposive activity, is distinguished from every other by its characteristic form and design. A sonnet differs from an ode, a landscape from a portrait, a march from a madrigal. But the limitations under which these artists labor,

whatever these limitations may be, are no bar to complete liberty of expression: by means of the same materials and forms different artists convey different moods or visions or intuitions or interests or aspirations. What art is made *of* must be distinguished from what art is made *into*. What the finished product is made of, the raw material within a specific medium, is indeed subject to the limitations inherent in that material or medium; but the finished product itself, what the artist makes it into, depends for its structure and meaning upon the artist's creative power and purpose. Thus all artists, though constrained to adapt themselves to what they work with or work upon, are nevertheless autonomous in adapting their material to whatever they please to make it an expression of. This autonomy is manifestly not the privilege of the tragic poet: he is under compulsion to embody in his material a singular theme and an inflexible point of view. A sonnet, for example, though restricted in form, is an unimpeded vehicle of expression for varying kinds of experience and for sundry valuations of them. Not so the form of tragedy: that form dictates what its subject matter shall be and how to present and interpret it. Tragedy *must* deal with suffering and death, and *must* so portray them that they become sublime and, in your own words, "inevitable in the larger context of human life." The world depicted by tragedy is one in which men suffer and die, not in vain, not without rhyme or reason, but to proclaim the glory of a divine or rational order of things. Tragedy, in short, is ultimately a philosophic apology for the necessity of evil.

MEREDY: Philosophy is not your *métier*, my dear Hardith. You mistake the purport of tragic art by reading into it a speculative intent. The deeper significance of this art is open to many views, depending upon what definition of the tragic one adopts or what tradition one follows. But the philosophic theory of tragedy is one thing, and its meaning as a species of art is quite another. Considered as a *genre* of dramatic literature, tragedy is not concerned with the abstract problem of evil or with the universal problem of destiny. The content of tragedy, like the content of every other art, is particular and concrete. The situation exhibited is always definite, in a local habitation with a name, and involved in it are individual characters acting in determinate ways under the dominance of particular passions. A tragedy, not being a philosophic treatise, eschews all generalities: its focus is ever on the specific—on the specific behavior of specific persons, on specific misfortunes growing out of specific conditions. What individuals do and suffer in their desperate struggles, whether they struggle against each other or against natural or social forces, becomes pathetic when the ends they pursue are doomed to inevitable defeat. And why is the defeat inevitable? Because the ends pursued fly in the face of reason or transcend the powers of their protagonists or run counter to interests too strongly intrenched. Such is the essence of tragic art as art, the theme of which is indeed human failure and human defeat, but made manifest in palpable form through individual characters and particular circumstances. And of how many variations is this theme susceptible! Think of the difference in thematic

material in the *Oedipus*, in the *Antigone*, in *Romeo and Juliet*, in *Macbeth*! What tragic art is made into, to use your expression, here as elsewhere receives its impetus from the autonomy of the artist; his creative imagination endows an imaginary subject matter with a sustained and compelling beauty, and the verisimilitude he achieves is but illusory. In this illusion of verisimilitude, produced by a great artist in his vivid portraiture of imaginary situations and personages, lies the secret of tragic emotion: grief and sympathy, despair and awe, pity and fear—in short, all the feelings and passions epitomized under the word "pathos"—are undergone in the presence of a definite course of fateful events set in motion by the definite actions of definite characters. Primarily, the pathos experienced is for the *dramatis personae* created by the artist, not for mankind in general, and if the pathos does extend beyond them it is because the individual characters are so fashioned that without forfeiting their individuality they may also serve as images of pervasive types. Although all great art reveals the universal in the particular, it must not be forgotten that it is the visioned particular which functions as the instrument and vehicle of the revelation. There is thus nothing singular about tragedy; to impute to it a didactic aim, as if it were designed to establish a jejune thesis, seems to me altogether gratuitous.

HARDITH: What pleasure you derive from being perverse! Can you seriously maintain that tragedy is nothing more than the work of an impassioned imagination devoid of philosophic purpose? Is its sole intent, the "be-all and end-all," to arouse pathos? A pathetic situation is indeed

the subject of a tragic art, but a subject transformed into an object of beauty and truth. Of tragedy, as of no other art, it may be significantly said that "beauty is truth, truth beauty." And the universal truth of which the particular beauty of tragedy is so singular an embodiment consists in this: the evil that men do and suffer is not fortuitous or irrational; men's failures and defeats have a necessary origin, their death and destruction a final justification. Not everything pathetic is tragic. Without a philosophic vision of the pathetic, in virtue of which the pathetic rises to the level of grandeur and sublimity, tragic art could merely depict, as a satire on life and as an affront to reason, the accidental misfortunes and disasters that befall men either through the forces of nature or through their own follies. Who can deny the pathos of the calamitous events that occur in the real world? Who is a stranger to the feelings of dread and compassion in the presence of actual torment and woe? Yes, Meredy, life is full of evil; there is everywhere a plethora of physical pain and moral wickedness. The cruel tortures of disease, the fatal ravages of passions, the fearful carnages of war, and all the diabolical things that turn this world for us into a vale of tears—are these not indefeasibly pathetic? And why do we not think of them as beautifully tragic? Simply because they strike us as episodic and contingent, bludgeonings of chance rather than results of necessity, to be bitterly lamented and not serenely endured. Tragedy is not a jeremiad or an elegy; though grave, it is not melancholy. Tragic art, in short, contains the pathetic and transcends it. The relation of the tragic to the pathetic is precisely

the relation of whole to part or of the universal to the particular. Not merely to exhibit suffering and death is the aim of tragedy, but to provide an intelligible ground, whether social or cosmic, through which suffering becomes sublimated and death transfigured. Before the actual evils of the real world we stand aghast, seeing in them no meaning or significance, but in the evils as presented through tragic art we are compelled to recognize those ineluctable forces against which the deepest human values must struggle to gain and vindicate their ultimate mastery. Thus does tragedy make philosophers of us all. It induces in our minds the persuasive belief that evil redounds to the glory of the good, that individual misfortune contributes to the triumph of the universal things of the spirit. No, it is not sheer pathos that tragic art luxuriates in. The pathetic is indeed what tragedy is made *of*, but what tragedy is made *into* is an idealization of the pathetic, the magic of beauty endowing it with grace and the vision of truth with dignity. Tragedy does not culminate in a demonodicy, if I may coin a word, a justification of the ways of the Devil, but in a theodicy, a justification of the ways of God.

MEREDY: You have broached a subject of central importance, namely, the relation of the pathetic to the tragic. I agree that the pathetic is a necessary condition of the tragic, but not that it is a sufficient one. To be called tragic, in life as well as in art, the pathetic must appear in a certain aspect or form. Consider for example death, with which tragedy is generally concerned. Does pathos pertain to the mere fact of death any more than it belongs to the bare

fact of birth? Hardly. Death as a natural phenomenon is a part of life, and life has its natural consummation in death. Who but a fool wants to live forever? Upon the science of biology the idea of pathos has no bearing; "to be or not to be" is for this science chiefly a question of tracing the conditions under which organisms begin and cease to exist. Pathetic, in a word, is not that life must run its course "from the cradle to the grave," to use the hackneyed locution of our journalists, but rather the way in which life is lived and the manner of its termination. The occasions of death, like those of birth, differ in kind, and correspondingly different therefore are the feelings they arouse. We do not long or deeply bewail a death when it occurs under what we call "normal" circumstances. A peaceful end, at a ripe old age, after a career of worthy achievement, is to be envied rather than pitied. What we usually lament is a life's extinction that is adventitious or violent, brought about by disease or murder or war, and particularly by those accidents which with unintentional irony lawyers speak of as "acts of God." In a word, it is death ascribed to "chance" which is a thorn in the flesh or the iron entering the soul. Here the source of unrelieved pathos lies in some unforeseen and blind catastrophe that "unnecessarily," as we say, cuts a life short and brings it to an "untimely" end. In tragedy, however, this pathos becomes a "cathartic," purgative and assuasive, because death is exhibited as predictable and inescapable, the climax, as it were, of a continuous and determined sequence of events, clothed with a strict necessity in which we acquiesce intellectually though not

emotionally. A particular chain of cause and effect in a
specific context, as in *Antigone* or in *Romeo and Juliet,*
decrees the lethal result; and this result, though releasing
the full intensity of our feelings, exacts from our reason
the judgment that under the given circumstances nothing
else is possible. The pathos engendered by tragic art re-
quires a situation in which the objects of pity or sympathy
or sorrow, or whatever other emotions they awaken, are
under the dominance of a causal and not merely a casual
fatality, death and destruction being recognized by our
thought as both inevitable and intelligible. This aspect of
intelligible inevitability, which we do not discern in the
"thousand natural shocks that flesh is heir to," is the
essence of tragedy. In tragic art the issues of life and death
do not tremble in the balance; the issues are preordained
by the characters involved and the actions precipitated.
The final catastrophe, though imminent or impending, is
immanent or latent in the situation. This immanence, of
which the artist must make us aware, is the mainspring
of tragic pathos, our minds contemplating with awe as
well as with understanding the imminence of the ensuing
doom. As an art, therefore, tragedy proffers no justifica-
tion of death or any other evil, being neither a demonodicy
nor a theodicy; it simply renders perspicuous the appear-
ance of fatal passion or lethal action in a chosen context
so idealized that nothing in it transpires without adequate
cause or sufficient reason. In the freedom to select and
to idealize its material, meaning by idealization nothing
more or nothing else than the portrayal of characters and
circumstances as divested of the accidental or contingent

features that pertain to them in real life, tragedy does not differ in principle from any other art. No art, unless it be absolutely photographic, can achieve its appropriate effect without a significant form, and the significance of form consists in the necessary arrangement and coherent structure of a definite content or a concrete subject matter. Tragedy, I repeat, is art, not philosophy.

HARDITH: With your view of the tragic in relation to the pathetic I readily concur. Pathos, though essential to tragedy, is not identical with it. The transfiguration of death, which as death never loses its human pathos, no matter when or how its knell be sounded, is indeed the supreme achievement of tragedy. All human misfortune, and not death alone, is ineradicably pathetic; to be discerned as tragic, misfortune must appear in idealized form, purged of its stark contingency and raised to the level of rational necessity. Yes, pathos assumes a tragic quality only when viewed under the aspect of intelligibility. You rightly insist that this aspect is fundamental to the art of tragedy. But how intelligible is death, which this art requires to be so grim a visitant? Is the necessity of death but artistic or dramatic, intelligible as a climactic episode in a literary composition? Or is its necessity moral or philosophical, intelligible in a deeper sense, as a justification of the good life or the divine order of things? *Tout est là*, as the French say.

MEREDY: No indelible line can be drawn between the two kinds of necessity in the structure of a tragedy as a work of art. Being primarily a work of art, tragedy must be faithful to its form, and its form demands presentation of

impending catastrophic events, such as are latent in the passions and actions of specific characters in relation to one another and to their natural or social environment. The necessity here is one of strict determinism in accordance with the law of cause and effect. What happens in a tragedy, so pitiful and awesome, is intelligible chiefly in a logical sense; it is intelligible, for example, that under the given circumstances there should be murder in *Othello* or *Macbeth*, but intelligible only within a pattern of events deliberately designed to exhibit their ineluctable sequence and linkage. And the strange thing is this: though the murderer is condemned, he is also absolved, condemned morally but absolved intellectually, his crime being depicted as the indefeasible consequence of antecedent conditions, comparable to a logical conclusion derived from assumed postulates or accepted premises. The transfiguration of death or of any other evil is here formal rather than material, a transfiguration presupposing an ideally ordered configuration of things. If of the evildoer Shakespeare says, " 'Tis necessary he should die," both an evildoer and the necessity of his death are logically or formally requisite for the construction of tragic art. Tragedy, a work of art created for the achievement of a certain aesthetic effect, requires that it be constructed as a coherent concatenation of all its parts, the evil that men do and suffer being as essential to its structure as the lines and colors related in a particular way are essential in the composition of the visual arts.

HARDITH: It is tempting to stake everything on form, and to attribute significance not to the representative function of

a work of art, but to the presented combination of sensuous qualities, such as lines and colors, sounds and rhythms. It is, of course, undeniable that among the visual and musical arts there are many creations conveying and evoking aesthetic emotions solely through their form; representing or expressing no subject or content, they are nothing more or nothing else than abstract configurations of their respective materials, and so have the power to produce in sensitive minds the purest joy. And I am willing to admit that even poetry of a certain kind may resemble in design and effect such of the abstract arts as have for their aim the dispensing of aesthetic pleasure merely through their formal values. But does tragedy move us by its structure alone? Is it one of the abstract arts? Can we divorce its significant form from its significant content? And is not a tragic subject significant precisely because of its likeness to human life? Yes, Meredy, tragedy is representative without being photographic. Tragedy expresses not what does happen, but what must happen in the real world under conditions viewed by the artist as pervasive or typical. The art of tragedy does not create the conditions of human suffering and disaster, it re-creates them, but with such singular fidelity that we recognize them as universal and necessary. Consider *Othello*. Although the theme is imaginary and the treatment imaginative, the causes productive of the fatal events in that tragedy are real causes. Men and women have been killed by the thousands as a result of jealousy, a passion often groundless, bred by misunderstanding, and fanned by scheming villains. Shakespeare's art lends to this sordid situation, which in

real life is but a subject of horror, formal beauty and material truth, thus kindling a tragic pathos at once poignant and lambent. Beauty pertains to the form in which this revolting theme is presented, and truth to the representation of it as an epitome of the perennial interplay of good and evil in human experience. The evil done and suffered in *Othello* is in essence identical with the evil inflicted and borne in real life. In the tragedy, however, such evil is idealized by its depth or grandeur and ennobled by its ultimate triumph over itself through defeat and expiation. The struggle of good and evil is characteristic of all tragedy, and the very disaster ensuing from this struggle enhances the spiritual values challenged and assailed. But so fused in tragic art are pathos and ethos that it is useless to allocate one to its form and the other to its content. Unlike abstract art, tragedy is basically moral, typifying the ethos of humanity and defending it against mutilation, and the source of tragic pathos lies in the emotive portrayal of this mutilation as inevitable, subject not only to the logical law of cause and effect but also to the spiritual law that evil is requisite for the vindication of the good. Every great tragedy is a sort of philosophic compendium of human life as a whole; from one point of view it exemplifies *realism,* from another, *idealism.* A great tragedy reveals the actual causes that continually lead to the violation of the things of the spirit, but it transcends the painful pathos of the violation by affording us a sublime vision of an ever victorious ethos. No, Meredy, the significance of tragedy does not lie in its form alone; the form is ancillary to expression, and

what tragedy expresses is a philosophy performing a dual task, one faithfully delineating the real and the other exultingly exalting the ideal.

MEREDY: You surprise me, Hardith! Is not form a characteristic common to all "works of art" by which they are distinguished? It is form that confers beauty on any subject or content. If we removed from art its formal values, we should jettison all its aesthetic values. Form *is* everything, even for representative or realistic art; otherwise, a photographer could be superior to a portrait painter and a newspaper reporter to a novelist. To stake everything on form, however, does not preclude the distinction between abstract art and representative art. Representative art, if it *is* art, has aesthetic value not by virtue of the accuracy of the representation, but by virtue of the expression of the represented content. Without exception, all art, when judged as art, must be judged primarily by the manner rather than by the matter of its expression. Tragedy, therefore, can be appraised as a work of art chiefly with reference to the form in which its content is presented. But apart from this general consideration, how truly representative is the content of tragedy? Is *Othello*, for example, representative in the strict sense of the term? Do the personages in that tragedy, though drawn with psychological acumen, bear any resemblance to real men and women? Are they speaking and behaving in realistic or lifelike fashion? From what actual models have the characters been re-created so unexampled in deluded jealousy or consummate virtue or monstrous villainy? What degree of verisimilitude belongs to the fabled plot in which these

extraordinary characters are involved? I shall not deny
that Shakespeare's art produces the illusion of reality both
of characters and circumstances; and it is this illusion
which enables us to experience tragic emotion. But the
illusion, required for pure pathos, is due to the form in
which the ethos of the drama is cast. A prosaic recital of
the murder story—and materially *Othello* is nothing else—
would inspire aversion rather than compassion, repug-
nance instead of awe. As you have phrased it so well,
"tragedy expresses not what does happen, but what must
happen," and what must happen, I hasten to add, nowhere
but in the world of the artist's imagination. The necessity
that tragedy is intent upon is a feigned necessity—feigned
by the artist, and feigned for the sole purpose of affording
aesthetic pleasure and emotional satisfaction. Tragic art,
being a creative and not a re-creative art, presents such
persons and situations as are prescribed by a conventional
form, and not by the principle of realistic verisimilitude.
When you speak of philosophy in relation to tragedy, what
you have in mind is a philosophy conceived *about* tragedy,
not a philosophy found *in* tragedy.

HARDITH: I might have known that you would misconstrue
my realistic view of tragedy. I do not mean, of course,
that *Othello* (or any other of Shakespeare's plays) illus-
trates the kind of realism which consists in reproducing
with painstaking precision actual persons and incidents
such as may be observed at random in a particular *milieu*
rich in local color and temporary interest. This obvious
or striking verisimilitude, so characteristic of many works
of art which preëmpt the label "realistic," is indeed alien

to tragedy, implying as it does that what is real is no deeper
than what is extant or palpable, open to common percep-
tion, and revealed as authentic in those arts that employ
the so-called representational forms. The practice of exact
imitation or reduplication of things in their minutest de-
tails is inspired by a naïve philosophy. No wonder that,
in protest against a superficial view of reality, attempts
should have been made, notably those associated with
"surrealism," to go to the opposite extreme, not merely
in eschewing all representation, but in cultivating modes
of expression that are fantastic and distorted, as if a true
vision of things could be conveyed only through the im-
agery of the demented. Yet theoretically, in spite of its
aberrations, surrealism is a welcome *tour de force;* what
I chiefly like about it is the name, indicating a philosophic
doctrine, similar to the tenets of the mystics, that the nature
of the real, in the pregnant sense of the term, is to be sought
and found in regions beneath or beyond the verisimilitude
established by our practical intelligence and pictorial
imagination. Surrealism, which is but one antidote against
naïve realism, is an affirmation that reality has hidden
layers and sunken strata of which the conventional arts
can give us no inkling. In a subtle sense, however, sur-
realism may also claim to be representative, aiming as
it does to recapture the nature of things that are free from
our habitual incrustations, the things that are amorphous
and fluid and wavering and intangible and confused, such
as they appear at the subliminal or irrational level, in the
twilight zone of dream or delirium. Surrealism is ulti-
mately subrationalism, a violent divagation from literal or

familiar or naturalistic verisimilitude, having its source in the conviction that the heart of things can be espied only on or below the threshold of conscious thought. But there is another antidote to naïve realism, and this I call "rational realism," the doctrine that reality in its essential features conforms to the demands and ideals of reason. To view things under the aspect of reason is to look beyond their particularity and contingency. We do not fathom their real nature until we uncover the conditions which underlie them and the laws by which they are governed. The generating causes and the pervasive laws of things must be included in our conception of the real world. If they are excluded or not sufficiently adumbrated, what we receive from art is but a servile transcript of immediate impressions, kaleidoscopic events, episodic situations, endemic circumstances, idiosyncratic characters—in a word, candid-camera shots of what lies on the surface or moves in the foreground. Yes, for naïve realism the real is the actual, and the actual is the perceptively apparent or transparent; for surrealism the real is likewise the actual, but the actual as buried in subterranean obscurity and hence requiring for its disclosure a technique for delving into the unconscious or the subconscious. If rational realism refers to the actual, the reference is mainly to what makes it amenable to thought, to the necessary conditions and relations by which the actual is determined and sustained. Primarily, however, the subject chosen for representation by the species of realism I have in mind is what the actual might be or could be under circumstances conceived as probable or plausible, and of this species of

realism tragedy is a supreme example. Latent or potential
in the actual is the possible, and in endowing the possible
with substance and form lies the superlative achievement
of tragic art. Let us return to *Othello*. This tragedy, though
not a portrayal of what does transpire in our everyday
world, depicts with perfect accuracy what may happen
there. It is Everyman's potential nature which the hero
embodies with such superb realism. Who is not, under
similar provocation, capable of comporting himself as
does Shakespeare's Moor? In witnessing the destructive
potency of a passion so convincingly motivated, a spec-
tator, aware of his own potential jealousy, is tempted to
confess, "There, but for the grace of God, go I." What
great tragedy produces is not an illusion of reality, but
the *rationale* of it. The evil exhibited, however imaginary
in detail and imaginative in treatment, is always possible
in essence, thus possessing a verisimilar or credible na-
ture. This *rationale*, an explanation of the actual in terms
of the possible, has also a moral side—here, as I have said,
realism is one in principle with idealism;—for tragedy
proffers a solution of the evil that is potential in our world,
a solution according with our ethical sense and satisfied
when evil is expiated or atoned for. A world in which evil
triumphs, in which it is suffered to violate with impunity
our cherished values, is not a world we can ultimately
acquiesce in. A tragedy would be a moral farce if it did
not proclaim in sure accents that, though evil be rampant
and evil deadly,

> God's in His Heaven,
> All's right with the world!

Yes, you may smile cynically at this as much as you like, but remember that not by cynics is tragedy written or to cynics addressed. I repeat, therefore, that tragic art voices a deep philosophy marked by a double verisimilitude: it is realistic in fidelity to what is genuinely possible, and idealistic in fidelity to what is universally spiritual.

MEREDY: Yours is indeed an intrepid soul, my dear Hardith. With what temerity you plunge into a hornet's nest of polemical notions! Ah, the blessed word "reality," so much bandied about by philosophers and critics! What does it mean, and what does it not mean? A fertile source of sterile disputes, the word has all but lost its sting. By what criteria shall we distinguish the real from the unreal, the actual from the possible, the contingent from the necessary? You must be aware that these criteria are numerous and conflicting; the many systems of thought, each invoking a different standard for its conception of the nature of things, are still at loggerheads. Where is the philosophy worth its salt that could not explain the meaning of art in its own peculiar fashion? Of what art may it not be asserted that it is a reflection of "reality" in accordance with a special use of this elusive term? To be sure, one of the arts chosen as privileged will then appear preëminently as the aesthetic analogue of a metaphysical version of things. For example, Schopenhauer found this aesthetic analogue in music, Hegel in poetry and notably in tragedy. The hierarchy of the arts is a favorite theme of speculation; various degrees of "reality" are alleged to be embodied in the various arts, the "highest" degree being enshrined, of course, in that art, and in that art alone,

which is congenial to a preferred type of metaphysical doctrine. But, alas, definitions of reality are at variance, and so are the scales for measuring its degrees, and the hierarchy following from one definition will differ altogether from the hierarchy derived from another. The relation of art to reality, and to its supposed gradations, depends accordingly upon the point of view of a particular metaphysical theory. Why inject metaphysics into art or art into metaphysics? An artistic creation—whatever its subject or form, its medium or technique—has nothing to do with the abstruse ideas and recondite idioms by means of which incompatible versions of the ultimate nature of things contend for mastery. If an artistic creation is said to be realistic or representative, these words have the obvious meaning—yes, the "naïve" meaning, if you will—as domesticated by aesthetic criticism and sanctioned by general usage. A work of art is lifelike to the extent to which it resembles "life" as known on the level of ordinary or habitual experience. This kind of verisimilitude, which many artists aim at, is a concept of common sense innocent of metaphysical subtlety. When works of art have such forms as are clearly and distinctly recognized to be commensurate with the forms of everyday reality, the reality of usual experience, then, and only then, may they be spoken of as verisimilar or representative. And these recognizable forms have aesthetic value if they have the power to charm our senses, stir our emotions, and kindle our imagination. The issue of realism in art is chiefly an aesthetic one, and it is absurd to criticize representationalism on the ground that the matter represented is not what

would pass muster as "ultimately real" in terms of a particular philosophy. No artist, unless he be a Lucretius expressing through the medium of poetry a systematic view of the nature of things, could be expected to accept such criticism as pertinent or valid. An artist is creative though he *re*-create with the utmost fidelity aspects of "life" or "nature" regularly perceived and easily recognized, for what he creates is an artifact, and if the artifact produces the illusion of reality through its representational form, it is the form and not the illusion which is the source of aesthetic experience. In other words, we enjoy the illusion of reality of a representative artifact *as* illusion: the mode of picturing the observed material is the object of delight, rather than the pictured material itself. I thus come back to form as the primary concern of the artist. If an artist chooses to express his creativity through the representational form, embodying in that form his sensitivity and taste and inspiration and vision and skill and technique—how foolish to disparage his art because it fails to conform to conceptions of the nature of things involving nonpictorial or unrealistic standards! Since the principal consideration for judging all art is significance of form, it is not foolish to accord, on strictly aesthetic grounds, preference to nonrepresentative artifacts. There are those who hold that art is only pure when it is purely formal, devoid of every vestige of pictorial realism or naturalism. In this sense it is indeed permissible to speak of nonrepresentative art—abstract or impressionist or postimpressionist or surrealist or under whatever label or banner it appears. Nothing but confusion results

from maintaining that every art is representative because, forsooth, it corresponds with one or another philosophic variant of the notion of "reality." What you say of surrealism, for example, strikes me as preposterous. Instead of recognizing the fresh aesthetic values for which this species of art strives, through the deliberate creation of new forms never seen on land or sea, you interpret surrealism as representing the actual, not as commonly observed, but as experienced in esoteric fashion below or beyond the level of habitual perception and conscious awareness. If the content of surrealism can be called actual, and its form representative, then indeed words signify nothing at all, and all good sense goes by the board. Surrealism, as the name implies, is an original art intent upon aesthetic effects having no relation whatever to the normal denotations of things or their familiar connotations. And equally preposterous is your attempt to interpret the art of tragedy as representative or realistic because this art, though not dealing with the actual as generally understood, is supposed to portray possible characters latent in the actual. The possible, you aver, is real—real as an object of reason; "rational realism" is the name you choose to give to a doctrine that discerns in our everyday world the unrealized but forever potential essences which might or could under proper and sufficient conditions assume concrete existence. And of this species of realism you pretend to see in tragedy a supreme example. But this, I repeat, is metaphysics and not art. For art, the distinction between the actual and the possible is gratuitous: *within* art every content is actual, present as

it is in a painted surface or in the printed words, the content being inseparable from the form by which its presence is made manifest. The primary function of criticism is to determine what sort of aesthetic value pertains to the formal expression of this content. Does it greatly matter whether the content present *in* the context of a work of art is actual or possible in the world *outside* it? Of what aesthetic importance is the judgment that an artistic subject does or does not correspond with the "real" facts of nature? Such a judgment has little aesthetic significance, not only because the word "real" is so ambiguous, but chiefly because works of art are artifacts of the imagination appealing directly to the senses and the emotions, to be distinguished from the artifacts of reason, such as science and philosophy, which alone possess the methods and the techniques requisite for describing and interpreting the existent world. Witches, ghosts, and the like, have certainly no existence outside the world of Shakespeare's plays, yet what an aesthetic impertinence to question their reality within that world! What we find in *Othello*, therefore (to revert to our former example), is such content as the poet chose to present, being actual in the medium or form in which he presented it, and it is altogether irrelevant, if our interest is purely aesthetic, to raise the extraneous issue of whether the presented content represents what is possible in the natural world.

HARDITH: You have talked at great length, in your usual vein of paradox, but I still remain unregenerate. I can only reiterate my old objection to your method of partition. To divide an argument is not to conquer it. By divorcing imag-

ination from reason, or art from philosophy, you simply
evade the issue between us. The artifacts of reason have
an imaginative quality of their own, and the artifacts of
imagination are not all without a rational ingredient. I
cannot look upon the human mind as exercising one fac-
ulty in the construction of philosophy, and another, quite
different one in the creation of art. Not that I dispute the
distinction between reason and imagination; what I deny is
their separation. Both art and philosophy are the achieve-
ments of human intelligence, and intelligence, when it is
sane or organic, brings into play all the faculties, though
some more prominently than others, depending upon the
end aimed at and the means chosen for its accomplish-
ment. Besides, I refuse to admit that philosophy is merely
what is preëmpted as philosophy by its academic profes-
sors, the preoccupation of a class of specialists who speak
to each other in a forbidding diction, and who pretend to
be unbiased and dispassionate. In their preference for a
particular view of the world and a particular way of life,
all reflective men are votaries of philosophy, in the broad-
est sense of the term, and what they express is not in-
articulate or unintelligible because it lacks the technical
trappings of the professionals. All serious artists have
always incorporated into their artifacts some basic con-
ception and appraisal of the nature of things. The endemic
ideas and ideals of mankind do manifest themselves in
sundry ways, but for the historian the parallelism between
the artifacts of thought and of art in a given state of civi-
lization is a conspicuous fact. What is characteristic of the
art of a certain epoch—Egyptian art, Greek art, Roman

art, Christian art, Renaissance art, Modern art—is a distinctive "ideology" (to employ a word now in vogue) integral with that inherent in its society, its institutions, its religion, its metaphysics. To identify art with its abstract forms, as if their inception and dominance could be understood without reference to a pervasive "ideology" which they sustain and by which in turn they are sustained, is to ignore or to neglect the specific historical contexts in which the forms of all human creations, including those of art, have their rise and decline. The arts do not flourish in a cultural vacuum, nor is a whole cultural frame contexted by its arts alone. The history of a culture is the history of its manifold expressions bound together by a particular view of life and the world: a common ideology pervades and informs all the artifacts produced in a given period, such as the theological, metaphysical, political, social, aesthetic. For example, Greek or Christian art mirrors a definite "mental climate": the aesthetic artifacts of the Greeks or the Christians are in ideology or philosophy concentric with the other achievements peculiar to their civilization. And I go even further. Not only is art a reflection of the prevalent spirit of an age; in a more special and systematic sense there is an intimate correlation between the artifacts of imagination and the artifacts of thought. The schools and sects of philosophy, whatever be the epithets by which they are differentiated, have their analogues in art; naturalism or realism, subjectivism or mysticism, idealism or rationalism, and other characterizing names for certain tenets, retain in essence the same meaning whether applied to theoretical or to aesthetic versions of

things. There is hardly a typical view of existence and of value as formulated in conceptual terms which has not its counterpart in artistic presentation. The schism between art and philosophy is a fiction invented in behalf of a doctrinaire aestheticism. This fiction, I cannot help thinking, must be repudiated by such artists as are not entirely mindless. Works of art generally deemed great are saturated with ideas, and ideas deeply conceived, about the nature of the world and the meaning of life, and in their ultimate persuasions artists differ as emphatically as philosophers do. But it is in tragedy, the highest form of art, that we find imagination impregnated with thought and emotion with theory: no artistic creation is more reflective and more expressive. What tragedy reflects is a conception of reality cognate with that of rationalism, the conception that the world is, essentially, in the words of Plato, "cosmos or order, not disorder or misrule"; and what tragedy expresses is the faith of idealism, a faith in the sanctity of the eternal values, their desecration being followed inevitably by death and destruction. To be blind and deaf to this recurrent message of tragedy is to be deaf and blind to its unique significance.

MEREDY: You have adduced a strong argument for your point of view, and I am not disposed to withhold from it a certain degree of cogency. But to render your argument plausible how greatly must the notion of philosophy be diluted and that of art dilated! In the limbo of vagueness things lose their distinctness and thus appear as if they were kindred or allied. It is undeniable that in a general theory of culture the major activities of men in a given

period may be said to exemplify a common "ideology," if this fashionable word denotes a set of flourishing and shared beliefs. But such a pervasive set of beliefs is certainly not identical with philosophy in its exact sense. Moreover, no matter how relevant an ideology may be to Art "writ large" when Art appears as a chapter in the story of a civilization, that ideology has little bearing on artistic productions. No particular painting or poem or musical composition, which as a physical or concrete object embodies in a definite medium or form a specific content, is beholden for its significance to an ethereal or disembodied spirit of an age. It is so easy to make sweeping statements about art as a vehicle of a prevalent culture or a ruling ideology, on the basis of some well-chosen examples; but the very examples of artistic creation selected have a quality and structure peculiar to them in virtue of which alone they lay claim to aesthetic value. Consider *Othello* once more. Does this tragedy reveal clearly the spirit of Shakespeare's age? If we did not know by whom and under what historical conditions the work was created, could we surmise the particular state of culture which it is alleged to reflect? An anonymous tragedy, the same in form and substance as that ascribed to Shakespeare, would possess the same intrinsic beauty or excellence, as a rose by any other name would smell as sweet; for, after all, the play is the thing. Yes, the play is a thing-in-itself, as it were, and not a phenomenon or shadow or echo of a phase of civilization transcending it. And you bewilder me completely when you turn a play wrought by fancy, addressed primarily to our senses and emotions, into a philosophic

document, as if its chief intent were to exhibit the inter-
play not of characters and circumstances, but of concepts
and categories, such stuff as speculation is made of.
Rationalism and idealism are names for complex and dif-
ficult doctrines, involving in their arguments or demon-
strations abstract analysis and subtle reasoning, and to
suppose that of these doctrines *Othello* is an artistic epit-
ome is to carry a theory of tragedy to absurd lengths.
What is to be gained by grafting upon a work of art the
interests and the values imported from the field of specu-
lative thought? Who could take seriously your contention
that in constructing his tragedies Shakespeare was intent
upon vindicating the truth of a certain type of metaphys-
ics? Philosophy is philosophy, and art is art, and though
it be folly to decree that never the twain shall meet, it
is wisdom to insist upon their contrast. Philosophy and
art may be compared to the two sexes, which meet and
mate as opposites, each seeking and finding in the other a
distinct nature and a separate function. But I mention the
analogy only to drop it, lest you press me to show which
of the two, philosophy or art, more nearly resembles the
eternal feminine.

HARDITH: All this is clever and amusing but hardly relevant
or profound. Even the sexes, though opposites in some re-
spect, are not opposites in every respect. How fantastic
is the analogy between artifacts and the natural facts of
anatomy or physiology! However, I am not inclined to
take seriously a frivolous *jeu d'esprit*. Art and philosophy,
though divergent in their materials or media, in their
forms or methods, often converge upon similar if not the

selfsame attitudes toward life and the world. For this convergence I make an unimpeachable claim. Of all the arts
tragedy is the most articulate, for its medium is consecutive and coherent speech. Through this medium, at once
impassioned and perspicuous, tragedy offers a compendium of the incessant struggle of good and evil in human
life. To be sure, if it is to be dramatic the struggle must
be personified, involving individual characters in specific
situations, but, though particular in presentation, a tragic
conflict is representative or symbolic of universal destiny
or fate. If what tragedy depicts and typifies is the source
of pathos, kindling our compassion for human pain and
suffering, it is also the ground of spiritual delight, inducing admiration of man's dignity in the face of evil, and
recognition that our moral values ultimately remain inviolable and triumphant. Yes, I repeat, tragedy is a breviary of philosophy, and the philosophy it adumbrates is
a peculiar blend of *realism* and *idealism*. And I use these
names not for the recondite doctrines that bear them in
their abstruse and technical expression, but rather for the
visions and persuasions that inspire and sustain these doctrines. And such visions and persuasions lend themselves
to poetic or artistic expression often superior in force and
clarity.

MEREDY: We seem to have reached an *impasse,* and I am not
at all eager to reach a final decision in a matter so controversial. The issues at stake are too important to be
settled in categorical fashion. Our debate, however, has
not been futile: in matching our wits over the significance
of tragedy we have succeeded in casting an oblique light

on a feud that has long persisted, the feud between artist and philosopher. A philosophy of art, like a philosophy of science or religion or society, is indeed not only feasible but necessary. I maintain, however, that a comprehensive theory of any human practice or interest is not intrinsic to it. A general interpretation of art, therefore, is distinct from the specific activity of artistic creation. There is, I reiterate, no philosophy *in* tragedy, though one may entertain a philosophy *about* tragedy. And I accentuate again the fact that tragedy is a work of art, amenable primarily to aesthetic standards: these standards are concerned chiefly with the beauty or excellence of the form in which a pathetic subject is presented. In the form of presentation lies the significance of any art, and tragedy is no exception. Consideration of the content, apart from the beauty or excellence of its form, I regard as nonaesthetic or extra-aesthetic. In the "literary" sense of the term, no subject is "tragic" unless it is exhibited in dramatic shape and conveyed through emotive language, and we enjoy or appreciate this subject only as transfigured by the artist's imaginative treatment and technical skill. But I admit that the idea of the tragic has other uses. Men have often conceived of life as "tragic," and philosophers have employed the epithet for their particular version of the nature of things. But the extension of the meaning of tragedy beyond the aesthetic domain opens up a new theme for discussion. I propose, Hardith, that we attempt to delve a little more deeply into this meaning and to bring it into clearer focus.

VIII

The Fallacy of Tragedy

HARDITH: Our last discussion was chiefly concerned with tragedy as a species of art. And, alas, we failed to agree regarding its significance. You maintained, and with some force, that if tragedy belongs to the domain of art its content must be ancillary to its form, the transformation of the pathetic into the tragic being largely a work of literary craftsmanship. The idea of the tragic, you held, is feigned by an artist, and presupposes an imaginary situation amenable to imaginative treatment. I, on the other hand, contended that what is tragic in tragedy must be derived from the intrinsic pathos of a content essentially true to life, and that the beauty of the form is subservient to a spiritual conception of human destiny. The recurrent theme of tragedy, I insisted, is the philosophic problem of good and evil, the solution of which requires, in response to our ethical demand, the exaltation of good over evil. No, you declared, tragedy is an art which has nothing to do with philosophy; its problems are formal instead of material, aesthetic rather than speculative. Pertinent criticism of tragedy, therefore, is literary criticism; tragedy must be judged primarily as a dramatic creation designed to produce certain hedonic effects upon our senses and our

emotions. You admitted, however, that although there is no philosophy *in* tragedy, one may entertain a philosophy *about* tragedy. And you conceded also that the meaning of the tragic may be extended beyond the aesthetic sphere. I should like to hear your opinion about the idea of the tragic, not merely as embodied in a work of art, but in its more general use or wider application.

MEREDY: You are suggesting for discussion two distinct topics, one concerned with a theory of tragedy as a particular form of art, and the other with a view of tragedy in its broader connotation, in the sense in which we speak of the "tragedy of life" or the "tragedy of existence." The notion of tragedy is ambiguous: one meaning of it is specific and definite, denoting a literary artifact; the other is derived and figurative, signifying a comprehensive intuition or interpretation of the nature of things. A theory of tragic art and a tragic philosophy of life constitute what the logicians call two separate "universes of discourse." Tell me, Hardith, which of them you have in mind.

HARDITH: You resort as usual to your favorite method of partition. The content of tragic art cannot be divorced from human existence, and human existence reveals to contemplation the same pathos as is exhibited in tragic art. Art and life may indeed be distinguished, but they cannot be separated; for art, and particularly tragic art, draws its material from life, and life, in its graver aspects, resembles tragic art, manifesting as it does the continual conflict of moral forces and the perennial struggle of spiritual values. Yes, a theory of tragic art must coincide with a tragic view of the real world, and a philosophy of

life dwelling on the universality of pathos is in essence though not in form cognate with the art of tragedy. The idea of the tragic has the same basic meaning, whatever expressions it may assume: tragic art and tragic philosophy are inspired by kindred visions and kindred persuasions.

MEREDY: No, no! With your penchant for synopsis you are in the habit of blurring important distinctions. A tragic philosophy of life does not necessarily follow from a theory of tragic art. A theory of this art (like that of any other art) need not coincide with a view of the real world. Does a theory of music, for example, involve a melodic or harmonic conception of the nature of things? Can we seriously speak of the "Dance of Life" as based upon a theoretical analysis of the ballet? Is it not fanciful to single out a particular art as a replica or paradigm of human existence? What a theory is about has for its frame of reference a particular subject of inquiry; a theory of tragedy, not unlike a theory of music or a theory of the dance, presupposes for investigation extant artifacts serving as its special data, and the result of the investigation throws no light on any other data. If you speak of a philosophy intent upon maintaining that life is "tragic," the data here are those supplied by human experience. I ask you to bear in mind that the data for a theory about tragedy, which are works of the imagination, differ essentially from the data for a tragic philosophy: these are not artifacts, but facts and events comprising our natural world.

HARDITH: You seem to mistake entirely my main contention. I grant, of course, that a study of tragedy may be under-

taken with exclusive attention to its psychological or artistic or cultural aspects; and such a study, though one-sided, may eschew emphasis on the philosophic import or purport of tragedy. I speak advisedly of a *philosophy* of tragedy and not merely of a *theory* of tragedy such as an aesthetic critic or literary historian is concerned with. By a philosophy of tragedy I understand an interpretation of its deeper implications. What this art implies is a clear and profound vision of human destiny: the evil that individual characters do and suffer under particular circumstances is here represented as typical or universal: the evil portrayed is nevertheless necessary, and rational, to vindicate the cherished things of the spirit: the perennial pathos of life thus becomes sublimated or transfigured through faith or persuasion in a divine order and rule of the world. Without this philosophic implication, as I argued in our last discussion, tragedy would be but a moral farce, revealing the calamities of life as contingent and fortuitous, as occurring without rhyme or reason, at the bidding of blind chance or at the behest of a dark fate. No, in the presence of suffering and disaster, in the face of death and destruction, tragedy inculcates neither cynicism nor pessimism; effectually silencing irony and despair, it releases, rather, and enhances our natural inclination to believe and trust in the ultimate triumph of the good. What is pathetic in tragedy is thus raised to the level of grandeur and sublimity, and on that level the pathetic is seen in its true light, as an essential part of the spiritual world, as dissonance in music is an element in a more perfect harmony, as a deformed or shaded line

in a painting is the ingredient of a richer texture or brighter radiance. And this is the point of view of a tragic philosophy in relation to all evil. When formulated in conceptual terms, such a philosophy renders explicit what in tragic art is but implied—implied only because the material it deals with is particular and concrete, and the form in which the material is clothed is sensuous and imaginative. The truth which the lambent beauty of tragic art partly conceals, namely, that in the universal order of things evil is transcended and transmuted—this a tragic philosophy makes overt and intelligible through reasoned discourse. So don't talk to me of separate data for a philosophy of tragedy and a tragic philosophy. Both are based on the same data, present in profusion in real life. The artistic and the speculative uses of these data, though different in many ways, ultimately coincide in principle, governed as they are by the same view of the significance of pathos.

MEREDY: Very well! I shall playfully assume your position in order to disclose its anomaly. Yes, a tragic view of life, whether latent in dramatic art or embodied in a system of thought, is downright fallacious.

HARDITH: Fallacious? Do you mean that such a view is untenable in a material or formal sense? Is it inconsistent with the facts of human experience, or is the interpretation of these facts logically defective?

MEREDY: Both. The facts of life are not inherently tragic, and to describe them as tragic involves reasoning by a false analogy. What transpires in our actual world is indeed often felt to be pathetic, but to regard it as tragic

requires a special meaning of the term, a meaning intel-
ligible only in relation to the dramatic form of art. To be
sure, in ordinary parlance the epithets "pathetic" and
"tragic" are employed as if they were interchangeable:
we are in the habit of loosely characterizing as tragic any
and every human calamity and disaster. How tragic, we
exclaim, is a shipwreck, an epidemic, a suicide, a murder,
a war! But in our last conversation we agreed not to con-
fuse the tragic with the pathetic. Tragedy as an art, though
dealing with human ills and misfortunes, must so deal
with them that they appear as necessary and inevitable,
necessary in an ideal or imaginary context, and inevitable
as the consequence of the passions and actions of ideal or
imaginary characters. Thus the pathetic is tragic only
when presented through the medium of art, and whatever
art touches, I insist, becomes transformed in accordance
with its creative purpose and design. In other words, a
work of art is an artifact, and its fidelity to the facts of
life or of nature is an illusory and not a real fidelity. Art
adds a new dimension to these facts which they do not
possess in their own right. This is the dimension of aes-
thetic form—a form present also in representative art, for
no art is a mere imitation or reduplication of existing
things, but a re-creation of them in combinations or pat-
terns different from those they exhibit in their natural
state. And this is exactly what happens to the pathetic when
endowed with aesthetic form; through this form it acquires
a fresh quality lacking in its natural medium. The quality
of the tragic is an aesthetic quality created by the artist
who deliberately arranges the elements of a pathetic situ-

ation in causal sequence and dramatic development. Without a predetermined succession of events culminating in a foreseen catastrophic climax there could be no tragedy as a work of art, whence it follows that what is tragic is tragic *only* in the created artifact and not in the re-created facts that constitute its material. The conditions requisite for the impact of character and circumstance leading to a fateful result are controlled by an artist intent upon producing the appropriate aesthetic emotion for the sake of which the artifact is designed.

HARDITH: I must interrupt you, Meredy, to point out that art is limited by its material, which the artist does not produce but can only shape or mold. He either alters the forms of given things or invests them with a new form. But what he works with or works upon is supplied by nature. You speak of the tragic as if it were a quality artificially imposed upon the pathetic. The pathetic is a quality of experience, and the tragic is not another quality than the pathetic: it is the same quality seen in clear perspective and from a universal point of view. What is tragic, therefore, is not created, but discerned, and discerned in human life subject to ills and misfortunes. The function of tragedy is to give to the discernible pathos of things, which is the material of this art, the charm of beauty and the dignity of truth.

MEREDY: You are quite right in insisting on the supremacy of form in all art as contrasted with the material subservient to it. Of course no artist creates his material, his creativity being but a formative one. The sculptor, for instance, produces a statue out of marble, but not the

marble itself. And every artist—the painter, the musician, the poet—is limited to his appropriate material within the medium of which alone he can construct his artifacts. But apart from the materials, from which artifacts are made, artifacts, unless they are completely abstract, present some subject or theme; and it is this theme or subject which we usually designate by the word "content." With respect to tragedy, the material is, strictly speaking, nothing else than words, linguistic symbols being its characteristic medium; but the content, which is not the same as the material, is precisely a pathetic situation, acquiring a tragic quality only when the artist embodies it in his creative form. To be sure, the pathetic is also a quality, characterizing not events themselves, but the feelings experienced in their presence. There is, for example, nothing pathetic about death as a natural fact; the pathos supervenes upon the attitude taken toward it by the human mind. The facts and events that occasion distress and affliction, pity and fear, or whatever emotions we epitomize under the word "pathos," are neutral in their nature: they are painful or lamentable only from the point of view of sentient or conscious creatures whose aims or purposes they frustrate or defeat. The pathetic, in short, is a *relative* quality, in the sense of arising nowhere but in the context of relations between certain circumstances and the characters upon which they impinge. Now if the quality of the tragic is not to be confused with the quality of the pathetic, it must be a distinct quality, distinct in pertaining either to the specific content as adapted to the formal demands of dramatic art, or to the emotional reaction which this im-

aginary or imaginative content elicits in the reader or spectator. In either case, the adjective "tragic" is a name for a superadded quality, qualifying a given situation called "pathetic" by virtue of the feelings aroused in relation to it. If the tragic is not viewed as factitious, a quality created by art, then the meaning of the tragic becomes altogether indistinguishable from that of the pathetic. The tragic is, so to speak, a quality of a quality, not inhering in the pathetic, but grafted upon it by a specific form and a particular design.

HARDITH: Your analytical distinctions, which you accuse me of blurring, are overrefined if not sophistical. I see no reason for drawing so sharp a line between the material of art and its content or between one quality and another. The "matter" of an art, in contrast with its "manner," includes the medium as well as the subject, and the aesthetic quality is the quality of the total artifact, embodying in organic relation all its aspects—sensuous and imaginative and formal. The theme of tragedy, conveyed through the vehicle of language, consists primarily of a pathetic situation, a situation in which men do and suffer evil, and this evil, which appears to be without significance when inflicted and borne in "real" life, artists and philosophers view and interpret as subject to a spiritual or rational necessity, the idea of the tragic not differing from the idea of the pathetic in kind but only in degree. What is described as tragic is the pervasive pathos of human life purged of its fortuitousness and assimiliated with a divine order of things. When the pathetic is seen in its inwardness—as universal rather than particular, intelligible and

not groundless, sublime instead of repellent,—then and only then is the pathetic seen as tragic. Where, then, is the fallaciousness which you say adheres to the idea of the tragic?

MEREDY: Ah, Hardith, your own words betray the fallacy I have in mind. You cannot avoid transforming the notion of the pathetic by qualifying it as tragic. It is indeed an undeniable fact that in the presence of certain events we experience pity and fear, sympathy and sorrow, and many cognate emotions, on the basis of which we ascribe to those events a pathetic quality; but it would be sheer redundancy to speak of them as tragic unless this epithet denoted a separate quality. And what is this quality if not a quality of value? What you say in effect is this: A tragic judgment differs from a pathetic one not in description but in appraisal of a grievous situation. Both kinds of judgment have reference to the same facts, the former demanding acquiescence in them as things to be lamented, the latter requiring their exaltation as witnesses of a spiritual world. Consider death, for example, which is usually felt to be destructive and calamitous, the source of torture and woe—hence its universal pathos; this pathos, however, is transfigured in tragedy, not only because death appears under the aspect of heroic or majestic beauty, but also because it is symbolic of a negative agency over which the moral forces are alleged to be ultimately triumphant. Thus does death lose its sting, and a natural fact amenable to disinterested description becomes a matter of impassioned valuation. Impassioned valuation of life, which justifies death and destruction, is precisely the task devolving upon

the art of tragedy. Such valuation is unexceptionable in dramatic form: it is a sort of poetic license. But poetry is not philosophy, nor is beauty truth. The fallacy of your position rests upon a confusion between facts and values. It is one thing to describe particular situations such as induce actual pathos, but it is quite another to create for these situations an ideal or imaginative context, as tragedy does, in which alone they can be appraised as significant or rational or spiritual or sublime.

HARDITH: You are again confronting me with a formidable dichotomy. I have heard of the contrast, which can so easily beguile the unwary, between judgments of fact and judgments of value. The contrast is a logical and not a real one. Facts and values, though distinguishable by analysis, are inseparable aspects of experience, like the two sides of the same shield. We are seldom if ever concerned with pure facts without ascribing or imputing to them some worth, even if their worth, as in the domain of science, consists only in confirming the truth of a hypothesis or theory; and the values we ordinarily deem significant are those based upon known and factual evidence. There are all kinds of fact and of value, and after discerning them we must not lose sight of their relations to one another; otherwise, human experience would disintegrate into artificial parts, forfeiting its manifest unity and integrity. The glory of tragedy lies in being a compendium of the facts of life and of the values of life in their essential togetherness. The distinction between them is there, as well as their connection. What is pathetic in tragedy has an indefeasible verisimilitude: the causes of

human misfortune and disaster which it depicts are real causes such as we find operative in the actual world; and what is tragic in tragedy is the pathetic invested with meaning and significance: the causes of human misfortune and disaster have a spiritual source and a spiritual result, originating in the struggle of moral forces and culminating in the victory of good over evil. If the linkage of facts and values, which tragedy exhibits as intimate and ultimate, constitutes a fallacy, make the most of it. It is the fallacy of human life itself. How could life be lived if its moral struggles and spiritual conflicts were but pitiful, the view of their sublimity being illusory, the figment of a poetic imagination? Life has no meaning at all unless it is inspired by the truth that tragedy proclaims, namely, that the very evil which men do and suffer, the source of pathos, is the means and vehicle for realizing the good.

MEREDY: What you are voicing is a subtle version of what is known as the "pathetic fallacy." In its obvious form the fallacy appears when human traits or feelings are ascribed to natural phenomena. Is the sea cruel or the storm pitiless? Is a rose passionate or the moon chaste? Is a mountain brooding or a willow weeping? Such expressions are sanctioned by the license of poets, to bring us in tune with nature. But the tune is not nature's; it is the poet's. It is sentimental to endow nature with sentiment. Although the attribution of consciousness to nature may inspire great poetry of superlative beauty, it is nevertheless a fallacy appropriately spoken of as "pathetic." And is it not paradoxical to glorify such a fallacy as the fountainhead of truth?

HARDITH: How should I answer your rhetorical question? You appear to assume as a matter of course that the truth about nature is exclusively scientific, as if poetic images and symbols, because their use is metaphorical and not strictly descriptive, were lacking in validity. It is fatuous to condemn poetry on the ground that its imaginative intuition of nature precludes literal verification. We debated this issue a long time ago in relation to the aesthetic experience of nature, and I am not disposed to revive now my former argument that the ascription of beauty to natural phenomena involves the poetic compulsion, and not merely a poetic license, to view such phenomena as if they were cognate with human works of art. There is a poetic truth of nature as well as a scientific one, and a philosophic truth of it must include both. But granted that the pathetic fallacy lies in the literal attribution to nature of human aspects or emotions, what bearing has this on tragedy? Surely, tragedy does not imply that nature is sentient or passionate or volitional.

MEREDY: No, Hardith, I am not disparaging but eulogizing poetry in demanding that poetry be poetry subject to no other standards than its own. In its proper medium, poetry does not commit the pathetic fallacy; it is only when its medium is abandoned, and when its creations are judged in alien terms, such as scientific or philosophic, that the fallacy becomes glaring. To speak of flowers, for example, as smiling and blushing and sighing and whispering and dreaming is certainly valid—valid in the domain of poetry, but hardly in the context of botany. Whatever "poetic truth" means, and I am not sure if the phrase admits of

exact definition, it is obviously not the truth of things in
their own right, applicable to their objective or intrinsic
characters. But we are not discussing poetry in general,
but the art of tragedy, and this art, in its form and appeal,
hinges on a refined use of the pathetic fallacy.

HARDITH: The use of this fallacy in tragedy must indeed be
so refined as to be virtually unrecognizable. Why is it
fallacious to give tragic significance, which is ultimately
a spiritual significance, to those human ills and misfor-
tunes which are undeniably pathetic?

MEREDY: The very term "pathetic," when used without dis-
crimination, is itself a pregnant illustration of the pathetic
fallacy. Yes, it is pathetic, if I may play upon the word,
to characterize as pathetic the nature of things. Pathos is
a name for certain emotions felt in the presence of certain
events, pertinent to the subjective concomitants of these
events and not to their objective determination. When we
speak of the "pathos of events" we speak in an elliptical
fashion: the phrase has reference solely to the particular
ways in which specific circumstances affect individual
minds. It is sheer animism or anthropomorphism to endow
the causes of our feelings with the feelings they produce,
this being in essence the pathetic fallacy. The animistic
or anthropomorphic tendency, exemplified in expressions
such as "satires of circumstance" or "irony of fate," as
if circumstance or fate had a mental disposition to be satir-
ical or ironical, is perhaps ineradicable, but it hardly
possesses philosophic merit. Thus, if I am the "victim"
of a circumstance, let us say when a brick falls from a
roof on my precious head, I may in pain and anguish curse

the object of my misfortune. "God damn it!" I am inclined
to cry out, as if the brick had chosen intentionally to act
at that particular moment in accordance with the law of
gravitation. To "damn" inanimate things for behaving in
conformity with objective causes is the pathetic fallacy in
its childish aspect. Is it less childish to invest with pathos
(which we do feel, and feel poignantly in the presence of
any of the calamities that may befall us) the causes or
conditions of our calamities? The disasters resulting from
an earthquake, for example, are undeniable, and the
pathos they induce is real, but it is real only as experi-
enced either by the "victims" themselves or by those in
sympathy with them. How absurd to attribute pathos to
the earthquake! To do so is to attribute to a natural event
the consciousness of our misfortune and our emotional
reactions to it; for pathos can denote nothing else than
conscious feelings, and to describe as pathetic an earth-
quake or any similar event is to commit the pathetic fal-
lacy, the fallacy of imputing to the cause of our emotions
the very emotions it generates.

HARDITH: Ah, my dear fellow, you have reached the limit
of what can be achieved by dialectical legerdemain! So
a fallacy is involved in the use of the term "pathetic" as
applied to human disasters because, forsooth, their causes
are, so to speak, "apathetic," in the sense of being insensi-
tive or indifferent to the effects they engender! But this
is simply preposterous. If philosophic analysis leads to
so complete an abandonment of common sense, surely
something is wrong with the analysis. Nothing is gained
by the logic of partition which demands that subjective

effects be altogether divorced from their objective causes.
I am aware, of course, that causes and effects are distin-
guishable, and that if we separate them it is possible to
discern, in the effects, qualities different from those pos-
sessed by the causes. Thus, the causes of color are not
colored, nor are the causes of scent scented; and this being
so, certain philosophers, addicted to the method of parti-
tion, have denuded the world of color and odor and many
other qualities, on the ground that they are but "subjec-
tive" and hence unreal. In the real world, so they aver,
a rainbow is without color and a rose without smell. And
to impute these subjective qualities, which are dependent
on the mind, to the nature of things, a nature to be con-
ceived as real only in separation from the experiencing
psyche, is to commit the pathetic fallacy. But what non-
sense! Causes and effects are not only distinguishable,
they are also related, and related intimately; causes cannot
be understood without reference to the effects they pro-
duce. If color, for example, is said to depend on light of
different wave lengths affecting the retina, the causes of
the experienced spectrum being uncolored rays impinging
upon the organ of vision, why is it necessary to deny real-
ity to color because in the absence of a retina there would
be no such quality? After all, the retina *is* present, and
it too belongs to the real world: the spectrum exists because
it is the nature of differing wave lengths of light to act
upon an existing retina in certain specific ways. There is
no reason for excluding from the real world a sensitive
retina and the complex mechanism requisite for the ex-
perience of colored surfaces. The conception of an uncol-

ored world—that is, the conception of the world in the absence of a retina—is certainly a "hypothesis contrary to fact." Why not entertain the notion of a world without light? But I am not sufficiently learned in these matters, and what I have said may strike you as naïve. What I am driving at is this. If it is a fallacy, which you call "pathetic," to ascribe to the real world qualities that do not arise until a psyche is affected, then we must have a name for the opposite fallacy, which consists in removing these qualities from the real world, and this fallacy I venture to describe as "apathetic." Yes, it is an apathetic fallacy to deny the reality of the psyche, and the reality of everything connected with its sensitivity and activity, in order to appropriate the epithet "objective" for a world conceived as alien from the psyche and indifferent to it. All this has a significant bearing upon the idea of pathos. How legitimate is it to speak of the pathos of events? The expression is fallacious, you say, because pathos has to do exclusively with the effects of certain events upon the psyche, and these effects are altogether extraneous to the "objective" nature of the events. There is nothing pathetic about an earthquake (to cite your example): what is pathetic is but the subjectively experienced evil unwittingly caused by it. I cannot take this view. Events are pathetic in the same sense in which surfaces are colored. If the psyche is not arbitrarily extruded from nature, the effects wrought upon it are not extrinsic to their causes. Of course, an earthquake is pathetic whenever it wreaks havoc upon the inhabitants of the region where it occurs. This felt havoc in the context of human life is as essential

to the objective behavior of an earthquake as the experienced spectrum is essential to the objective action of light waves on the human retina. Away, then, with the absolute dichotomy between the subjective and the objective! You may prove me guilty of the pathetic fallacy when I speak of the color of things and the pathos of events, but I turn the tables on you, Meredy, and I accuse you of the apathetic fallacy in reading out of objective nature all the facts that require reference to the psyche as if such reference rendered them nonnatural or unreal. . . . I see that you are smiling. Do you find what I say amusing?

MEREDY: No, Hardith, it is not amusement that prompts me to smile, but sheer delight. How clever of you to hit upon so singular a fallacy, and to give it so striking a name! The apathetic fallacy is indeed exemplified by an old-fashioned materialism which either denies outright the reality of mind or spirit or reduces it to the status of an epiphenomenon. And the fallacy is not altogether absent from some versions of modern naturalism. But I don't see how you can charge me with it. I don't assert that the distinction between the subjective and the objective is absolute, nor do I use one term in a eulogistic and the other in a disparaging sense. Far be it from me to emulate certain philosophers in drawing a sharp line between reality and appearance or between primary and secondary qualities of nature. And with your contention that cause and effect are inseparable I am in full agreement. Nevertheless, the distinction between the objective and the subjective, however relative and attenuated, is a valid one, and to eschew it is to abandon a useful instrument of thought. For after

all, there is a difference between the conscious states of
pleasure and pain and their physical conditions, whether
these conditions be identified with specific processes of
the nervous system or with external stimuli setting them
in motion. If we characterize the effects of causes as sub-
jective and the causes themselves as objective, we indicate
clearly that the former are facts of conscious experience,
and the latter are nonmental facts determining through
their antecedent behavior the conscious concomitants in
question. Subjective facts are certainly facts, but distinct
in quality from those we designate as objective. The argu-
ment that it belongs to the nature of objective causes to
produce subjective effects does not vitiate the difference
between them. Your example of the causal relation be-
tween light and color is too recondite a theme for me to
expatiate on, my knowledge of it being no more adequate
than yours. But surely the intrinsic properties of light are
dissimilar to the series of hues we are conscious of. More
relevant to our purpose is the relation between an objec-
tive event, such as an earthquake, and its subjective per-
cussions and repercussions, the ensuing calamity and the
supervening pathos. Would it not be absurd to regard the
subjective consequences of an earthquake as so essential
to its objectivity that in their absence the event could not
be said to have manifested its full nature? Earthquakes
do occur without ruinous results to human life, and are
thus lacking in pathos, yet this lack has no bearing upon
the objective description with which geology is concerned:
their effect upon human fortune and the human psyche
is adventitious to their physical behavior. This is true of

all objective events: pathos forms no part of their nature, and to view pathos as intrinsic to them, since pathos is admittedly a subjective notion, is, I repeat, a pathetic fallacy. No fallacy is involved in describing the world as "apathetic" if the term be used to signify merely the negative of pathetic. The nonpathetic nature of things is obvious: human sensibility and human feeling are but human, measures of human values, not standards to which the universe must conform.

HARDITH: We seem to have lost sight of tragedy, which combines in its philosophy of pathos natural and human, or objective and subjective, aspects. For tragic pathos does not depend upon natural circumstance alone, unless we include under "natural circumstance" the passions and actions of man, in which case the "pathos of nature" is not a misnomer. But if we distinguish between objective circumstance and subjective character, their *reciprocal* relation being essential to tragedy, then the cause of pathos lies in the total situation in which human individuals, as in *Othello* or *Macbeth*, precipitate the events that inevitably culminate in catastrophe. An earthquake, an illustration altogether inapposite to our purpose, is no subject of tragic pathos; it is a circumstance which human beings can neither initiate nor avert. What arouses tragic pathos has its primary source in such events as result from human agency. The calamities produced by human agents have a peculiar poignancy; we cannot help feeling that they might have been avoided if the characters responsible for them had chosen to act in a different manner. What men do by their free volition they might by the same volition

have left undone. The deepest pathos is engendered by
the disasters issuing from courses of action which the
agents could have elected not to pursue. The postulate
of free volition is requisite for tragic pathos if we are to
retain the distinction between calamitous events due to
natural causes and those produced by human agency. Now
the proper theme of tragedy is basically the theme of
human agency: death and destruction, and other cata-
strophic occurrences, have their origin in the passions and
actions of men. Considered as an *art*, tragedy, concerned
as it is with human causation, exhibits a connected series
of objective events determined by subjective motives and
interests, the pathos of the ensuing calamities being felt
because of the evil that men do and suffer through their
own voluntary behavior. But tragedy also implies a *phi-
losophy* of the evil created by human agency, and this
philosophy refers to the reasons rather than the causes of
evil. The evil of the world caused by human action finds
its justification in the spiritual nature of the world. It is
not in vain that men struggle, inflicting torment and woe
upon themselves and others; though free volition deter-
mines their behavior, this free volition is under the guid-
ance of a higher necessity, the necessity of vindicating the
good through the very instrumentality of evil. Men who
assert their overweening passions, challenging the moral
forces that ultimately rule the world, inevitably court
defeat and disaster. Although knowingly or unknowingly
antagonistic to these moral forces, they are in truth their
disguised protagonists. By expiation, which tragedy exacts
of evildoers, evildoers are made to proclaim the glory of

the universal things of the spirit. Tragic pathos, depending upon human causation for the production of the world's evil, thus reaches grandeur and sublimity: what we are made to perceive is objective evil proceeding from subjective conditions and justified to render victorious and inviolable our eternal moral values.

MEREDY: I should reprove you perhaps for employing a method you have so often disparaged. Surely the issue between us cannot be settled by the partition between human and nonhuman causation. The causes that operate in tragedy to bring about human disaster are no less strictly determined than the causes producing an earthquake. From the spectator's point of view, the monstrous action of an Othello or a Macbeth is as unalterable as volcanic action, preconditioned as it is by a specific character endowed with specific propensities. Othello or Macbeth cannot help acting as he does: his given character dictates his mode of behavior. There would be no tragedy if Othello could by his free volition curb his consuming jealousy or Macbeth his goading ambition. Although tragedy deals with the fateful events caused by human action, such action, given the particular nature of the agent, is ineluctable. To be sure, the agent, under the illusion of free volition, acknowledges the guilt of his deeds, as if he could have refrained from committing them, and admits the justice of atonement; but the spectator perceives these deeds as determined by the character of the agent, and the agent being what he is, no other deeds are possible at all. The illusion of free volition on the part of the agent and the recognition of it as illusion by the spectator are

complementary aspects of tragedy viewed as a work of art. The spectator, through imaginative identification with the character of the agent, vicariously experiences the sense of guilt and the retribution of justice, but upon this identification supervenes the insight that, as the justice is "poetic," so is the guilt, the guilt as well as the justice involving the imaginary assumption that the determined and predetermined action need not have been initiated or could have been averted. Hence the high or deep pathos of tragedy: fateful events are exhibited as inevitable and necessary, inevitable in the sense of exemplifying conformity to the principle of strict determinism, the chief conditioning factor being the nature of the agents, and necessary for the sake of the aesthetic effect that tragedy aims at. Tragic pathos, in short, is the pathos of imaginary agents treated imaginatively as if they were responsible for the disaster ensuing from deeds which they are under compulsion to enact in accordance with their character. But we are here in the realm of art in which the creation of illusion is requisite for the creation of aesthetic values. Tragedy owes its construction as a work of art to an unrestricted use of "poetic license"—it is license to portray characters as if they were free agents, it is license to impute to them a sense of guilt for their inevitable action, it is license to make them suffer expiation for the sake of retributive justice, and it is license to arouse pathos for feigned disaster dramatically proceeding from feigned causes. Such license, essential to tragic art, is, of course, unexceptionable, and no one can dispute its aesthetic validity. It is the philosophic validity of this kind of license

which I impugn. Tragedy, I repeat, is an artifact, embodying in imaginative form an imaginary situation, the pathos it induces being a factitious one, created by an artist deliberately for the sole purpose of affording an aesthetic experience. To view tragic art as an expression of a tragic philosophy, to mistake as real or objective a fictitious plot culminating in a fictitious catastrophe, and to speak of aesthetic pathos, that is, a pathos produced by artistic design, as revealing the universal pathos of life or existence—all this is a pathetic fallacy.

HARDITH: You are harping once more on the untenable separation between art and life. If I speak of human causation as basic to tragedy, I mean by this causation action initiated by the same free volition which every agent in ordinary life assumes to possess. That man is responsible for his conduct, as a result of the exercise of his free will, is a universal moral postulate affirmed by tragedy. And that the consequences of voluntary action are strictly determined, this too tragedy confirms. If there is a dilemma between free and determined volition, it is a dilemma not peculiar to tragedy, all human morality being burdened with the same antithesis. And if free volition is said to be an illusion, the illusion is one to which every moral agent is subject and not merely the characters in a tragedy. Of the so-called dilemma of determinism, the illusion of free will being one of its horns, tragedy is a perfect epitome, manifesting in this respect a close affinity with philosophic thought. Assume that the pathos of tragedy is nothing more than the pathos of imaginary agents bringing misery upon themselves and others by deeds which they

falsely suppose to proceed from their free volition but which we perceive to be predetermined by their character; even so, such pathos could not be construed as exclusively aesthetic, the creation of an artistic design through the use of a poetic license, symbolizing as it does the universal predicament of mankind, on the alleged theory that every human agent, though he claims to be free in his choice of a course of action, can only act, after the manner of Othello or Macbeth, in accordance with the specific propensities of his nature. The personages in a tragedy, however imaginary, are thus typical representatives of humanity: they exemplify in their behavior the general supposititious belief in liberty of decision, and the pathos of the fabled situation produced by tragedy is therefore the pathos of real life, for the plight depicted is the plight of every individual who in asserting his will is the victim of an illusion that he has a free will to assert. Yes, Meredy, your own view of tragic art must perforce identify it with a tragic philosophy.

MEREDY: Ah, Hardith, how perverse you are in mistaking so completely my point of view! I should indeed be open to criticism if I maintained that free volition is an illusion and that determinism entails a tragic philosophy of life. Who can deny the freedom of the will as a fact of experience? And who can set aside the genuine feeling that in the presence of alternative courses of action every man in everyday life has the power of choice? The consciousness of option prior to decision is not illusory; what may be deemed so is the belief that the decision once made could have been a different one, in the light of all the

circumstances, including the character of the agent, that determined it. The *feeling* of option, which is never deceptive, and the *opinion* regarding the nature of this option, which may be erroneous, are thus two distinct things. Tracing a decision back to its causes to show that, given the causes, the decision was inevitable, does not render illusory the felt freedom of choice on the part of the agent when confronted by the need of making a decision. Every agent, in making his decision, is conscious of his power to make it, and no theory can take away from him this actual consciousness of power, though it is always possible to question whether this felt power was the only power in effecting a decision, and whether this felt power was not itself determined by antecedent causes. I wish, however, I had not broached this hoary problem: the freedom of the will has been a subject of endless debate of which the results still remain inconclusive. But the topic cannot be altogether eschewed in relation to tragedy, for tragedy exhibits events in their unalterable causal sequence, the culminating disaster being predetermined by the mutual impact of circumstance and character, and designed by the artist for the purpose of arousing pathos. Whence the pathos? Now there is no necessary connection between philosophic determinism and a tragic view of life. Those philosophers who deny the freedom of the will do not consider the denial a ground for pathos. On the contrary, they hold universal determinism to be the very foundation of a rational and even an optimistic view of the world. I am thinking, for example, of Spinoza: his "intellectual love of God" consists in contemplating

the universe "under the form of eternity"—under the form,
that is, of strict necessity by which everything is deter-
mined in accordance with the operation of the immutable
laws of nature. Spinoza's philosophy, which does not
countenance free will, is emphatically not a tragic philos-
ophy. And I cannot help mentioning Leibniz: his extrava-
gant optimism that "this is the best of all possible worlds"
is a speculative deduction from the principle of universal
determinism. And I need only allude to Schopenhauer,
who is a sort of Leibniz in reverse, to show that universal
indeterminism may serve as basis for an uncompromising
pessimism: this is the "worst of all possible worlds" pre-
cisely because it is the expression of a free and insatiable
will, the pathos of life having its source in the groundless
pursuit of illusory ends. No, Hardith, if we consult the
philosophers, we find among them no agreement that the
pathos of human existence is or is not to be derived from
a predetermination in the nature of things. And, I repeat,
whence the pathos of tragedy? This pathos, I insist, is a
special and not a universal one; it is produced by means
of a fancied plot and emotive language for the sake of
inducing a particular aesthetic experience, and when its
aesthetic value is ignored or discounted, the pathos ceases
to be tragic and becomes ordinary, such pathos as is felt
daily in the face of any misfortune whether wrought by
human causation or nonhuman, for tragic pathos is made
to order, so to speak, by a creative imagination to satisfy
the requirements of dramatic art and to provide the spe-
cific pleasure this art is intent upon. Everything in this
art is contrived by its creator: the consuming passions and

monstrous actions of the characters, the illusion of the
dramatis personae that they are free agents, the necessity
for this illusion as a basis for guilt to be avenged by a
poetic justice, the awesome inevitability of all that trans-
pires (so as to make determinism coincide with fatalism),
the beauty of the form through which an inexorable catas-
trophe becomes at once poignant and pleasing. Yes, the
creator of tragedy is a sort of *deus ex machina* at whose
bidding the creatures of his fancy comport themselves as
they do for the purpose of charming the spectator by the
beauty of their fictitious fate, and when the beauty is
compelling the spectator is beguiled, suffering his pity
and fear to be aroused by an imaginary situation as if
it were real. In the last analysis, the pathos of tragedy is
pathos clothed in the form of beauty, and to conceive of
tragedy as revealing the pathos of life is to misconceive
both art and life. The significance of tragedy lies in the
creative form which an artist imposes upon his material,
even though the material be drawn from ordinary experi-
ence; life as it is lived on the natural level is not like an
artifact with its incidents and episodes prearranged in a
form designed in accordance with aesthetic standards. We
cannot speak of the tragedy of existence without inter-
preting its pathos as cognate in beauty or value with the
factitious pathos of a work of art, and such an interpreta-
tion is simply another aspect of the pathetic fallacy.

HARDITH: I have listened to your long speech with increasing
amazement. It surely cannot be your contention that life
becomes falsified when presented through the creative
forms of art. Should all art aim merely at photographic

verisimilitude? I do not believe that you intend to defend
a thesis so palpably absurd. Life and art are related not
by similarity in form but by correspondence of material.
The forms in which artists exhibit the material drawn
from life bring into focus the true nature of the material,
rendering its meaning perspicuous and its significance in-
telligible. Tragedy is an art peculiarly fitted to perform
this task. Its material is the pathos of life, the depth and
universality of which do not become clear and persuasive
until cast in artistic form. This form is not exclusively
aesthetic, charming the spectator by its beauty, and be-
witching him, as it were, to mistake fiction for truth. No,
the form which tragedy employs, though sensuous and
pleasing, is also a vehicle of ideas and ideals, for by
means of it we are made to understand the source and
purport of human pathos. Tragedy is inspired by an im-
passioned vision that the greatest misfortunes are conse-
quences of human action tainted with guilt. The guilt is
not specious, but real, the behavior of the agents being
determined by their own choice. The postulate of self-
determination, in the sense that no will save their own
directs the conduct of the agents, is the fundamental pos-
tulate of tragedy. To be sure, tragic characters are por-
trayed as more self-willed than ordinary characters are;
but this, far from being a departure from verisimilitude,
typifies rather the basic human persuasion that responsible
action is deliberate action proceeding from no will other
than the agent's. Of the freedom of the will, for which
self-determination is the proper synonym, requisite for
responsible and hence for guilty action, tragedy is thus

a philosophic avowal in artistic form; and this avowal is compatible with the presentation as inevitable of the ensuing results, which the agents can neither initially foresee nor subsequently control, the effects of voluntary action depending upon the action of other agents as well as upon the circumstances of nature. Hence the pathos: self-willed or willful deeds breed disastrous consequences that are mistakenly and therefore criminally supposed to be precluded, and consequences that follow nevertheless by necessity, that is, by natural causation. If tragedy were nothing more than an artistic treatment of this human predicament, it would still be an accurate epitome of the universal pathos of life, for the greatest evils that men do and suffer are those their own self-determined deeds precipitate in a world subject to relentless laws that brook no interference or control by human volition. But the true grandeur of tragedy lies in the exaltation of these laws as rational and moral and sacred. Because the order of the world is a spiritual order, the mutilation of it by self-willed or willful deeds calls for expiation, thus vindicating the claims not of poetic but of divine justice. The truth proclaimed by tragedy is deeply conceived: free volition, which is real and desirable, is subject to perversion, creative of evil rather than good, the evil consisting in an overweening passion to pursue ends in violation of the moral forces of the world; and when these forces are wantonly challenged, there is set in motion a sequence of events which culminates in catastrophe; and this catastrophe, being causally determined as well as divinely ordained, produces and transfigures tragic pathos, for the

finale represents a cleansing atonement of the evil that threatened but failed to subvert the sacrosanct values of life. Tragedy is indeed purgative, but purgative chiefly of despair. It teaches men not to resign themselves to evil, however ubiquitous, without seeing in its universal pathos the meaning and significance of a sublime purpose. If this be a pathetic fallacy, it is the fallacy of every philosophy which seeks to justify the efficacy of moral ideals and the sanctity of their value.

MEREDY: Far be it from me to impugn the importance of moral ideals or to detract from their dignity. But is a speculative philosophy usually called "idealism," of which tragedy is an alleged artistic version, the only philosophy that can vouch for the validity of moral values? Rival philosophies, such as realism or naturalism or any other, may likewise adduce arguments for the efficacy of the things of the spirit, and even for their sanctity, without attempting to anchor them in a superhuman or cosmic order. Human ideals are but human; it takes a desperate *tour de force* to invest them with a divine origin or divine sanction. There is nothing eternal about human values: they rise and decline, they belong to a historical ethos or culture of a people; and such an ethos or culture is essentially relative and variable. To speak of any specific ethos or culture as universal, as if it typified a life of reason decreed forever for all mankind, is to use the hyperboles of the poet or the prophet rather than the sober locution of the thinker. What fallacy is more pathetic than the idealistic apotheosis of human values? It is absurd enough to single out a particular ethos or culture as a universal

standard, binding unconditionally upon all men, but to
construe the universe in its terms is simply fantastic. The
forces of nature are not moral powers conspiring, as it
were, to avenge evil for the glory of God. The struggle
of good and evil is an earthly struggle; its deification by
idealism, all for the sake of justifying the pathos of life
as inherent in the dialectic of a celestial Logos, is a superb
feat of mythical speculation. But it is a myth nonetheless,
beautiful as poetry but fallacious as philosophy. In the
apotheosis of human values we have a most flagrant exam-
ple of the pathetic fallacy. And this is the fallacy of
tragedy, not as a work of literary art, in which the deifi-
cation of the earthly struggle of good and evil is a poetic
license legitimate for aesthetic purposes, but as an alleged
philosophy of life and the world, cognate with that of
idealism, taken literally and seriously.

HARDITH: It is useless perhaps to reiterate my contention
that the fallacy you discern appears so only from a certain
point of view. Idealism is not fallacious unless we accept
the truth of that philosophy which is opposed and hostile
to it. Your approach to tragic art is that of a naturalist,
and of course, if the tenets of naturalism are true, those
implied in tragedy must be false. If you reject my position
because it cannot be supported by scientific evidence, I
will not quarrel with you. A tragic philosophy, I admit,
is not a naturalistic one. But why should you quarrel with
me if, refusing to acquiesce in the exclusive truth of nat-
uralism, I appeal to a different standard for judging evi-
dence? To stigmatize as fallacious and thus to rule out
of court whatever cannot be forced into the procrustean

logic of a particular philosophy, is the rankest kind of dogmatism. If the idealistic fallacy is a pathetic fallacy, on the ground that the nature of things is beyond good and evil and hence indifferent to human ideals and values, I can only retort by describing the naturalistic fallacy as "apathetic," the fallacy of ignoring the craving of the heart and the inspiration of faith. Tragedy embodies the simple and pious idealism of the greatest prophets and the greatest poets, who, though speaking in hyperboles, invoke the testimony of intuition for the religious belief that in the spirit of man is to be found the secret of the world, that this spirit is an image of the divine, that the struggle of moral forces is a universal struggle, that in this struggle the good eternally triumphs over evil, and that evil is the very vehicle and instrument for exalting and enhancing the value of the good, the pathos of human life thus becoming sublimated into a sublime necessity.

MEREDY: Your appeal to prophets and poets is touching. I am not insensitive to what their hearts desire. Nor do I belittle the deliverance of their faiths or the evidence of their intuitions. But to accept such deliverance or such evidence without criticism is to relinquish the task of philosophy. Is the idealism of prophets and poets, which you find to be embodied in tragedy, just an asseveration, impelled by deeply felt emotions? And what can challenge an asseveration save another, inspired by a different feeling or intuition? I question no asseveration if it refrains from claiming the cogency of an argument. What I hold to be a pathetic fallacy is the argument that the real world is responsive to the aspirations of the heart, and that the

objective nature of things is amenable to the categories of good and evil. I reject the view that the universal pathos of life is the pathos of the universe, as if a divine mind, and not merely the human, were suffering evil and atoning for it, all for the sake of glorifying our moral and spiritual values for the realization of which sin and crime must be continually struggled against. Tragedy thus becomes a divine comedy, providing a "happy ending," so to speak, in a preternatural sense and on a cosmic scale, the infernal work of Satan necessary for supernal triumph, Hell and Purgatory requisite for the ascent to Paradise. That human tragedy is a divine comedy may be profound religion and sublime poetry, taken as asseveration and not as argument, and hence not fallacious at all; for imagination is free to create worlds without end, in accordance with impassioned vision and perfervid intuition. But the fallaciousness is pathetic when tragic art is said to contain a tragic philosophy, a philosophy justifying human evil as contributing to the joy of a divine comedy, and applied to this world of ours, "with all its suns and milky ways," in relation to which earthly life is an incident and the human scene infinitesimal.

HARDITH: Yes, Meredy, "earthly life is an incident and the human scene infinitesimal." A tragic philosophy is not incompatible with this statement, provided only that earthly life be viewed as an incident in a larger life and the human scene as a microscopic epitome of the macrocosm. You beg the question by assuming this macrocosm to be lifeless and impersonal. I grant, of course, that no philosophy can usurp the function of science in the detailed study of

nature's phenomena. Scientific knowledge of the world, which is always knowledge of special areas of fact, and hence literally the knowledge of specialists, must not be confused with a more comprehensive synopsis of the nature of things. Naturalism too is such a synopsis, ultimately based upon intuition and faith, intuition of a universal mechanism which no particular science is competent to justify, and faith in scientific hypotheses as preempting truth about the macrocosm. Without denying the limited truth of scientific hypotheses, in the sense that such hypotheses are pertinent only to specific areas of phenomena, an idealistic synopsis includes stretches of human experience not superseding science, but supplementary to it—the inspirations of religion, the aspirations of morality, the visions of art. The whole truth about the universe is comprised in all the insights of the human spirit and not merely in the diagrammatic representations of things by the scientific mind. To speak of the universe as "apathetic," as transcending good and evil, as alien to the values cherished by man, is but an asseveration, to use your word, and if an argument, its doubtful cogency depends upon the unwarranted assumption that scientific description is an exclusive as well as an exhaustive explanation of nature. I refuse, if you permit me to say so, to put all my eggs in one basket. I refuse, in other words, to submit my philosophy of tragedy to a naturalistic judgment which is a scientific judgment extended to a domain over which it has no jurisdiction. A tragic philosophy is free from the so-called pathetic fallacy if we do not accord to science the privilege of being the sole arbiter of truth.

MEREDY: I am not disposed at this late hour to debate the intrinsic merits of naturalism and idealism. The aim of every philosophy is indeed comprehensiveness, and none can exclude from its purview the various aspects of human culture, such as science and religion and art and morality. But which of these aspects is to serve as standard for an adequate understanding of the world if the basis of the understanding be ascertainable knowledge? Now science is a name for the most ascertained knowledge the human mind has thus far achieved, and to evade or weaken its jurisdiction is to court intellectual disaster, since scientific discipline alone can curb our wayward feelings, our irrational intuitions, our wishful beliefs. Naturalism is a philosophy chiefly inspired by science because no other criteria governing our understanding of the world can vie with those of science in objective validity. If any philosophy is to be taken seriously as affording knowledge of the nature of things, it must use these criteria; otherwise the knowledge proffered remains but pseudo-knowledge, achieved by means alleged to rival or to replace the methods which science depends upon for acquiring and testing truth. It is the cognitive claim of idealism that is crucial here. The knowledge to which idealism appeals is assumed to be higher or deeper than scientific, vouched for by the asseveration of the spirit, resting on moral imperatives or impassioned convictions or dialectical demonstrations. I decline to accept this as knowledge in the proper or pregnant sense of the term. Now tragedy, to return to our main theme, is a work of art which I for one would never dream of subjecting to scientific or naturalistic criticism, simply

because I do not impute to it a cognitive purport. It is you who read such a purport into it. And I still maintain that when tragedy is interpreted as a philosophic compendium said to reveal a supposititious knowledge of life and the world, as attested by speculative idealism, tragedy partakes of the same pathetic fallacy characteristic of all idealism, the fallacy of according to human passions and actions a cosmic or divine significance.

HARDITH: Ah, to be sure, science is great, and wonderful are its achievements! You seem to forget, however, that science too is a human creation, of assumptions and postulates all compact, its elaborate framework buttressed by far-flung hypotheses involving for their truth certain canons of confirmation, both the hypotheses and the canons wrought by mind in quest for mastery over the forces of nature. The very existence and the very value of science proclaim not that nature is alien to man, but rather that it is congenial to his spirit, yielding to his ideas and responding to his theories. If knowledge is power, it is the power of man to make nature conform to his ideal of truth. But this ideal of truth may appear in sundry forms. I shall never believe that all truth is contained in the artifacts of science, and that the intuitions or visions embodied in works of art are cognitive counterfeits. If I adopted your narrow view of science, and the naturalism based upon it, despair would prey upon my mind that all human values are delusive things, arising and perishing in a macrocosm that is apathetic and indifferent to them, ultimately no more substantial than the stuff that dreams are made of.

From this pessimism I am saved by a broader view of science as well as by a deeper interpretation of art, especially tragic art. I find nothing in science to justify the alienation of the human spirit from nature, since the truth about nature which science formulates is true only in accordance with ideal standards governing observation and inference, hypothesis and experiment, induction and theory. Science, in short, is a name for human artifacts which purge nature of everything not amenable to their methods of construction. The knowledge yielded by scientific artifacts is a special or specialized knowledge that is valid indeed if we accept the special criteria for winning and winnowing it. But there are other human artifacts that deal with nature in different ways. What artists convey through their artifacts—perceptive acumen, acute discernment, perspicuous insight—is also knowledge, bred in the mind by sources other than intellectual. The intellect has no monopoly on intelligence. And an intelligent apprehension, primarily of our cherished values as rooted in the nature of things, though implicit in all art, is explicitly adumbrated in tragedy. There the spirit of man is depicted as subject to evil and misfortune when deliberately alienated from the larger spirit of the world, which demands, because it is the fount and origin of all our values, retribution for such willful alienation, thus proving that human agents, far from being strangers in the universe, must serve as protagonists of cosmically grounded and divinely ordained moral injunctions and moral imperatives. Unless I believed in the truth of this I should succumb to an unmitigated pessimism.

MEREDY: What! A tragic philosophy as the antidote to pessimism? This is a strange specific for a strange poison. Pessimism signifies that this is the worst of all possible worlds, and optimism that it is the best, either view being a matter of feeling or temperament, not the result of ascertained or ascertainable knowledge. To speak of nature as wholly good or wholly evil is extravagant if not absurd. Are all the facts of nature to be judged solely with reference to their capacity to foster or to frustrate human interests? The choice between optimism and pessimism is a Hobson's choice between two untenable extremes. To goodness and evil I can attach no meaning save as categories applied by the human psyche to its preferences and aversions. It is not nature's concern what the mind cherishes or abhors. This is indeed the pathetic fallacy with a vengeance, the fallacy of imputing to nature values that have no significance apart from the human scene, values depending upon human desire and human purpose. Now a tragic philosophy, which you offer as a refuge from pessimism, must therefore be construed as an affirmation of optimism. Can it be thus construed? What is central in tragedy is the indefeasible reality of evil: through their passions and actions men suffer and inflict pain and woe, the events they precipitate engulf them in disaster—they see their plans thwarted and their purposes frustrated, their interests and values reversed and subverted, their world wrecked by violence and death. For the characters involved in tragedy, and for the spectators imaginatively identifying themselves with their fate, what other point of view is compatible with the facts than that

of an unrelieved pessimism? Those who are embittered by their ghastly failure to bend the world to their will do not in real life glorify the world's goodness. Yet this paradox is precisely what by a tremendous *tour de force* you attribute to tragedy if its philosophy is to culminate in optimism. The bitter experience of distraught and shattered souls becomes somehow ineffably sweet, and the insufferable evil they let loose ultimately good. What to tragic characters must appear as the worst of all possible worlds, ending as it does for *them* in misery and destruction—this very world must be accepted by *us* as the best, because forsooth an avenging spirit rejoices in expiation of crime and atonement for sin. How odd an optimism that requires for its justification the pessimism of those who are the necessary agents and victims of evil! The irony of such a philosophy would be offensive if it were not sublime.

HARDITH: The irony, Meredy, is altogether yours, and it would be deplorable if it were not so clever. But your dialectic leaves me cold. Tragedy is no formal discourse on such technical issues as provide intellectual pabulum for philosophical schools or sects. Tragedy is not concerned with the logical opposition between optimism and pessimism. I use these terms in a general or colloquial sense, denoting attitudes toward life that are dominated by hope or despair. A tragic philosophy may be called optimistic simply because in the face of evil it fortifies our faith and sustains our conscience, enhancing our trust in the validity of spiritual values. It bids us not to sicken with despondency if these values are desecrated—if honor is sullied, love degraded, justice despoiled, truth outraged. These

values are sacred and enduring, and rendered all the more so because willful challenge to them is visited by death and destruction. The ancient virtues are not obsolete. In dedicating life to their universal governance consists the divine mission of man. Yes, the glory of tragedy is its unshakable optimism, but not the fatuous kind that denies the reality of evil. The evil exhibited in tragedy is grim and awesome, and while in the ascendant its reign is a veritable reign of terror. Such terror, however, is but an episode in the life of the spirit, which emerges from it more majestic and more radiant. This I regard as the philosophic quintessence of tragic art. And if to a logically fastidious mind the philosophic truth of tragedy appears vulnerable, it appears so only in accordance with the demand that all philosophic truth be couched in intellectual terms. Imaginative versions of truth, of which tragedy is a supreme example, have a depth and cogency of their own which we neglect at our peril—at the peril of consigning philosophy to the limbo of the arid abstractions of heartless men.

MEREDY: This is strong language, my dear fellow, betraying your impatience if not disdain of rigorous analysis and systematic thought. A philosophy not arrived at by intellectual means I cannot take seriously, because it defies criticism. The appeal to the heart as if it were guided by "reasons" of which reason is ignorant undermines the very basis of the distinction between valid and fallacious reasoning. The pathetic fallacy, which I discern in a tragic philosophy, is a fallacy only on the assumption that such a philosophy lays claim to being a reasoned and rea-

sonable one. I repeat: tragedy as a work of art is not fal-
lacious; what I find fallacious is the theory that the art
of tragedy is a revelation of the tragedy of life and exist-
ence. The fallacy of tragedy is the fallacy of transforming
a poetic into an objective view of the nature of things. Your
vehement rejection of this fallacy shows that, like all
idealists, you are a sentimentalist at heart. In the course of
our discussion you have brought into clear focus your im-
passioned point of view, and I will not deny the persuasive
force of it, taken as a moral and emotional response to
the world. And I have learned much from your wise and
illuminating opinions: they have helped me to clarify my
own philosophy and to throw it into a fresh perspective.
But I am still firm in my position that the pathos of human
life is not the pathos of the universe, and that we cannot
convert one into the other without committing the pathetic
fallacy. . . . But come, Hardith, let us resolve to pursue no
farther the theme of tragedy. I, for one, have lost interest
in so austere and solemn a subject after the three long con-
versations we have devoted to it. Let us, when we meet
again, choose for debate a more pleasant topic, and one
that will invite us to treat it in a lighter vein.